THE ULTIMATE **CONCEPT ART** CAREER GUIDE

3dtotalPublishing

Correspondence: publishing@3dtotal.com
Website: www.3dtotal.com

First published in the United Kingdom, 2017,
by 3dtotal Publishing.

3dtotal.com Ltd, 29 Foregate Street, Worcester,
WR1 1DS, United Kingdom.

Soft cover ISBN: 978-1-909414-51-8
Printing and binding: Taylor Bloxham (UK)
www.taylorbloxham.co.uk

Visit www.3dtotalpublishing.com for a
complete list of available book titles.

THE ULTIMATE
CONCEPT ART
CAREER GUIDE

3dtotalPublishing

CONTENTS

ABOUT THIS BOOK

Although concept art is a relatively new field in the creative industries, it is a quickly evolving area of expertise offering enormous opportunities to develop an art career in a wide variety of specialities. For anyone considering a career in the exciting and varied world of concept art, it may at first seem that there is an overwhelming amount of information to learn, and many decisions to make. This book is intended to help you navigate those decisions so you can make informed choices about your future.

Throughout this book you will find insightful career profiles from professional concept artists that outline their daily working habits and describe how they built successful creative careers. Regardless of the career stage you are at — whether the idea of concept art as a career option is new to you, whether you are a student, or already on your way to building a career as a concept artist — this book provides valuable advice on how to achieve your career goals.

The content of this book has been broken into four distinct sections — *An Introduction to Concept Art*, *Getting into Concept Art*, *Working in the Industry*, and *Future Options* — to ensure you can easily find information relating to the career stage most relevant to you. If you have only recently been introduced to the notion of a concept art career, it is highly recommended that you start with *An Introduction to Concept Art*, which will provide you with an introduction to concept art as a career choice. In this section you can learn about the key industries that concept artists are employed in, the tools and software that are commonly used, and the production process of a project.

In the second section, *Getting into Concept Art*, you can find information on the education options available to concept artists, advice on how to develop your skills, and ways to present yourself as a strong candidate to employers. Plus, learn how to create a successful CV, portfolio, and promotional materials.

Through the *Working in the Industry* section you can discover how concept artists work, learn how you can manage your time as a professional artist, and develop your work through critiques. Experienced professional artists advise on how you can form good working habits that will enable your career to grow. Here you will gain an understanding of what life as a professional concept artist can be like.

In the final section of the book, *Future Options*, you can explore additional ways to supplement your career once you have become an experienced concept artist. In this section you can learn about the advantages and disadvantages of freelance work, and how to develop a freelance career if you choose this route. You can also find advice on selling your work through online retailers, creating your own online shop, and other ways you can enrich your income.

Annie Moss
Editor, 3dtotal Publishing

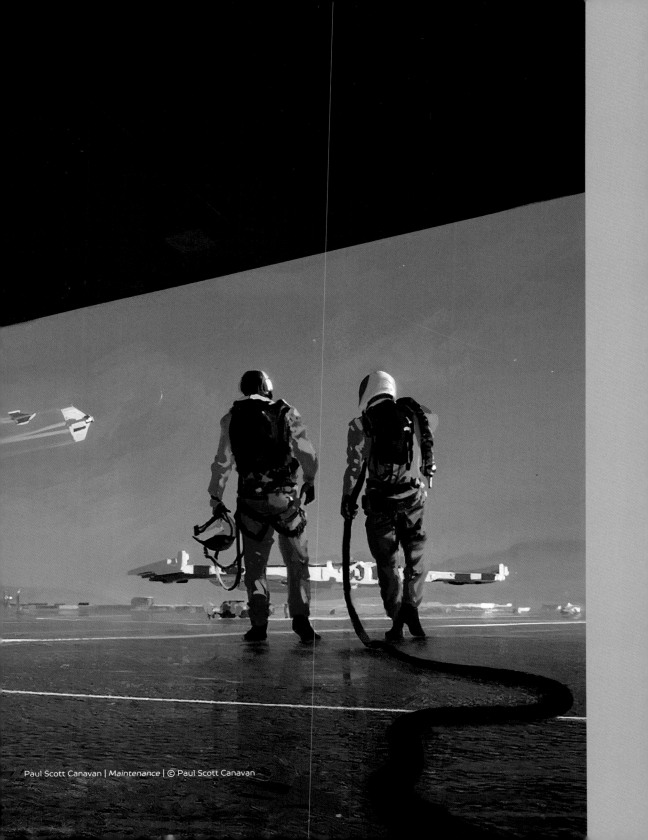

AN INTRODUCTION TO CONCEPT ART

Concept art is a relatively new career option so, compared to other creative occupations, there is limited information available about what a concept artist does and how they are employed. As a result, this career choice can often seem mysterious and confusing. In this section you will learn what a concept artist is, the industries they are employed in, and how they fit into the wider production process of a project.

WHAT IS CONCEPT ART?

BY JAN URSCHEL

Working professionally as a concept artist is becoming increasingly popular, but it is often misunderstood. Starting your career with accurate expectations and appropriate preparation can set you up for success from the beginning. This guide will help you on your journey, but initially you need to understand what concept art is and what a concept artist does.

OVERVIEW

Concept art, or concept design as it can also be known, is understood as the visualization of ideas which currently only exist as written words, or thoughts, in someone's head. For example if a film director wants a haunting, desolate sci-fi background as one of the environments that will be incorporated into a movie, a concept artist (or team of concept artists) would produce an artistic impression of that environment brief in order to provide a visual guide for the production artists who will actually create that environment

- RESEARCH
- IDEATION
- SKETCHES
- REFINEMENT
- FINAL CONCEPT

later on. These production artists could be 3D modelers if a 3D environment is required, or set designers if a physical environment will be created.

In order to transform these ideas into images that others can see and comprehend, you have to develop various skills which can be used at different points of the process. However, the general process itself does not differ greatly from other design disciplines. The concept art process tends to occur as shown in the flowchart on the left.

SECTORS

As you will learn more about on pages 22–25, there are four key industries concept artists can be found in: the video game, film, TV, and animation industries. Within those industries, concept artists will often focus on a specific category of concept art: characters, environments, and more mechanical design. Within these categories though there is a level of flexibility expected as areas overlap depending on the creative vision being followed.

Since concept art is a relatively new practice, you will find that many people working in the field today studied different courses, attended a variety of universities, and have experienced many other disciplines before taking a concept art role. This diversity of experience has shaped the jobs of today and you will find

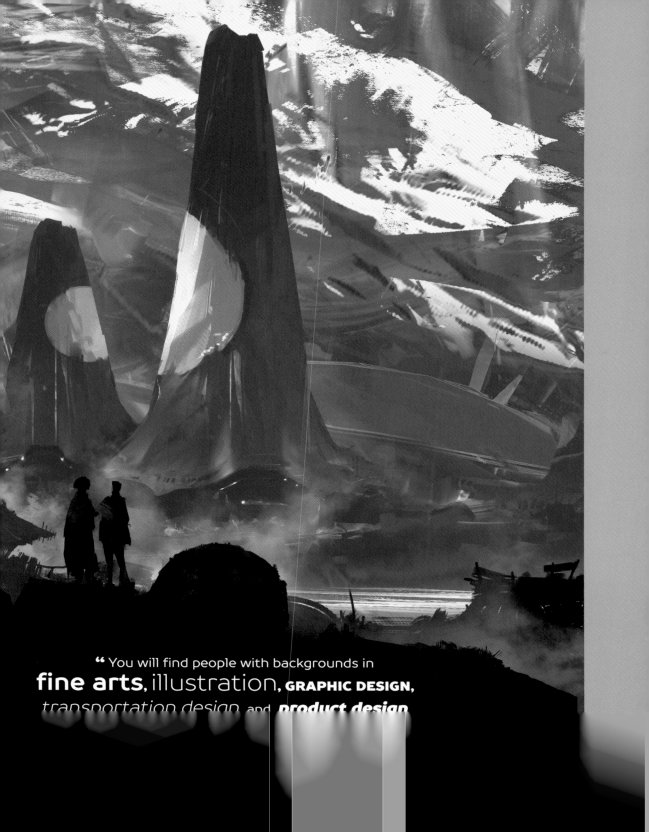

" You will find people with backgrounds in
fine arts, illustration, **GRAPHIC DESIGN,**
transportation design and **product design**

people with backgrounds in fine arts, illustration, graphic design, transportation design, and product design working in concept art. On top of this is a new generation of artists who have not necessarily gone through a formal art or design education to become respected artists in their industry.

This flexibility comes with the expectation that concept artists can visualize almost any topic without being an expert in it – such as drawing an airplane without having detailed engineering knowledge. As a result, concept art can be a demanding field that requires constant learning.

OPPORTUNITIES

As in many creative vocations, concept artists can either work in a studio or be self-employed as a freelancer – or in some cases a combination of both. As you read through this guide you will learn about what studios expect and gain insight into what it is like to work in a studio. Freelancing will then be discussed in more detail on pages 162–165. Different lifestyles suit different people, but generally, beginning your career in a studio is a great way to build experience and contacts. Many of the artists you will meet in this book have done a mixture of both during their career.

Career progression within a studio can take many directions. Many concepts artists will move on to become lead concept artists and art directors. As an art director it would be your responsibility to ensure the concept's vision is consistent and maintained by all concept artists working across a project. You may also come across production directors in this book, which is another role that involves overseeing the concept artists, but more in terms of schedule and budget.

WHAT DOES A CONCEPT ARTIST DO?

To understand what a concept artist does it is best to start by analyzing where a concept artist fits into the production pipeline of a project. We will look at the production pipeline in more detail on pages 18–21, but for now here is a brief summary. One of the advantages of being a concept artist is that your skills can be utilized at various stages by slightly adjusting the kind of work you do.

In the games industry, for example, a project starts in the pitch phase where new ideas can be tested and presented to a potential publisher. It is in this stage where the wildest and most creative ideas can be tested to see what works. Concept artists will work from a brief to translate

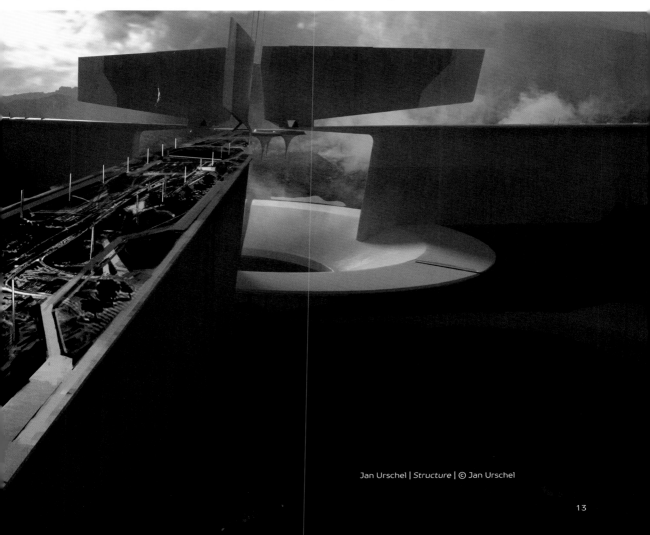

Jan Urschel | *Structure* | © Jan Urschel

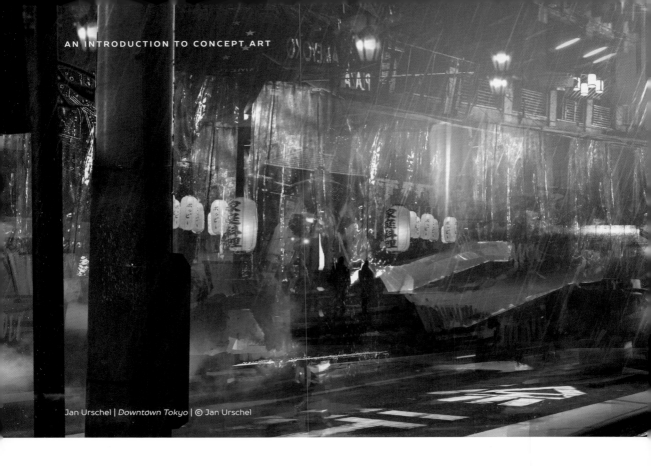

Jan Urschel | *Downtown Tokyo* | © Jan Urschel

an idea into something visual that can be used to evaluate the potential of the project and develop concepts further. Even at this stage though, the process is very much a team effort so a concept artist should be open to his or her colleagues' ideas.

The busiest time for concept artists is once an idea has been approved for pre-production. In pre-production, a whole universe needs to be designed including the overall look, environments, characters, vehicles, and props. It is a very exciting time indeed. Here concept artists will work on

concepts in more detail so they can actually be created by the production team in either 2D or 3D. For example for a fantasy game you could be designing the main character's costume, which will then be created by a 3D artist.

If the studio you work for has multiple projects at different stages of development you might be moved onto another project once your project goes into production. Often however, you will stay on your original project to help the production team with continued concepts.

You may also be required to do paint-overs to demonstrate the lighting, materials, and so on. As the project evolves into an interactive experience there will be many changes from the original idea which will need to be worked into the concept to create a cohesive whole.

Towards the end of a project you may be required to create further VFX (visual effects), or work on marketing art.

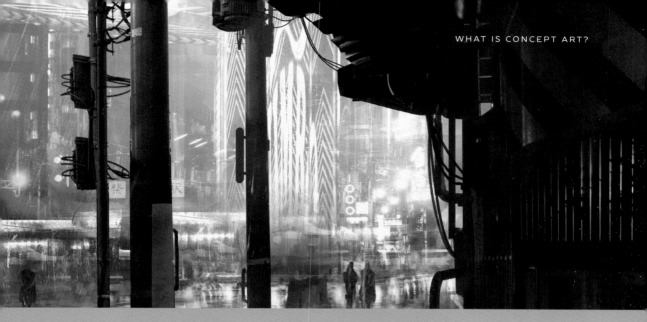

ARTIST PROFILE

JAN URSCHEL

Concept Designer

hendrix-design.com

Jan is a concept designer and illustrator in the entertainment industry. He has worked on feature films and video games with clients including Paramount Pictures, Warner Bros., Lucasfilm, Microsoft, Framestore, and MPC.

Career highlights

· Concept Designer at Hendrix Design

· Concept Designer at Ubisoft

· Concept Designer at LucasArts

· Lead Graphic Designer at OANDA Asia Pacific

· Graphic Designer at Bokowsky + Laymann GmbH

What aspects of your job do you love?

Being able to create worlds and express my ideas visually – alone and in teams – and be paid for it.

What factors are important when trying to find work as a concept artist?

Timing and luck is everything when it comes to landing good jobs. I make sure I am always prepared by having my portfolio updated and ready when an opportunity comes along.

Is there anything you think budding artists should try to avoid?

Developing artists should try to be creative and not just copy their idols. A concept artist's job is to create something new. While learning from others is a good idea, what you ultimately produce should be original.

What has surprised you about your concept art career?

That it is not so much about technique, but about knowledge and ideas.

What advice would you give someone wanting to get into concept art?

Do not be fooled by the images you see online. Creating beautiful finished images is only a small part of the job.

EXPECTATIONS AND WORKLOAD

BY ZAC RETZ

WHAT IS EXPECTED OF A PROFESSIONAL CONCEPT ARTIST?

Beginning a career in any sector or industry can sometimes feel like a leap into the unknown. You may wonder if the lifestyle will suit you, or if you will be able to do the kind of work you really enjoy. In many studios, production designers let you be yourself and use your abilities to the fullest. It is the production director's job to manage the artists and enable them to create the best artwork possible for the project. For example some artists will be at their best when creating quick concept paintings that reflect the story and design of the environment. Some people are great at drawing and some are great color artists; everyone tends to have their niche which dictates the work they do.

Whatever your focus is, the overarching goal is to create artwork that reflects the script or brief and that is full of emotion and originality. As the project moves into production you will be required to design very specific areas. For example if your assignment is to design the interior of a boat, you will need to design the area as a whole, and then design the props, flooring, and anything else that is needed to make the interior complete. There can be variations depending on how the scene is shot, but you will always need to make sure you are giving the modelers enough information about the design concept to build the set.

THE WORKLOAD OF A CONCEPT ARTIST

When a project is just beginning you have a lot of time to explore. There might be a couple of weeks or a month to develop a set for example. In this time you will make a lot of sketches and paintings, and, for a film, capture story moments to show the designs in the wider context of the narrative. Usually there will be meetings with directors and producers twice a week to show them your progress.

As the project goes into production and everything you have designed needs to be built, the process starts to speed up. By this time you know exactly what the style of the project will be, so the art you create is very specific and will either go directly into the project or be used to meet the production's needs.

During the production stage you might be expected to create two or three color keys a day, a detailed painting in a week, or a set of props in a couple days. Even if deadlines are tight, the workload is managed by the production director to ensure that it is manageable. Sometimes it can even be fun to be put under a little pressure.

" The **overarching goal** is to create artwork that reflects the script or brief and that is full of **EMOTION** and *originality* "

Zac Retz | *Beach* | © Zac Retz

THE PRODUCTION PROCESS

BY DONGLU YU

In this chapter you will gain an insight into how project pipelines generally flow, which will prepare you for the type of work you may be expected to do as a professional concept artist. You will learn about the three main phases of production and develop a greater understanding of what a concept artist does at each stage.

THE PRE-PRODUCTION PHASE

The pre-production phase is where concept artists can enjoy the most artistic freedom. The artworks produced during the pre-production phase often serve as materials in pitches to company executives in order to push the project forward into the production phase.

As mentioned on page 10, concept artists are usually divided into three categories: environment, characters, and anything related to mechanical hard surfaces such as vehicles, props, and weapons. During the pre-production phase, all concept artists need to understand the high-level direction established by the art director and apply the specifications of these guidelines to their artwork. A close communication with the art director is essential for delivering satisfying results. Concept artists are also encouraged in this phase to work as a group to spark ideas.

THE PRODUCTION PHASE

Once the project hits the production phase, concept artists are required to work not only with the art director but also with artists from different departments. In video games, environment concept artists work closely with level artists (who create the playable game level and ensure the design elements can be integrated) to provide them with finished concept artworks, research material, and photo references.

When the art director is particularly busy during the peak of production, artists from other production departments will often seek the opinions of concept artists to see how they can improve the design elements that they are building. Environment concept artists also often work with the lighting and VFX departments in order to achieve the proper mood and ambiance that they have established in the approved concept art pieces.

Character concept artists work closely with character modelers, animators, and riggers in order to make their designs both visually appealing and functional. To build a successful 3D character that can have a proper rigging system for animation for example, character concept artists need to know how to balance the designs with the technical constraints of the project. Accessories such as a helmet, shoulder plates, a cape, and long fabrics can often cause problems during the rigging process. Thus all character designs need continuous adjustments throughout production from the concept art team in order for the models to perform properly.

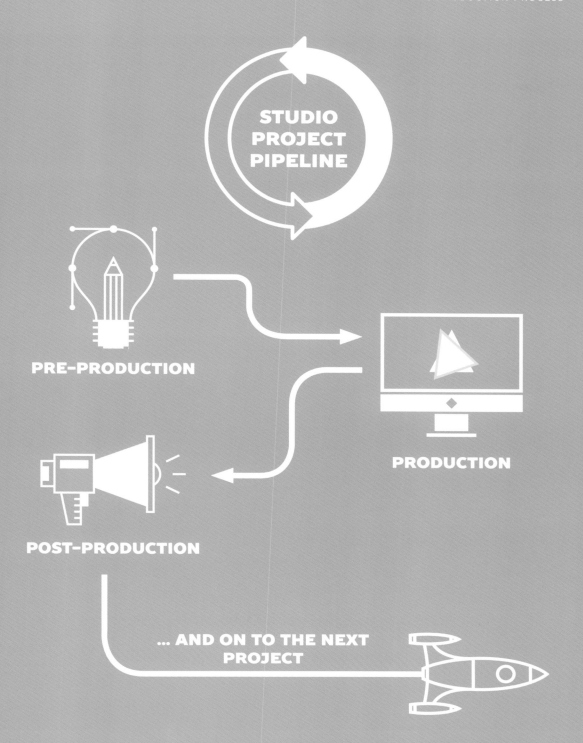

STUDIO
PROJECT
PIPELINE

PRE-PRODUCTION

PRODUCTION

POST-PRODUCTION

... AND ON TO THE NEXT
PROJECT

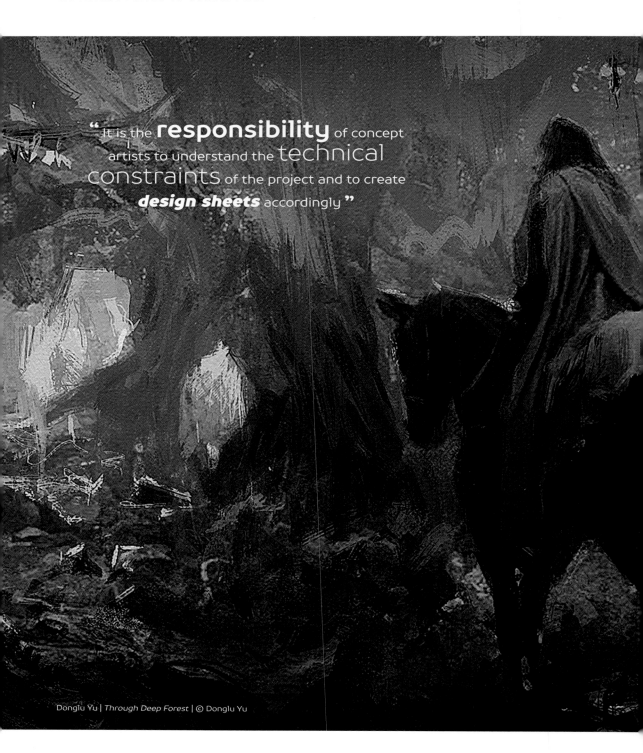

" It is the **responsibility** of concept artists to understand the technical constraints of the project and to create *design sheets* accordingly "

Donglu Yu | *Through Deep Forest* | © Donglu Yu

The concept artists who are making vehicles, props, and weapons are required to work mostly with modelers and technical artists. Concept artists working in this field often need to create model sheets that include different angles of each object so the modelers can fully understand the designs. Sometimes the modelers may give the concept artist a basic 3D blocking of an object with the correct metrics for the concept artist to paint on top of when creating the model sheet.

As there can be a large number of props needed, technical artists might create a polygon and texture budget limit for each kind of hard-surface object. It is the responsibility of concept artists to understand the technical constraints of the project and to create design sheets accordingly. If there are any exceptions, such as special props for the hero for example, do not hesitate to communicate with the technical artists to see if there is a compromise that can be reached.

POST-PRODUCTION

During the post-production phase, only a few concept artists will remain on the project. Their job is usually to create marketing materials and provide quick paint-over work for other departments to carry out some final polishing on. The concept artists who are no longer needed for these tasks will be moved on to new projects.

KEY INDUSTRIES

BY JAN URSCHEL

There are four key industries which dominate the concept art world: the video game industry, the film industry, and the TV and animation industries. In this chapter you will discover how each one differs in terms of the opportunities and working environments they offer to concept artists.

VIDEO GAME INDUSTRY

The video game industry has now surpassed the movie industry as the highest grossing area in entertainment. This means that it is the industry with the most jobs for concept artists, with the majority working in-house for studios.

The incredibly diverse range of game and art styles means that this industry provides the most artistic freedom. When creating concepts for video games you are regularly not limited by real-world concerns, meaning you can explore imaginative ideas which will assist in the creation of a great game. Hardware like VR (virtual reality) headsets is also increasing the exciting areas that this industry can expand into.

" With new and more **powerful HARDWARE** however comes the need to boost the **visual fidelity** and *sophistication* of the art when working on AAA games "

With new and more powerful hardware however comes the need to boost the visual fidelity and sophistication of the art when working on AAA games (games with the highest production values and budgets). As a result, concept artists often have to increase their understanding of 3D modeling and materials to aid environment and asset artists in the creation of highly complex designs.

Furthermore, production cycles are becoming longer and longer. It is now common for artists to have to wait up to five years for their NDAs (non-disclosure agreements) to be lifted and be allowed to show their work to the public.

FILM INDUSTRY

The film industry has employed concept artists and illustrators for many decades and it is often considered the highest achievement to work on inter-national blockbusters. There are several reasons for this but the most significant are that there are comparatively fewer jobs than in other industries, and often these roles have higher technical and design skill requirements.

There are numerous challenges in the film industry which are often not present in other industries. More often than not your concepts have to be built as physical sets with real materials that have their own characteristics. Understanding this and the jobs of other people working on a film can go a long way to increase your value in the industry. An example would be a character artist in the costume department. Based on your concepts, real clothes have to be sewn or otherwise made, so it is useful to understand how the materials work, their relative cost, and how easy they are to obtain.

Meanwhile, concept artists focusing on sets can positively contribute to a production with an understanding of how sets are built, the locations they are based on, and how cameras and lights can be set up.

TV INDUSTRY

The TV industry can offer a variety of opportunities for concept artists. You could, for example, work in pre- or post-production on VFX-heavy fantasy or sci-fi productions, similar to opportunities in the film industry. Alternatively, there is an increasing number of jobs in TV commercials and also in music video production.

For this medium the scale, budget, and visual possibilities are more limited, which often requires you to tone down your concept to deal with the technical limitations of the production. There are also very short turn-around times and almost no lead time (the time it takes to complete a process), which can make working on something like a commercial very stressful.

However, shorter production cycles also mean that you can show your work soon after a project. The budgets for TV are ever-increasing, and private content providers like Netflix, Amazon, and HBO are producing lavish shows which rival Hollywood films. This shows that the TV industry is a promising area for concept artists, with plenty of jobs.

ANIMATION INDUSTRY

The animation industry is similar to some of the aforementioned industries as projects are produced for both TV and film. In animation there is stylistic freedom to explore many visual possibilities, but it is a notoriously difficult field to enter. Just the mention of having landed a job in the visual development department of a company like Pixar or Disney usually results in jealous looks.

The animation industry also has very high expectations of concept artists in terms of their skills. Art books for popular projects show the wide variety of styles that are used during the development phase, however these do not necessarily reflect the final look of the animation, which is a team effort. Artists working in animation need to be proficient in expressing feelings, emotions, and mood through various styles, color, and characterization.

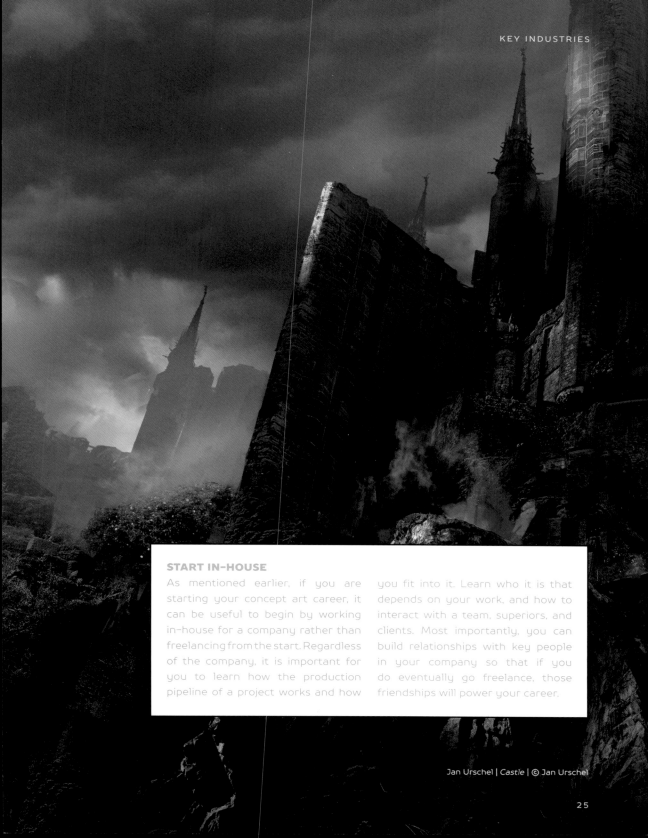

START IN-HOUSE

As mentioned earlier, if you are starting your concept art career, it can be useful to begin by working in-house for a company rather than freelancing from the start. Regardless of the company, it is important for you to learn how the production pipeline of a project works and how you fit into it. Learn who it is that depends on your work, and how to interact with a team, superiors, and clients. Most importantly, you can build relationships with key people in your company so that if you do eventually go freelance, those friendships will power your career.

Jan Urschel | *Castle* | © Jan Urschel

PROFESSIONAL TOOLS

BY JAN URSCHEL

Although the different industries that hire concept artists, and the individual studios within each industry, use varying equipment, there are some common professional tools it is useful to be familiar with. Knowledge of these tools will help you build a suitable portfolio and make you a more attractive applicant to studios. Even in your personal work you may find that experimenting with a new medium helps you to develop new techniques and quicker working processes.

MACS AND PCS
There was, and still is, a lot of debate about whether PCs or Macs are better for working as a concept artist. In some ways it is not important which operating system (OS) you use as both provide a stable production environment to work in. The system you choose should really depend on the kind of hardware you want and how much you are prepared to deal with having to fix your computer.

Macs are generally the more expensive option of the two but you tend to receive better service on your machine. PCs, on the other hand, can be easily upgraded but come with the caveat that you have to do your own maintenance. In the end, what is more important is how you use your system and not what the specific computer is.

DRAWING TABLETS
Drawing tablets are the tools that are most commonly used by concept artists. They provide an intuitive input method not only for drawing and painting, but also for general navigation in the OS and other applications such as 3D software.

Over many years Wacom has retained its status as the top brand when it comes to specialist drawing tablets. They release regular updates for their main line of drawing tablets for professionals (Intuos) and amateurs (Bamboo) and

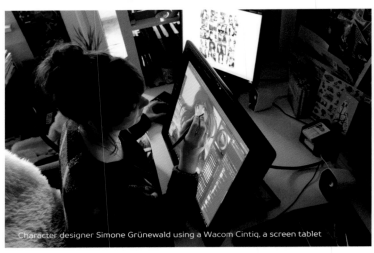
Character designer Simone Grünewald using a Wacom Cintiq, a screen tablet

continue to innovate their products through features such as a function that allows you to transfer a paper drawing into a digital file. Other tablet manufacturers include Ugee, XP-Pen, and Huion, who offer cheaper options than Wacom, but are used less widely. Regardless of which model of tablet you choose, it is a highly recommended tool.

SCREEN TABLETS

Besides drawing tablets, which usually lie on the desk as an input method, there are also a variety of tablets that incorporate the pen technology into a screen. The most popular is the Cintiq series from Wacom. Coming in various sizes, they give artists an alternative to the Intuos range but they are not necessarily superior. Whether a drawing tablet or a screen tablet is better to work with very much depends on the preference of the artist. They are quite expensive, so it is crucial to test the tablets extensively before you buy.

For artists looking for something transportable, there is the MobileStudio Pro range from Wacom, and the iPad Pro from Apple. Both offer great solutions so the one you choose should depend on your personal requirements and preferences.

CAMERAS

A digital camera is among the most important tools for concept artists as it can be used to take reference images, not only while traveling but also during everyday situations. Inspiration can strike you at anytime and anywhere so it is always a good idea to have something to capture the moment with. A camera is also useful for taking quick photos of poses of yourself or friends for character designs and for capturing textures to be used in paintings.

For taking reference images the make of camera does not matter. You can use a cell phone camera, a high-end DSLR, or anything in between. The best camera is the one you have with you.

TRADITIONAL TOOLS

Amid all the current technological advancement you should not forget the most important tool for a concept artist, which is your brain. The simplest, most direct line between your brain and expressing your idea is a pen and a piece of paper. It is dangerous to rely too heavily on advanced technology to do your thinking for you. You should always be able to express your concept and your idea with the simplest tools.

Many artists swear by certain brands of sketchbooks and pens. Usually these artists have gone through long periods of experimentation, trial, and error to arrive at those preferences. However, specific tools are by no means necessary to enabling you to draw well and have great ideas. As with digital cameras, the best drawing tools are the ones you have with you.

KEY SOFTWARE

In this chapter you will learn about some of the industry-standard software you might come across in a professional environment. You will see how they differ from other digital art programs and how you can make yourself appealing to potential employers through proficiency in the correct software.

ADOBE PHOTOSHOP

Photoshop is undoubtedly the most commonly used software across the four key industries that employ concept artists. Initially created as a photo-editing tool, Photoshop is not custom-built for concept artists, but its image-editing tools, versatility, and easily adaptable brushes make it the most suitable and powerful software you can use in this profession.

Concept artists are required to work in a plethora of ways to get the results required by a studio or art director. This could involve creating quick concepts from photos or painting scenes with a traditional feel using textured brushes. Photoshop's extensive tool set can be used to achieve multiple objectives in a variety of ways while also helping you to streamline your process.

Photoshop is also widely used by 3D artists working in the game and film industries, meaning the assets and textures created by concept artists can be used later in the production pipeline within 3D creations. This level of streamlining and re-using assets is vital in professional industries as it saves time and money.

Compared with other software, Photoshop is relatively difficult to use. This is because it is not tailored toward artists, and therefore the names of tools and settings often feel less intuitive. However, as Photoshop is the software of choice for such a high proportion of professional concept artists, the amount of useful books and online resources demonstrating how to use it for painting far exceed the resources for any other software in this list.

AUTODESK SKETCHBOOK PRO

SketchBook Pro is 2D software made by Autodesk, a company known for making 3D software such as 3ds Max and Maya. These are used by 3D artists tasked with turning a concept into a play-able game or film environment. SketchBook is available as an app on Android and Apple devices, but SketchBook Pro is exclusively for use on a PC or Mac. SketchBook Pro features useful tools for concept artists which are similar to tools in Photoshop and Corel Painter (see page 31). The user interface is very clear and easy to navigate, so capable artists can quickly learn how the tools work to a level that would allow them to create concepts.

Although this software is widely used, it is best as a simplified software to use on the go. It is unlikely that an employer will look specifically for someone proficient in SketchBook Pro. It is a great tool to have access to for practicing and developing your skills, but will not help you in your career pursuits.

PHOTOSHOP

FROM: photoshop.com

PROS: Photoshop is the most widely used software by professional concept artists and employers will expect you to know how to use it proficiently.

CONS: As a student or hobbyist, Photoshop's monthly subscription is an ongoing financial commitment.

TRAINING RESOURCES:
There is a fantastic selection of books, YouTube tutorials, and training courses easily available to help you learn how to use Photoshop to create concepts.

FROM: sketchbook.com

PROS: SketchBook Pro is easy to learn and, in the hands of a capable artist, sufficient to achieve a lot of the goals and requirements of a concept artist.

CONS: It is not currently used widely by artists and studios, so proficiency in this is unlikely to be something a potential employer is looking for.

TRAINING RESOURCES:
Training resources are available, but sparse compared to other software in this list.

SKETCHBOOK PRO

FROM: artrage.com

PROS: ArtRage is an affordable option to try if you are new to digital painting.

CONS: It is unlikely that studios will consider an artist exclusively using ArtRage as an appealing candidate over a Photoshop user.

TRAINING RESOURCES: Resources are available on YouTube and through the ArtRage website, but they are not as useful as resources available from other software providers.

FROM: painterartist.com

PROS: Painter has exciting and beneficial upgrades with each version, but retains practical and recognizable brushes that react like real-world tools.

CONS: Painter lacks some of the photo-editing capabilities of Photoshop, and integrating photos into an image can be a core part of a concept artist's workload.

TRAINING RESOURCES: It is easy to find training videos on YouTube and a selection of useful books are also available.

AMBIENT DESIGN'S ARTRAGE

ArtRage has been around since the year 2000 and is dedicated to simulating realistic brush effects. Its developers have spent a lot of time perfecting their brushes to make them react as they would in the real world and also generated different textured surfaces to paint on. This means the paint brushes will react in different ways depending on your chosen surface.

Although this software is doubtlessly capable of being used in a professional concept art environment, it is not used exclusively by concept artists. Some artists however might use it in their pipeline when they are trying to achieve something particularly traditional looking.

The user interface is easy to navigate, which enables you to learn ArtRage quickly. Although there are tutorials online to help you use the software, the standard and availability is limited. However, ArtRage is very affordable and even offers a free, limited demonstration version. If you are new to digital painting and the idea of concept art, ArtRage is a good option to practice with and use to familiarize yourself with any new graphics tablet you are using.

COREL PAINTER

Painter's strength is that it has clearly named brushes which react just like their real-world counterparts. Painter also benefits from a practical and easy-to-use color wheel, and is relatively affordable as you do not need to pay a monthly subscription to use it.

Painter is perceived by many as hobbyist software; however the past few years have seen its creators, Corel, add updates that have given users some incredible and unique tools that can help professional concept artists. For example there is now a ZAppLink that allows you to move rendered passes from the popular 3D sculpting software, ZBrush, directly into Painter. A lot of studios will expect creature and character designers to be comfortable with some 3D packages so, by pairing up with ZBrush, Corel have created a cutting-edge tool that has a practical application in a modern concept art environment.

Although it is not as widely used in the concept art industry as Photoshop, it is very versatile and the brushes and tools are easier for a traditional artist moving into digital art to understand. Painter only really falls short of Photoshop when it comes to photo-editing and integration; therefore if you are more of a digital painter than a concept artist who uses a lot of photos in your artworks, this software will probably suit you.

Painter is also relatively easy to learn as the brushes are named descriptively, such as "Wet Acrylic Brush," and react as you would expect them to in the real world. As with all software there is some learning required to reach Painter's full potential, but online resources are easy to find.

PROCREATE

Procreate is an app that can be used exclusively on Apple devices and downloaded through the iOS app store. It is primarily digital painting software that consists of simple yet very versatile brush options and settings. It is for use on mobile devices so Procreate's strength is its portability, allowing it to be used on location.

Procreate, however, is not widely used to create concepts in a professional environment. This may be because it is relatively new software, rather than it falling short of professional requirements. The traditional-feeling and versatile brushes provide all the tools a concept artist would need to create a professional concept. Although photo-editing options are res-tricted compared to Photoshop, it features many layer mode options which make it an impressive portable tool.

Procreate is undoubtedly an easy piece of software to learn and new users will find tools simple to locate and adjust to suit their requirements. Additionally, it can save files as PSDs, allowing you to move your project between your iPad and PC or Mac.

PIXOLOGIC'S ZBRUSH

ZBrush is digital sculpting software where an artist can sculpt and design in digital clay. Much like real clay, ZBrush is fantastic for creating organic forms, but it is also incredibly capable when it comes to designing hard-surface concepts, like vehicles and weapons, due to its powerful toolset.

Part of any concept artist's role is to create practical, usable concepts that help the production artists later in the pipeline. It is becoming more prevalent that professional studios want concept artists who are capable of working in some 3D software.

For example a character designer might need to be able to digitally paint their concepts over a digital 3D sculpture. The benefit of doing this in ZBrush is that once a concept is created it can easily be posed to meet the adapting requirements of the studio. That 3D model made by the concept artist may even be used by the 3D artist later in the pipeline, making the entire process efficient and streamlined.

As ZBrush is intuitive and more like sculpting than modeling, it is perceived as being more expressive and artistic than other 3D software available. However that does not mean that it is easy to learn. You will definitely need to learn to use ZBrush alongside a manual or a training resource. As studios endeavor to make their creative processes more efficient, expect to see more character and creature artists being asked to create concepts using ZBrush.

SOFTWARE PRICING STRUCTURE	
MONTHLY PAYMENTS	
Photoshop	$$$
SketchBook Pro	$
SINGLE PAYMENT	
ArtRage	$
Painter	$$
Procreate	$
ZBrush	$$$

PROCREATE

FROM: procreate.art

PROS: Procreate is portable, allowing it to be used on location, and it is incredibly affordable, making it a fantastic tool for practicing your skills.

CONS: The tool set is restricted compared to PC-based software and to use it in a professional environment you would also need to be proficient in another software, such as Photoshop.

TRAINING RESOURCES: You will find training resources easily and will learn how to use the software proficiently in a very short period of time.

FROM: pixologic.com

PROS: Being proficient in ZBrush will make you an appealing prospect for a studio due to the time and money they might be able to save later in the pipeline.

CONS: It is expensive to buy and requires a great deal of commitment to learn to use well.

TRAINING RESOURCES: There are many fantastic books and resources to teach you how to use ZBrush.

ZBRUSH

CAREER PROFILE: SAM ROWAN

SAM ROWAN
Concept Artist
samrowan.com

Sam Rowan is a concept artist from Scotland who now lives and works in London. Since 2007 he has been working on feature films, specializing in creatures and character design.

CAREER HIGHLIGHTS
- Concept Artist at Framestore
- Senior Character Modeler at The Mill
- Senior Character Modeler at Weta Digital
- Character Modeler at MPC London
- Junior Modeler at Django Films
- Freelancer at Wizards of the Coast

BECOMING A CONCEPT ARTIST
I was working at The Mill in London, digitally sculpting characters for commercials and cinematic games when I was invited by Framestore to attend an interview. I was under the impression that it was for a modeling position, but when I arrived the interview was with the head of the art department. I had been hoping to move into concept art for a long time, so it was a dream come true. Opportunities like this can come at unexpected times.

Getting to work on the Kraken for the remake of the *Clash of the Titans* was a big break for me. I am a big Harryhausen fan, so to help sculpt and design that character was amazing — it was a creature that has been very important to me for a long time. This was my first step into concept art.

DEVELOPING A STYLE
For me developing a style is a subconscious thing, and your influences will steer your style. Initially I was influenced by films, cartoons, and anime from my childhood.

However, coming from a modeling background I have always tried to keep my style realistic and believable. Also this is the style that reflects the areas I want to work in. So I would say that my style is anchored in realism. Even where a creature concept is fantastical and has an extreme personality, I still like it to be believable.

FINDING INSPIRATION
I recommend looking at books and encyclopedias to find inspiration. It can be very easy for a concept artist to rely heavily on Google Images, which means you see a lot of ideas repeated on websites like ArtStation. We are all guilty of taking the easy option, myself included. Looking at old books and encyclopedias however can expose you to images that you would never have come across otherwise and images that other concept artists won't be looking at. You can sometimes find fresh ideas simply because you were not directly looking for them.

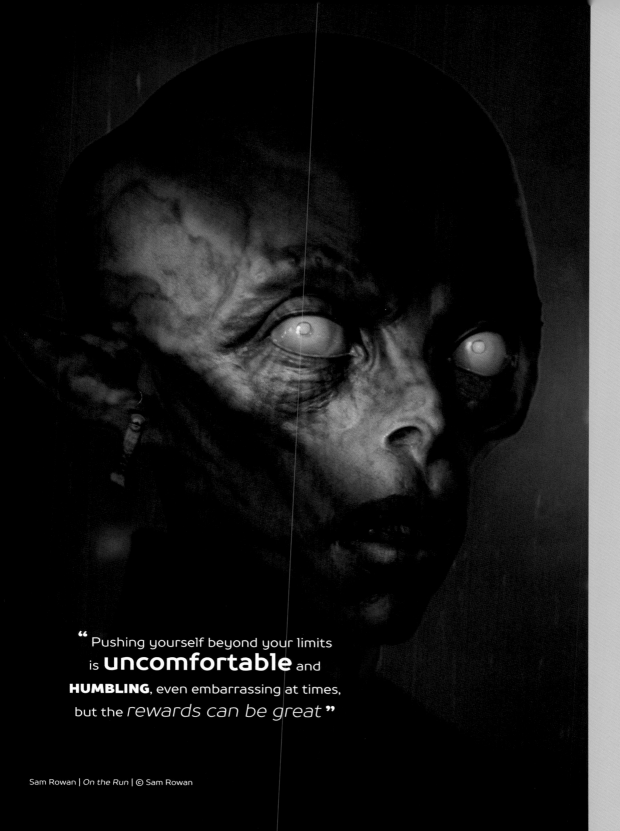

"Pushing yourself beyond your limits is **uncomfortable** and **HUMBLING**, even embarrassing at times, but the *rewards can be great*"

Sam Rowan | *On the Run* | © Sam Rowan

Sam Rowan | *The Bugman* | © Sam Rowan

NEW PROJECTS

The early phase of a new project is when you really get to experiment. You can be loose artistically, and free with your ideas. I spend a lot of my time creating very finished images, so any chance to sketch and explore mad ideas is very refreshing. You never know how these early ideas may influence a project.

TIME FRAME

An initial sketch can take minutes or hours to create. A presentable concept however can take up to a couple of days. It takes three to ten days to produce a final photo-real concept, and this stage involves taking on board a client's feedback.

The whole design process can take months to years. It all really depends on the brief and the budget. I find that it is best to under-promise and over-deliver to avoid disappointing clients.

I find the busier I am, the more focused I am. A little pressure can help to produce your best work. When you have too much time to work on something it is easy to become indecisive and inefficient.

DEVELOPMENT

I started my career modeling, but have been moving towards concept art and illustration. This has been a steep learning curve, but brilliant fun. Pushing yourself beyond your limits is uncomfortable and humbling, even embarrassing at times, but the rewards can be great.

PREPARING A PORTFOLIO

Knowing how to make a portfolio stand out is hard to judge. I often look at ArtStation and I am blown away by the number of talented people out there. However, I always try to ensure my work gives a VFX supervisor all the elements they need to make a character digitally. It is important to have the purpose of a concept in mind when you are developing it, and these practical considerations can often make a difference to your employers.

SELF-ASSESSMENT

The first question you need to ask yourself is "what do you want to do?", then "who is doing that already?", and "is the quality of the work in my portfolio equal to or better than theirs?" This is a good way to give yourself a little perspective on your own work.

It is very easy to be blind to your own work and think that it is better or worse than it really is. Seriously assessing your work and how it compares to the work of others will help you fill any gaps in your portfolio.

A DAY IN THE LIFE...

7:30 AM

My day almost always starts with two eggs on toast. I rarely skip breakfast and cannot work on an empty stomach.

8:50 AM

I feed the cats, and thanks to my wife I am invariably late for the train (she said it is okay for me to say that!) as we travel to work together. After a sprint to the train, we find a seat and I check my emails to be up to date on my personal projects.

SPECIALIZING

Specializing in a particular skill area can be a double-edged sword. It could help you get a job quickly, but if you focus on one area too soon it could leave you lacking in other skills. If you are a student I suggest you learn the fundamentals of art first and then try different genres and styles until you find what you like. If you have been working for a while and have a strong understanding of art, specializing might be the right thing for your career. You do need to have a deep passion for your specialism and show that passion in your work though.

9:30 AM

I arrive at work, say "hi" to everyone, and discuss our latest TV obsessions while waiting for the morning catch-up with the production department. If I receive a new brief I tend to scribble down a few thoughts and sketches before gathering references. It is good to pick a design point to roughly aim for at the start. If that changes along the way it does not matter.

12:30 PM

This is when we have the first review of the day. We show our latest work on the big TV and discuss it with the head of department and the rest of the team. Getting feedback from your peers is really important and can totally change the direction in which you take a concept.

1:00 PM

If I am lucky I will get some ramen with my colleagues and relax over lunch, then head back to the office with fresh eyes. Sometimes I just walk for an hour to clear my head.

3:45 PM

Usually around this time I look at the clock and begin to panic as I realize I have spent far too long working on some rubble in the background and the image looks no different from the lunchtime review.

4:25 PM

We have our second review. It is a similar process to the first but some of the feedback will be focused on what we need to achieve by the end of the day. I take careful notes and then set time limits to complete each task. This is a good way to hit deadlines and push yourself to make decisions.

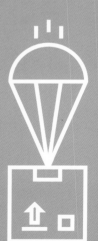

6:00 PM

This is when the production department will start asking us to save our work out so that it can be sent across to clients. If I am up against a deadline, this part of the day can be hectic and a bit stressful.

9:30 PM
I normally slip away to my desk and play with new tools or do some sketching. I think it is important to experiment and although you can experiment at work, it is not always beneficial when you have a deadline to meet.

11:45 PM
Finally, it is bedtime.

7:15 PM
By this time I generally only have food on my mind, but while I sit on the train with my wife we chat about the day. As someone who does not work in the industry it is nice to get her views on a topic. She points out things that only an outsider would know.

IDEAS AND CREATIVE THINKING

If you do not take in new information you will start to repeat yourself and never grow. A lot of young artists are too reliant on regurgitating other people's ideas; it is an easy trap to fall into. You can often find portfolios with similar images and styles, with very little to set them apart.

Try to approach things from a different angle. I think looking out the window can be really inspiring. Look around you and at books. Do not just take inspiration from film and video games; that is what everyone else is doing.

GETTING INTO CONCEPT ART

Once you have decided that concept art is the career choice for you, it is time to work on getting your first job. Aside from excellent art skills and a lively imagination, there are certain other skills you need in order to make an impression on your future employers. In this section you will find guidance on the different educational and training options you can use to learn these skills, as well as advice on developing your style, applying to studios, and creating a professional CV and portfolio.

EDUCATION AND TRAINING

BY GILLES BELOEIL

The secret to becoming a concept artist is loving the learning process. Learning art skills is a never-ending journey requiring an urge to know more and a desire to improve. The good news is that the more you practice your art techniques the better you become. In this chapter you will learn about the different educational and training options there are for aspiring concept artists.

UNIVERSITY OR COLLEGE EDUCATION

The first education system you may consider when you want to start any career is a formal education through colleges and universities. Usually a formal qualification from this type of institution will require you to study for two to four years. This is a great way to learn a lot of the necessary concept art skills, as you can gain an understanding of a large range of principles including design, drawing, painting, and 2D and 3D software.

Throughout a formal qualification you will practice your art skills regularly because you will be required to complete coursework. Your teacher may then comment on your work in front of the rest of the class. It is a great way to learn and encourages you to improve quickly.

There are many colleges and universities internationally that will teach you art and design for the entertainment industry or have similar course options. Before choosing a course, find out who the teachers are and what their backgrounds are. If they are professional artists, what is their skill level and style? Look at their online portfolios to get an idea of their specialties. Try to find information on former students too: where do they work after graduating? Do they produce work you aspire to do? Look at their portfolios as well to get an idea of the skill level they have achieved through the course.

To be a professional concept artist you will need to learn about anatomy, design, perspective, life drawing, color theories, lighting, and both 2D and 3D software. Before committing to a course, check that the specification and teaching covers these topics.

One of the most prestigious schools for concept artists is the ArtCenter College of Design in Pasadena, California. You can find some of the best teachers there, and if you graduate, big studios will look at your CV and portfolio with great interest. There are a number of other very good schools you may want to consider when it comes to your education. However, studying at these institutions can be very expensive. Unfortunately, high fees are common for this kind of education because the teachers are well-known professionals, and their expertise is expensive.

Something to be aware of when considering formal education is that you must be completely committed to your studies. There is a lot of competition for places and the courses are rigorous. If you have a family or another job, this route might not be for

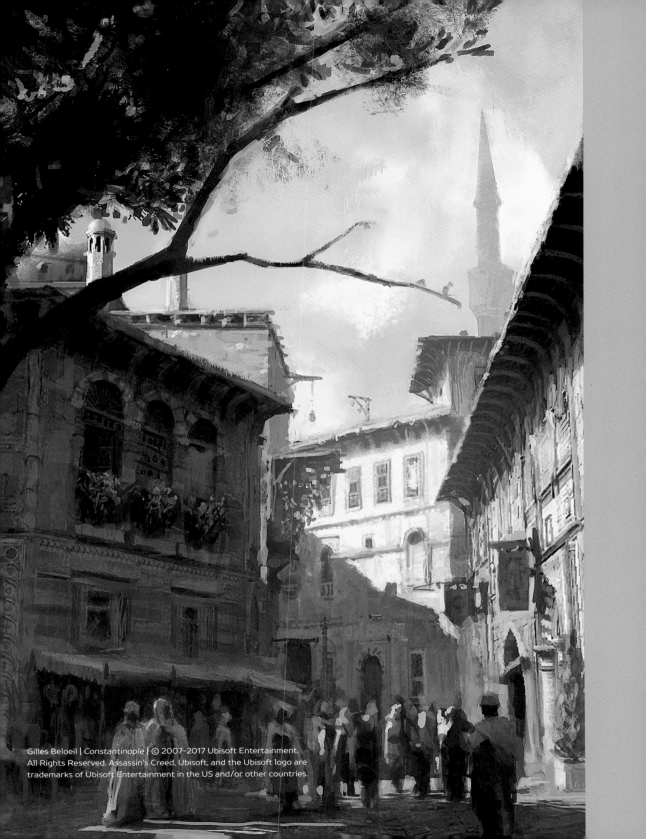

you. However, if you can finance your studies, are motivated, and have few commitments, college or university is a smart choice.

ENTRY REQUIREMENTS FOR COLLEGES AND UNIVERSITIES

Each college and university will have their own set of entry requirements for applicants, and sometimes there are different requirements for different courses, so you should check these before you apply to your chosen institute.

Generally, they may ask you to present a portfolio of your work with drawings, photos, paintings, and any visual art you have created recently. They will want to know that you have enough enthusiasm for the subject and that your work is of an acceptable standard before you begin. If there are high levels of applications for a course, the expectations for the quality of successful portfolios will be raised. To stand out, your portfolio must be excellent.

THE DRAWBACKS OF FORMAL EDUCATION

There can be some drawbacks to pursuing formal education. For instance, there can be variations in the quality of teaching between courses. It is very important to know that you are spending your time and money on a good education where the teachers are knowledgable.

Another drawback is that it takes a long time to qualify. There

are faster ways to learn the art fundamentals, and although studying is often fun, studying for a long period is expensive, and requires commitment.

Additionally, at a good institution there may be intense competition between students. This can have beneficial effects by encouraging you to constantly make your best effort and develop skills faster, but it can be very stressful. Some people find this situation very difficult and might quit as a result. Working with other artists should be fun and drive everybody forward. The environment at a good college or university should support the less advanced students, and not allow them to be disheartened.

Something else to be aware of if you are considering formal education is that learning alongside other people can cause you to develop very similar art styles. This is not a significant problem as it is more important that you are able to deliver high-quality work, but a unique style can make your portfolio more visible to employers.

You might also find with this type of education that you rely too much on the directions of your teachers, and forget to explore your learning further by reading books, and watching online demonstrations. Learning independently by using the world around you will help you develop your own visual language.

" At a good institution there may be **intense competition** between students. This can have **BENEFICIAL EFFECTS** by encouraging you to constantly make your best effort and *develop skills faster* "

ALTERNATIVES TO FORMAL EDUCATION

Many successful concept artists do not have the chance to study in a formal art school. They present living proof that formal education is not the only way to progress. These people are by no means an exception in the industry. Some have graduated from college or university, but many have found other ways to learn.

In any good book store, you can find instructive books about drawing, painting, anatomy, and perspective. Very often, the subject matter of the books is traditional mediums like charcoal, oils, or watercolors, but this does not matter. The fundamental skills of composition, perspective, value, color, shape, and texture which you will learn are the same. Your computer and image-editing software are only tools and you are still making 2D paintings and drawings.

You can also watch videos online from professional concept artists who do demonstrations. Some are better than others, but you can still learn from them and identify what makes an effective artwork. You can also buy some well-rated instructional DVDs and learn a lot from these with repeated viewing over time.

ONLINE CLASSES

Online classes are cheaper than college or university courses and allow you to work at your own pace. You can stop for a few months if you get a job for instance, and continue after that. Video tuition from New Masters Academy (newmastersacademy.org) for example is considerably less expensive than a college course. I recommend this online school if you are a beginner as you can learn a lot about fundamental art skills. However, these classes will only provide you with lectures.

CG Master Academy (CGMA; 2d.cgmasteracademy.com) courses cost a student several hundred dollars for eight weeks. This is more expensive than some online courses but you receive lectures, a one-hour live session per week with your teacher to ask questions, and personal video feedback from the teacher to talk about your weekly assignment.

There are many schools online, and you should spend time investigating which one is most suited to your needs. The great thing about this kind of learning is that you can select your teachers, and they could even be one of your favorite artists! It is a great feeling to learn from someone you admire, and getting feedback on your own work from them is priceless.

A downside to online learning however is that you can some-times feel alone in your journey. There is some interaction with classmates but they can be in other cities or countries so it is difficult to feel a camaraderie in the class.

Also, the diplomas you get from these schools are less prestigious because there is no selection process for students. There is no competition between the students either so the general level of the class can be average. To some studios diplomas are very important, and at others, the portfolio is more important. In my experience however, art directors look predominantly at your portfolio so it should not be a significant problem if you apply for a concept art position and do not have a diploma or degree.

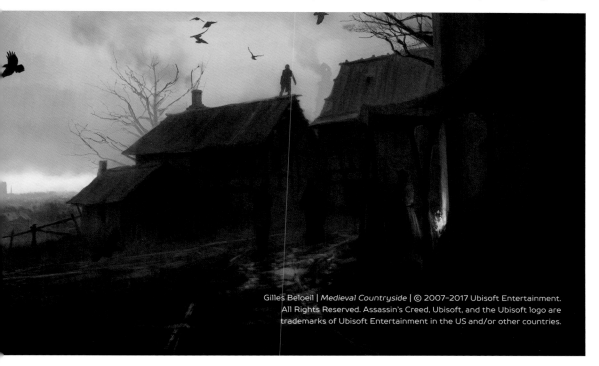

Gilles Beloeil | *Medieval Countryside* | © 2007–2017 Ubisoft Entertainment. All Rights Reserved. Assassin's Creed, Ubisoft, and the Ubisoft logo are trademarks of Ubisoft Entertainment in the US and/or other countries.

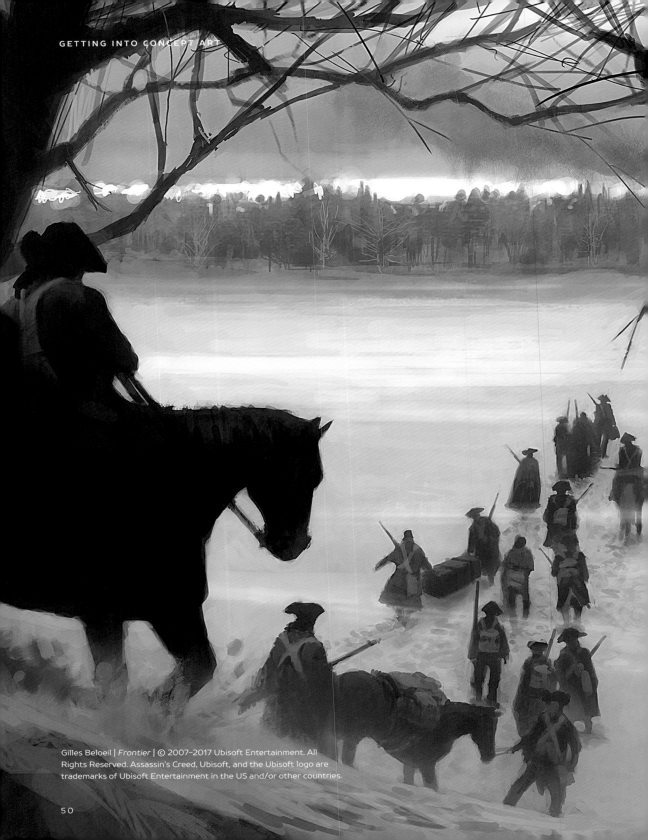

SELF-TEACHING

Self-teaching should be an important part of your education even when you are a professional artist. You should consider yourself a life-long student and always try to learn new skills. Learning is the fun part of this job and seeing your progress will make you happy over time.

A way to learn quickly is to make studies of art masterpieces. If you see an image, photo, painting, or concept art from someone else and you think it is excellent, you should study it and attempt to recreate the elements you like about it. Spend between twenty and forty minutes on the study. It is fun to do and very rewarding because you will see a result each time as the images you study are already of a high quality.

Building a good collection of books is also useful. Collect visual reference books, art books by artists you love, books about technique and theory, art history books, and the art books of video games and films. My favorite theory and technique books are all by Andrew Loomis: *Successful Drawing*, *Creative Illustration*, *Drawing the Head and Hands*, and *Figure Drawing for All It's Worth*. I also recommend *Alla Prima* by Richard Schmid, *Dream Worlds: Production Design for Animation* by Hans Bacher, and *Framed Ink: Drawing and Composition for Visual Storytellers* by Marcos Mateu-Mestre among others. I wrote a chapter about light and color in *Art Fundamentals* by 3dtotal Publishing and I recommend this for artists who want to refresh their memories on this topic as well as the fundamentals of perspective, anatomy, and composition.

The goal of self-teaching is to focus on the skills you are not so good at. You must be objective about your work; there must be something you could be better at. If you are good at designing things, work instead on your lighting and values knowledge. If you are great at drawing characters and creatures, work on creating complex perspectives for environment design. Once you have mastered everything from painting to drawing, learn some 3D software. If you are unsure what you should work on, ask someone else to look at your work and tell you. There is always something you can improve on.

THE PROS AND CONS OF SELF-TEACHING

Self-teaching is something you should always practice during your career and it is an effective way to build your own style. By self-teaching you will be influenced by artists you admire, rather than by your classmates or by your teachers. So the style you develop will be a mix between your own sensibility and the distinctive styles of artists you have studied. Self-teaching is also a very rewarding way to learn because you do your research by yourself. You become an explorer of art and it is very exciting when you find new information or learn a new technique.

The main disadvantage of this way of learning however is that it takes a lot more time to progress compared to other teaching methods. You will not receive direct feedback from more experienced artists and you might spend weeks on a problem a good teacher could help you with in a matter of minutes. When self-teaching you can only learn by trial-and-error so it takes a lot more time to understand new concepts. This can be a very frustrating process.

IMPORTANT TOPICS TO LEARN
Ultimately it does not matter which method of education you choose; the most important thing to focus on when you are preparing to become a professional concept artist is the fundamentals of art. The key skills you need to learn are listed here.

• Drawing

• Composition

• Design

• Values

• Light

• Perspective

• Color

• Texture

• Anatomy

You must at least have a basic knowledge of all of these topics to succeed. Try to find pertinent information about these subjects in books, and online, regardless of the education route you choose. You should also try to develop an interest in different visual arts. Go to museums and expositions, watch different film genres, observe nature, read about science, and so on. The goal of pursuing this variety is to build a bank of references, knowledge, and visual inspiration in your mind. You never know when you might need to use this information in your own art.

Another important thing to learn is how to manage your time with efficiency and develop good learning habits (see pages 122–139). You could try working one hour every night on anatomy, or do a five-minute drawing at breakfast every day. Try to do life studies, paint, and draw or visualize how you would paint something you can see in front of you when you are waiting for the bus, for example. You will learn a lot through practice and, if you do it on a regular basis, you will notice huge progress after just a few weeks.

Finally, an important thing to remember about learning is that your progression is not linear. You might feel sometimes that you are not as good as you were a few months ago, but do not panic as this is normal. Your brain is probably just focusing on processing the new information. When your mind has adjusted you will usually notice a great progression in your skills. Remember that the trick to being a successful concept artist is to keep practicing your skills and never give up!

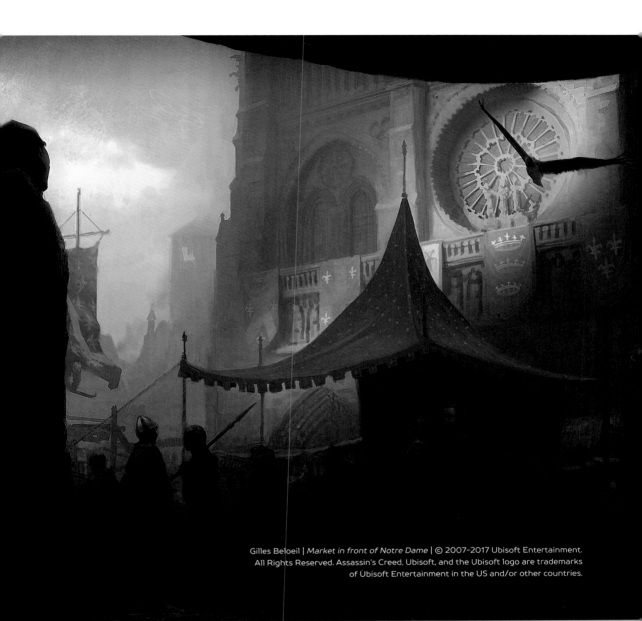

" You will learn a lot through **practice** and, if
you do it on a **REGULAR BASIS**, you will notice *huge
progress* after just a few weeks "

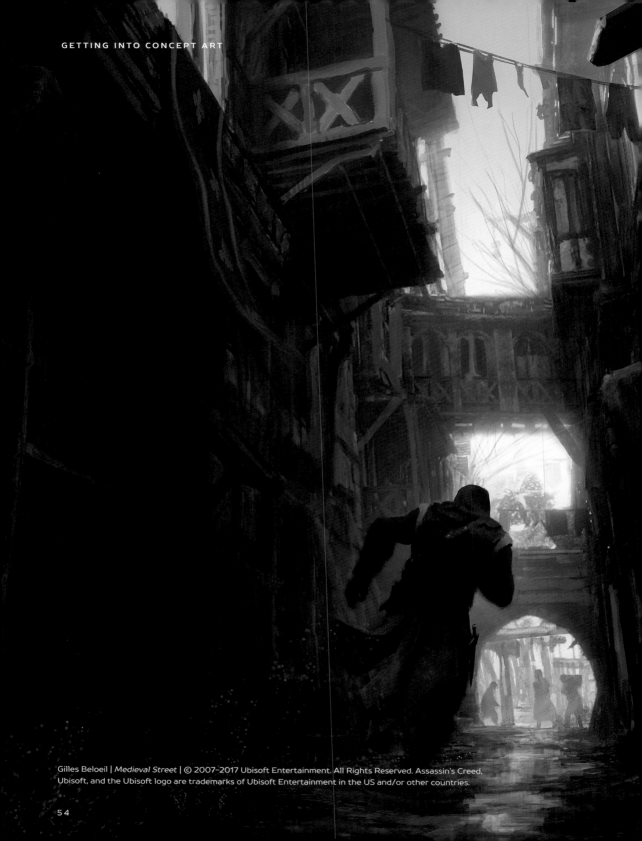

Gilles Beloeil | *Medieval Street* | © 2007–2017 Ubisoft Entertainment. All Rights Reserved. Assassin's Creed, Ubisoft, and the Ubisoft logo are trademarks of Ubisoft Entertainment in the US and/or other countries.

ARTIST PROFILE

GILLES BELOEIL
Senior Concept Artist and Teacher
gillesbeloeil.com

Gilles has been a senior concept artist at Ubisoft Montreal since 2007, working mostly on the *Assassin's Creed* games. Gilles has also taught at the online school CGMA since 2015.

Career highlights
- Concept Artist and Matte Painter at Ubisoft Montreal
- Teacher at CGMA
- Sequence Lead Lighting TD at Meteor Studios
- Lighter/Compositor at Animal Logic
- Lighting TD at Meteor Studios

Have you managed to achieve your career goals?
My career goals were unclear at first. I have been very interested in the visual arts since I was a child but I was unsure what I wanted to do. I studied cinematography, made some comic books, and took life-drawing classes. In 1995, I learned about Photoshop and decided to become a website designer; then I moved to Canada in 2000 to study 3D so I could work in the visual effects industry. This was when I first learned of matte painting and found I really wanted to do that full-time. After working in visual effects for six years, I was hired by Ubisoft as a matte painter.

My career as a concept artist began on *Assassin's Creed II*. I had not known such a job existed a few years before that, so it was not in my career plan. However, I feel today that it is a profession that suits me very well. It is very similar to what I liked to do as a child: imagining worlds, drawing, and painting.

Has the industry changed, and if so, how?
When I started as a concept artist in 2008, game art was not very realistic or detailed because of the technical limitations. The concept artworks could be very loose, without much detail as a result.

Now, the resolution of the final product is close to photorealism, so art directors expect more detail-oriented concept art from you. This generally means more 3D work and use of photos, although that is not the case for every project. I could still create painterly work on *For Honor*, thanks to the styling of my art director, Christian Diaz.

You teach your own art classes, what do these courses offer that students cannot get from other academic institutions?
I think every artist is unique, and therefore every art teacher is unique too. In my class, I talk about the things that I think it is very important to focus on, and I also demonstrate my creative processes. I try to point out precisely what each student could do to make their paintings better. So, if you want to know how I think when I work, and what techniques I use, it is the right class for you!

DEVELOPING A STYLE

BY JUAN PABLO ROLDAN

Having an individual style can be very beneficial to a concept artist, especially when you are trying to establish your career. However, it can be an intangible quality to learn. In this chapter you will discover what style is, why it is important, and what you can do to develop your own style.

WHAT IS STYLE?

Style is the group of elements, techniques, and visual aspects that define an artist's work. All these aspects are influenced by the culture and era that the artist belongs to, the school they came from, and the way they learn. The tools he or she uses can be influential too. For instance, software is constantly evolving and making new things possible, which can have an impact on an artist's style.

To some extent, one of the most important aspects of style is the unique perception that every person has of the world. If you were to gather together a group of artists to depict exactly the same scene, you would find that the results are totally different. The tools and techniques used, lighting, strength of the strokes, mood, and feeling that the scene depicts would be different in each artist's image. Your style is something that belongs to you and will flow from you naturally.

WHY IS STYLE IMPORTANT?

Style defines the look and feel of anything you are working on. It important because having a unique style will help your portfolio to stand out from the crowd, drawing the attention of potential employers. Knowing your own style can help you to maximize your potential in the career path you decide to take. You may realize, for example, that environment design has become second nature to you, or that you prefer to design robots rather than spaceships, or that you feel inspired by one genre more than others. All these preferences will define your personal style and help you understand where you fit in the concept art pipeline.

DEVELOPING YOUR OWN INDIVIDUAL STYLE

Style forms naturally from your experiences. It is therefore important to study art and design fundamentals, experiment, and look for new information to continue to develop your style. Eventually, this day-by-day practice will mean that you start to produce and exaggerate key elements that define your style. As you acquire more experience, your skills will develop and this will help you to identify the specific ingredients that stand out in your portfolio.

It is important to be open to new knowledge that will help your art progress. If you are trying to understand how your favorite artist developed their style and how to depict important art aspects such as composition, lighting, and strokes, there is nothing wrong in attempting their techniques and exploring the same style as practice. This exercise brings you additional information to complement and enhance your personal work.

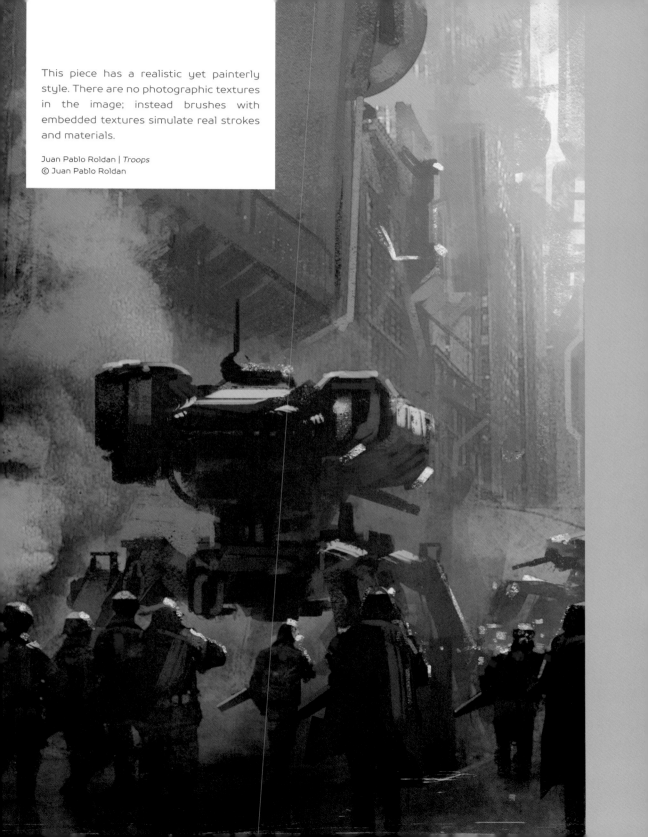

This piece has a realistic yet painterly style. There are no photographic textures in the image; instead brushes with embedded textures simulate real strokes and materials.

Juan Pablo Roldan | *Troops*
© Juan Pablo Roldan

Observing work from other artists you admire, start to analyze what they have done to create certain effects. Once you think you understand it, come up with an idea of your own, or inspired by a movie or book, to create an image you want to develop. Then, let all the learning you have gained from your analysis influence the final result.

It is no secret that the internet is an incredible, unlimited tool to search for references with. Investigate the traditional art masters as one of your main sources. They have significantly influenced contemporary art, so understanding their styles will lead you to understand current art styles. However, note that the aim of this research and study is to develop your own style, not to simply replicate someone else's. The things you learn from other artists should be used to complement your own preference of subject matter, mood, and technique, not replace it.

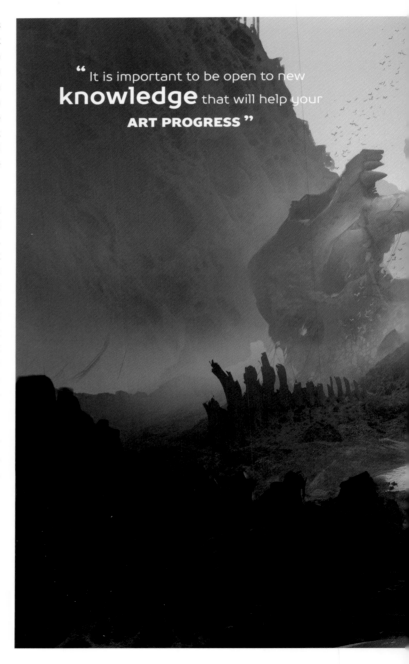

" It is important to be open to new **knowledge** that will help your **ART PROGRESS** "

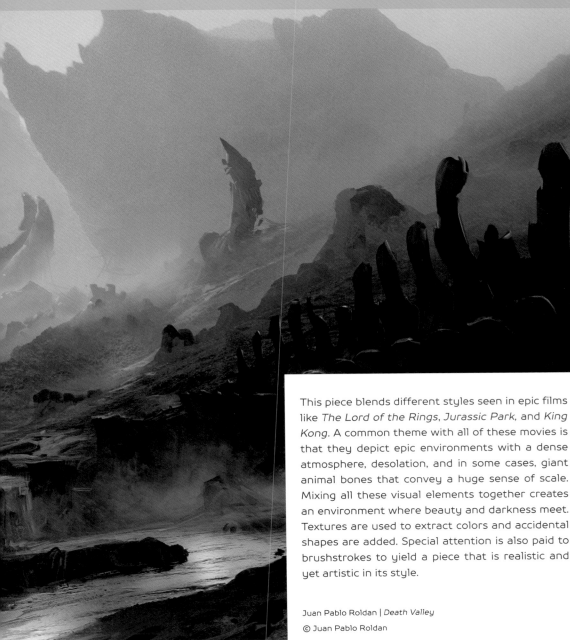

This piece blends different styles seen in epic films like *The Lord of the Rings*, *Jurassic Park*, and *King Kong*. A common theme with all of these movies is that they depict epic environments with a dense atmosphere, desolation, and in some cases, giant animal bones that convey a huge sense of scale. Mixing all these visual elements together creates an environment where beauty and darkness meet. Textures are used to extract colors and accidental shapes are added. Special attention is also paid to brushstrokes to yield a piece that is realistic and yet artistic in its style.

Juan Pablo Roldan | *Death Valley*
© Juan Pablo Roldan

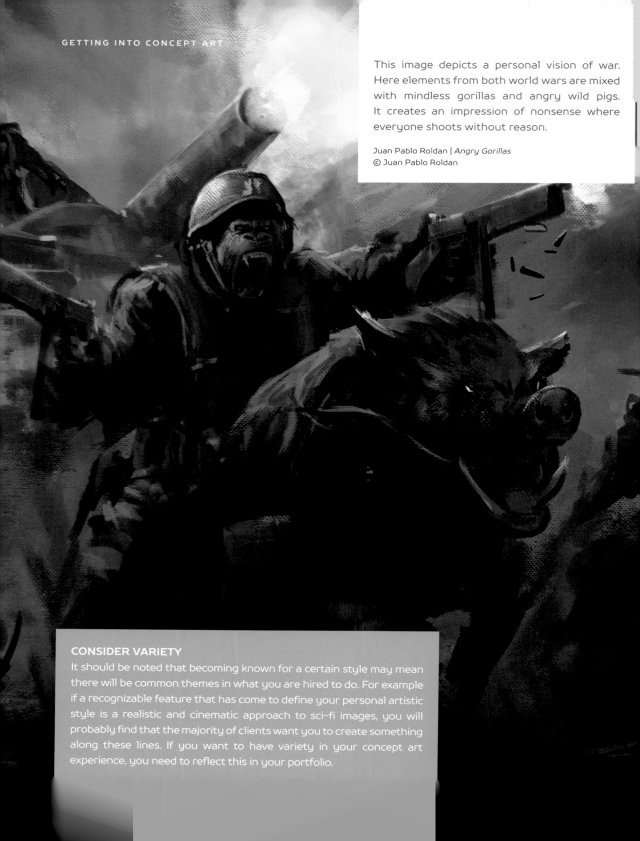

This image depicts a personal vision of war. Here elements from both world wars are mixed with mindless gorillas and angry wild pigs. It creates an impression of nonsense where everyone shoots without reason.

Juan Pablo Roldan | Angry Gorillas
© Juan Pablo Roldan

CONSIDER VARIETY

It should be noted that becoming known for a certain style may mean there will be common themes in what you are hired to do. For example if a recognizable feature that has come to define your personal artistic style is a realistic and cinematic approach to sci-fi images, you will probably find that the majority of clients want you to create something along these lines. If you want to have variety in your concept art experience, you need to reflect this in your portfolio.

ARTIST PROFILE

JUAN PABLO ROLDAN

Freelance Concept Artist
artstation.com/artist/roldan

Juan Pablo is a concept artist from Colombia with many years of experience working in the entertainment industry, including working on the visual development of films, next-generation games, and MMO (massively multiplayer online) games, and attending international conferences to promote concept art.

Career highlights

· Freelance Concept Artist at Blur Studios
· Concept Artist at Valiant Entertainment
· Concept Artist at Midwinter Entertainment
· Freelance Concept Artist at Combo Drive Pictures
· Freelance Key Artist at Maximum Games
· Freelance Concept Artist at Leading Light Design
· Freelance Concept Artist at LiKStudios
· Freelance Concept Artist at NetEase Games

What makes a project fun for you?

New projects mean an opportunity to improve my skills, learn new things, and challenge myself. However, I do love the sci-fi genre. Nothing makes me happier than receiving a brief which describes the scene of an invasion or encounter between super-powered heroes and villains, or robots falling from the sky.

Do you have any tips on how to stay focused when working?

When I work on a project I try to finish it ahead of the deadline. That allows me to have a little time to have a break between projects or to offer extra help to the studio I'm working for. To ensure that happens, I avoid staying up late, using my cell phone, and leave social media until the evening.

Another good habit is having a workout session in the morning. Exercise energizes me, and makes me more agile, and able to make good decisions during the day.

Are there any tools or software you would like to learn to use in the future?

Definitely yes! It is very important to know how to use 2D and 3D tools because different software makes it possible to achieve amazing and precise results quickly. Personally, I am focusing on learning and improving my 3D modeling and rendering skills.

How do you relax after a busy working day?

Just sleep! To me it is the best way to recharge for the next morning when I use exercise to reactivate myself. On weekends I try to avoid spending time in front of a computer and visit quiet places far from the city. I like to get in contact with nature, breathe pure air, and feel inspired for the next week. I also enjoy going to the cinema, playing video games, and of course having a beer with friends.

What has been the biggest learning curve of your career?

For concept artists, learning is a never-ending process. That is one of the many factors that makes me love the job. With every studio, director, and team I work with, my learning curve ascends.

I really enjoy working on a project that is focused on something I have never done before. It is the best way to learn. I force myself to experiment with new processes, be recursive, and find new solutions to design problems. Every day there is something new to learn, and that is wonderful.

SKILLS STUDIOS LOOK FOR

BY DONGLU YU

Aside from the specifications of individual job roles there are certain skills that most studios expect from candidates for concept artist positions. This chapter will discuss the key skills studios look for in successful applicants, the importance of feedback, and ways you can develop your skills to meet studio needs.

TECHNICAL REQUIREMENTS

When showing your work to studios there are two important messages you need to communicate: first, that you can deliver artistically successful pieces, and second, that your works are based on informed thought processes.

You can show your artistic ability throughout your portfolio by demonstrating that you understand art fundamentals, such as perspective, composition, value, color, lighting, and rendering skills. It can be useful to divide your portfolio into different sections in order to demonstrate those aspects in a more effective way. Group line drawings as a perspective section, show composition and value through black-and-white sketches, and collect color speed paintings for a color and lighting section. Show your rendering skills through a presentation of all your final artworks.

The second message you need to convey is that you are a thinker and that the final results of your artworks are more than merely happy accidents. You need to show that they are the outcome of well-executed research on a given subject matter. Because of this, it is important to show works in progress (sometimes referred to as WIPs) and development images as well as polished artworks in your portfolio.

Progress images will tell the art director how fast you can generate ideas and how flexible you can be with your artistic treatment for each potential assignment. For instance, if you are presenting prop concepts in your portfolio, do not simply show a well-rendered object. You should also show line art of the object from various angles, with section cuts, and silhouettes to show general shapes.

Explanatory drawings can help greatly when 3D artists come to build your design. Therefore, art directors always appreciate seeing a portfolio that shows you can generate production assets and build designs that assist the other art departments.

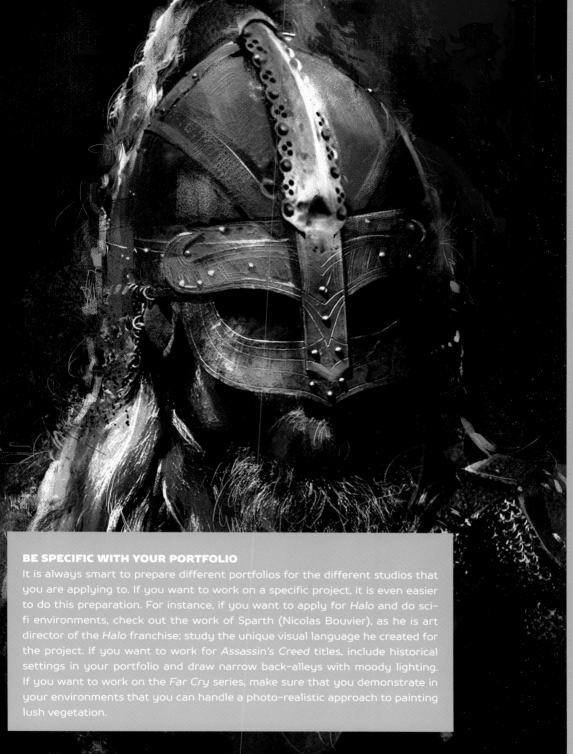

BE SPECIFIC WITH YOUR PORTFOLIO

It is always smart to prepare different portfolios for the different studios that you are applying to. If you want to work on a specific project, it is even easier to do this preparation. For instance, if you want to apply for *Halo* and do sci-fi environments, check out the work of Sparth (Nicolas Bouvier), as he is art director of the *Halo* franchise; study the unique visual language he created for the project. If you want to work for *Assassin's Creed* titles, include historical settings in your portfolio and draw narrow back-alleys with moody lighting. If you want to work on the *Far Cry* series, make sure that you demonstrate in your environments that you can handle a photo-realistic approach to painting lush vegetation.

Donglu Yu | *Medieval Lord* | © Donglu Yu

DEVELOPING KEY SKILLS

A great way to work on your key art skills is to draw from life. I love to draw outside when I have a chance as it is a fantastic way to reinforce fundamental art skills and gives me a break from using computers. With today's advanced technology and the endless software there is to learn, new artists often forget how important their artistic foundation is. You will be surprised by how many ideas you can generate and how well you can train your observation skills with just two simple tools: a sketchbook and pencil. So do not forget to step outside and observe the real world.

Look at how the buildings are actually designed by the architects, how light and shadow can affect the local color of the street props, and how objects are molded and manufactured. Observe how plants and flowers are designed by nature, and how color temperature can be used to express the different times of the day.

Traveling can also expose you to different cultures and architectures and allow you to collect great photo references to build your own image bank. Traveling of some kind can be done on almost any budget, but if you do have financial constraints, you can go to local museums, car shows, or nearby industrial areas to collect great photo references.

If you can save enough, trips to different countries can give you another kind of experience. The richness of foreign culture can spark your imagination even more and inspire you to create appealing artworks.

For learning new techniques, gumroad.com is a very affordable and easily accessible platform. Many great CG artists have a Gumroad account and actively share their tips and tricks through their tutorials. Do not hesitate to give them a try!

GETTING FEEDBACK

Feedback from an application or interview is not often actively shared with the applicant unless it is specifically asked for. I would suggest that you ask the art director directly to express their thoughts on your work during the interview, especially if you are applying for a junior concept artist position. This will allow you to not only get valuable input from professionals, but it can also show that you are not afraid of criticism and eager to learn.

If you do receive feedback on your portfolio, really try to establish an interesting conversation with the art director and be specific with your questions. Listen to the advice you are given and also express what you can offer the studio with your current skills. It can leave a very positive impression on the person who is interviewing you. Even if you feel that you are still lacking certain skills or that you are not yet fully

qualified for the position, at least you will know exactly where and how you should spend your time and energy to improve.

Even if you do not pass the interview stage, you will still have established a good connection with the studio. When there are new openings again, you can proudly show your new art pieces and demonstrate how much you valued the feedback they gave and are continuously improving your art skills. The art director should appreciate your effort and want to give you a chance as a hard-working candidate.

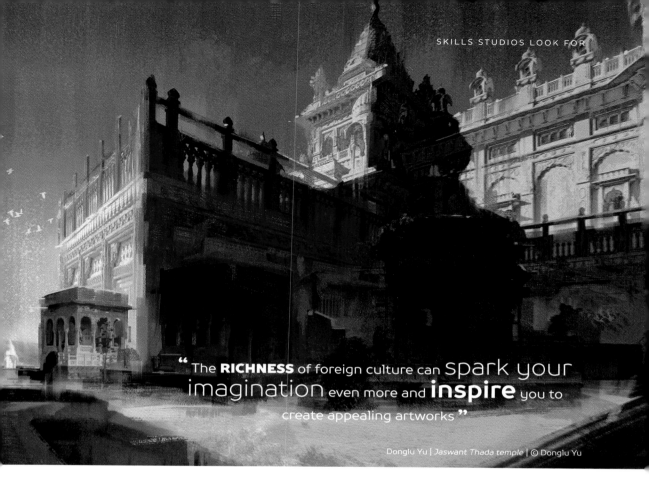

" The **RICHNESS** of foreign culture can spark your imagination even more and **inspire** you to create appealing artworks "

Donglu Yu | *Jaswant Thada temple* | © Donglu Yu

PORTFOLIO ADVICE
By Juan Pablo Roldan

Choosing the correct artworks for your portfolio is a task you should think carefully about. Do not publish every piece you have ever created, and try to be honest with yourself when assessing the quality of your work. You should keep in mind that a lack of fundamental art skills in an image is something that an experienced art director will identify immediately. Only choose images with the highest quality, otherwise your portfolio will be ignored.

An art director from an AAA company can see the potential of an apprentice who does not have enough experience. He will also recognize if the artist is not yet at a professional level but has a strong grasp of the basics, and makes an effort to generate creative images. This could result in an interview and the possibility of them being hired in the future.

It is a good idea to ask experienced artists for advice about the images you are intending to include in your portfolio. Get feedback on what your strengths are and apply them in your day-to-day work to make your portfolio stronger and more professional. You will learn more about creating a portfolio on pages 88–93.

SUCCESSFUL PORTFOLIO IMAGES

To understand what studios consider to be a successful image, examine these two examples by junior concept artists Cristian Vasquez and Sean Vo. In addition to being interesting artworks, you can see how these images demonstrate their understanding of art fundamentals.

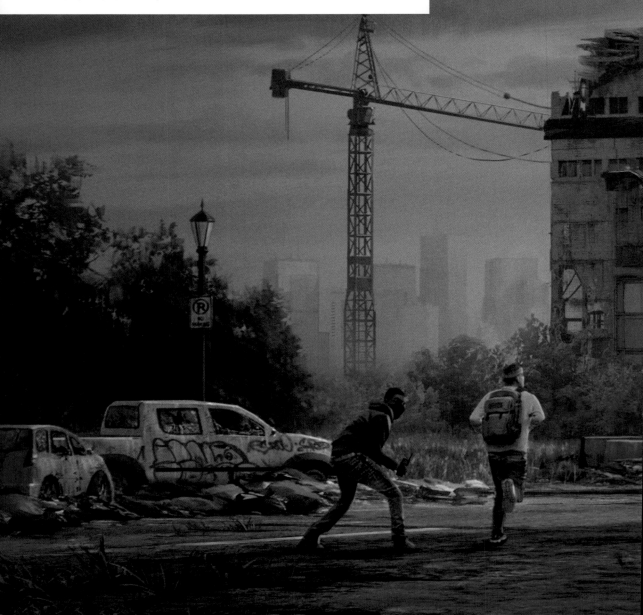

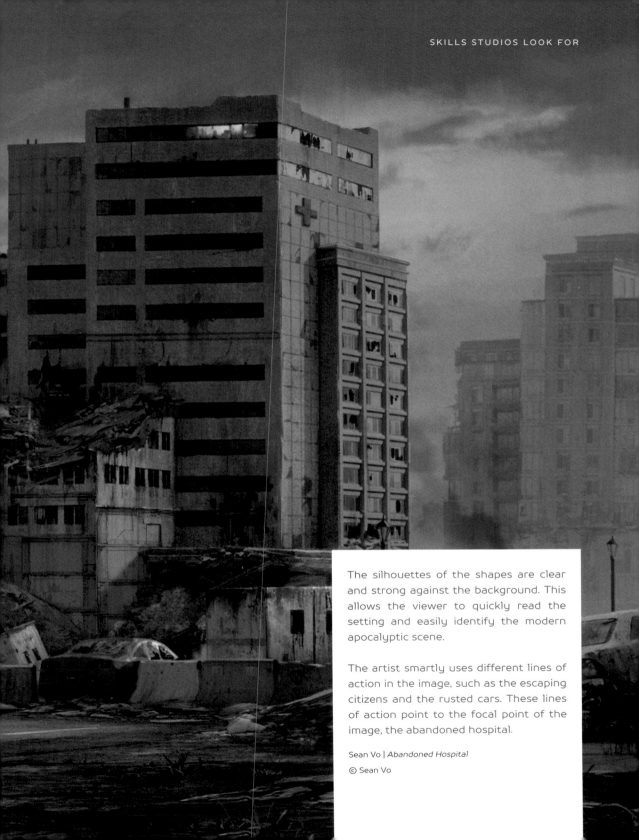

The silhouettes of the shapes are clear and strong against the background. This allows the viewer to quickly read the setting and easily identify the modern apocalyptic scene.

The artist smartly uses different lines of action in the image, such as the escaping citizens and the rusted cars. These lines of action point to the focal point of the image, the abandoned hospital.

Sean Vo | *Abandoned Hospital*

© Sean Vo

REMEMBER WHAT IS IMPORTANT

BY JAN URSCHEL

We all love the films, games and comics that our industry creates. They are the very things that make most artists pursue their concept art careers in the first instance. However, it is very easy to become too absorbed in the worlds you create. A pattern of creating and consuming the same material can create a vicious cycle that can make art derivative and degrade it over time.

Since concept artists are tasked with the creation of new ideas, it is important to find sources of inspiration outside those influences. You can literally look outside for inspiration, as real-world experiences are key to refreshing your mind.

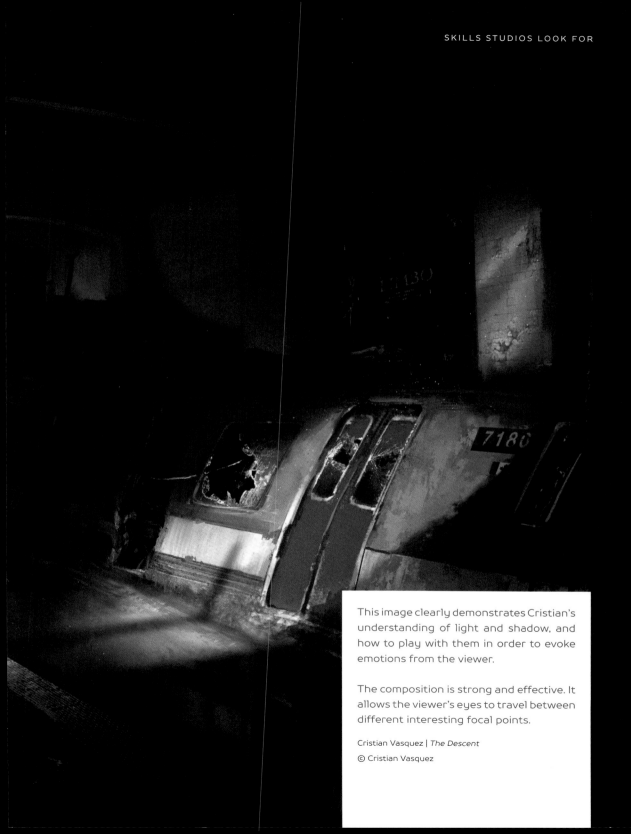

This image clearly demonstrates Cristian's understanding of light and shadow, and how to play with them in order to evoke emotions from the viewer.

The composition is strong and effective. It allows the viewer's eyes to travel between different interesting focal points.

Cristian Vasquez | *The Descent*

© Cristian Vasquez

PERSONAL REQUIREMENTS

Good communication skills and an ability to work in a team are two essential skills that studios look for in anyone they hire, but these are particularly important attributes for concept artists. This is because concept artists are the bridge between the art director and the different art departments. You will be expected to liaise with artists in the modeling, texturing, level art, lighting, and VFX departments.

Once your concept is approved by the art director, you will need to explain your choices to the other artists involved in the project. If they disagree with those design choices, you may need to show your references and research to support your work. Good communication skills will enable your designs to be translated into the final project.

An ability to work in a team is vitally important, especially for projects like AAA games or blockbuster films, which require an army of experienced people working on them. These people need to work together to make the project succeed in all aspects, including creative direction,

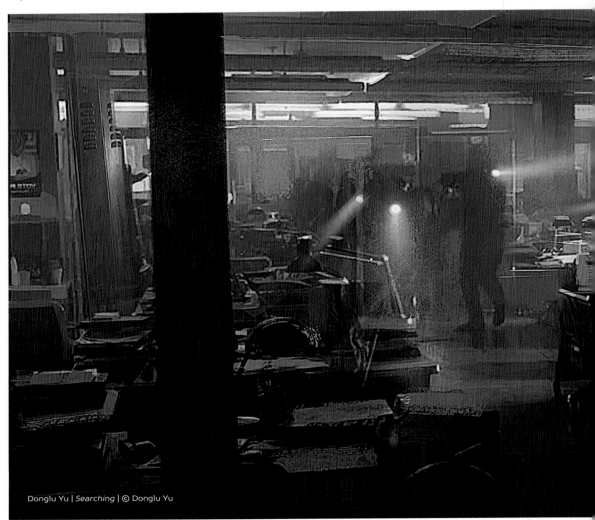

Donglu Yu | *Searching* | © Donglu Yu

game design, art direction, and marketing. Remember that each team member plays an important role in the project through their individual discipline. A big ego can prevent a game from moving forward, so your ability to work in a team is an absolute prerequisite in a large-scale production, no matter how good you consider yourself to be. Remember to always be humble about your work and professional when interacting with other artists; there is never success without solid teamwork.

Other valuable key skills are **organization** and **time management**. When you have a large workload, tight deadlines, and are part of a team, it is essential to be organized. You will learn more about time management and tips for organization on pages 132–139.

Research is another valued skill as you will need to collect references and additional information where needed to develop detailed and believable concepts. A **passion** for what you do is also important, as this will come across in what you create and provide motivation.

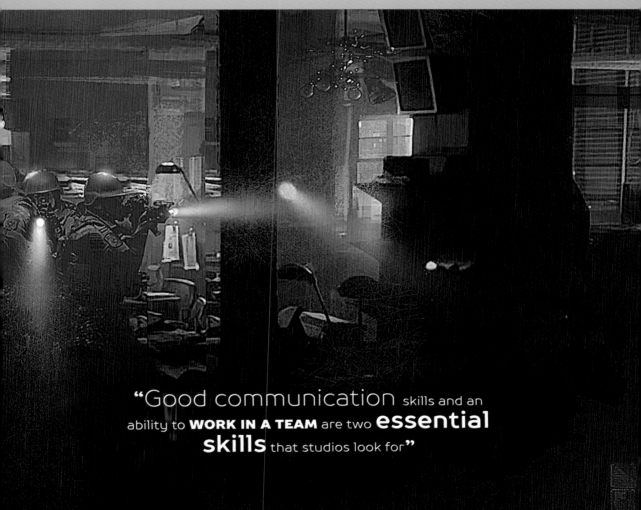

"Good communication skills and an ability to **WORK IN A TEAM** are two **essential skills** that studios look for"

APPLYING TO STUDIOS

BY DONGLU YU

In this chapter you will learn about the key methods that studios use to find new concept artists, and gain an idea of what the usual hiring process is. Recruitment processes will vary between countries and even between companies, but this chapter will give you an overview of what to expect so that you will learn how to approach studios and what the studio may be looking for when they consider your application.

HOW STUDIOS FIND NEW CONCEPT ARTISTS

Internal referral has a lot of influence when it comes to searching for new talent. Existing employees will recommend artists they know and respect. There are two obvious advantages with this option. First, through internal referrals the studio can be confident that the potential candidate's attitude and personality will fit with the studio's culture. Second,

internal referral easily connects studios with local talent, which can save a great amount of time in visa processing. Studios in the US, for example, will often consider qualified local artists advantageously over international talent.

Another way studios source new artists is by looking through online portfolios and forums. Art directors will research concept artists who meet the job specifications and look through artists' galleries to see if their artworks fit with the project's needs. The art director will give a list of names to the studio's HR department who will then contact the artists.

A further method studios use to find new concept artists is for the art director to look through CVs that the HR department has collected. These CVs generally come from online submissions to the studio.

ATTEND CG-RELATED CONFERENCES

It is possible to find your first position as a concept artist through attending CG-related conferences. Some of these have a dedicated job fair section where you can meet with employers and studio representatives. To prepare for the conference, you could print a selection of your best artworks and arrange them neatly in a portfolio. By doing this you may find that during the job fair you are able to get a lot of feedback on your work from different recruiters and art directors. This may lead to enriching discussions with professionals and will mean you are able to leave these potential employers with a strong impression of your capabilities and professionalism.

> " Through **internal referrals** the studio can be confident that the potential candidate's **ATTITUDE** and *personality* will fit with the studio's culture "

HIRING PROCESSES

In general, there are three steps to a hiring process: an initial phone call, a face-to-face interview, and then negotiation for remuneration. The studio recruiter usually makes the initial phone call to the candidate to introduce the studio, and the project if the title has been announced. If the project has not been announced, no project details will be discussed until you sign the non-disclosure agreement.

During the call you, the potential candidate, can talk about what you are looking for in terms of studio values and team culture. If the call goes well, the recruiter will usually schedule an interview with you to meet all the key team members in person.

The interview process can vary greatly in length and structure, from a forty-minute interview meeting everyone at the same time to a four-hour interview, meeting each key person individually. It really depends on the studio and the project requirements. However, there are two people you will most likely meet during the interview: the producer and the art director.

The producer is the person responsible for the project schedule and budget, and they will primarily be interested in your professional experience and painting speed. The art director is responsible for the final visual outcome of the project so they will be interested in your art style, how you approach an assignment, and what your artistic skills are.

CONSIDER INTERNSHIPS
By Glenn Porter

An excellent way to get studio work as a concept artist is to start working at a studio at any level available. Get an internship or apply for an entry-level position. Get to know everyone at the studio and once you have a good rapport with your colleagues, show your work. Many people have risen through the ranks this way from intern to artist.

Internships provide invaluable experience though they are often unpaid. This is not a problem as long as the unpaid work stays within the parameters of the internship. Never produce art for free. If someone at the studio takes an interest in your work and wants to see what you can do on a project, it is time to negotiate your rate.

LEARN HOW TO PRESENT YOURSELF
By Paul Scott Canavan
Learn how to present your work and how to write a professional email. You would be amazed by how bad most people are at this. On your website, push your work to the front: it should be the first thing someone visiting your site sees. When you apply for a job, keep the email short: say hello, explain in a sentence or two who you are and why you want to work for them, and then share a link to your portfolio. You can attach a few sample images (three-five images is perfect), and thank them for their time.

Some studios may also want you to meet the lead artist, production director, or creative director. This will often be to see how you and the team interact, and if you will be a good fit. At the end of the interview, the HR representative may make a note of your financial expectations.

The studio will usually take a few days to collect comments from everyone you met based on the interview and make sure the budget is aligned with your remuneration expectation. If the team want to know more about you or still has questions, you may be asked to attend another interview before the studio are able to present you a draft contract. Once a final decision about your suitability is reached, the studio will contact you to review the draft contract and offer the position.

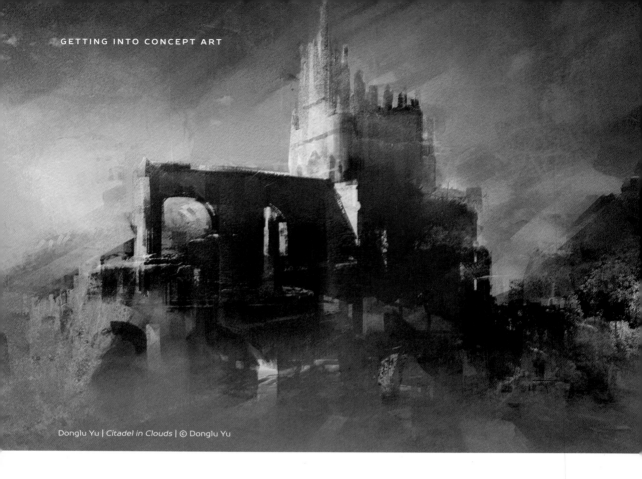

Donglu Yu | *Citadel in Clouds* | © Donglu Yu

WHAT TO EXPECT WHEN APPLYING TO A STUDIO

If the studio has no immediate need for a new concept artist and you have submitted an unsolicited application, you may not get a reply to your application at all. All submitted CVs are usually compiled in an HR department system and will be analyzed only when the studio has an official opening for a position.

However, if the studio has imminent production needs, the hiring process may move forward very quickly. It can take as little as one week to go from the first call to signing a contract with a local artist. The process will be lengthy however when a work visa is needed for hiring a foreign artist. This is why a company will usually only go through the process for getting a visa for senior artist positions. When a visa is involved the whole process takes months to be completed.

There is another possibility: an art director may find that you have a lot of potential in your portfolio, but that it does not fit with the production needs. In this case the art director may contact you to request additional artwork. For example, if they need a concept artist for environments and you mostly have prop designs in your portfolio, you may need to submit extra work to prove that you can perform equally well with environment designs.

To avoid this kind of situation, which may slow down your hiring process, thoroughly research the open position before submitting your portfolio to the studio. Try to find out what kind of concept art they currently need for the production (environment, character, or props) and the style of the project (realistic, stylized, or cartoon); then tailor your portfolio to suit.

ARTIST PROFILE

DONGLU YU

Lead Concept Artist
artofdonglu.wixsite.com/home

Donglu is a senior concept artist for the video game industry. She has contributed to many AAA titles, including *Deus Ex: Human Revolution*, *Assassin's Creed: Brotherhood*, *Assassin's Creed III*, *Assassin's Creed IV: Black Flag*, and *Far Cry 4*.

Career highlights
- Lead Concept Artist at WB Games Montreal
- Senior Concept Artist at Ubisoft Montreal
- Concept Artist at Eidos-Montreal

What was your first concept art job?
My first experience of working as a concept artist was designing props and environments for *Deus Ex: Human Revolution* at Eidos-Montreal.

What has been the biggest learning curve of your career so far?
When I had the opportunity to work on *Assassin's Creed IV: Black Flag*, I learned so much from my art director, Raphael Lacoste, and my talented colleague, Martin Deschambault.

How do you approach a new work brief?
First I analyze who the target audience of the assignment is, then according to the answer, I put my focus on different aspects of the artwork. If the artwork is for the art director to take to a high-level art pitch, I accentuate the mood. Alternatively, if the artwork is for the lighting department, I put my energy into rendering different lighting effects and an interplay of light and shadow. If the artwork is for the modeler, I render the forms and create a design sheet that shows the props from different angles.

How much of your process is studio-led, and how much of it is the result of your own discipline?
It depends on the project and which phase of the production it is at. If the project is in pre-production I have more artistic freedom, so it is the result of my own discipline. If the project is in full production my process is studio-led and focuses on a standard process to create multiple artworks under tight deadlines. This helps to satisfy the project's production needs.

What do you do to rest your eyes, and mind, in between work sessions?
I sip a cup of tea or coffee, and chat with my colleagues, as they give me valuable feedback on my artwork. I also learn about new tools and techniques that my artist colleagues have picked up recently.

CREATING A CV

BY SZE JONES

A professional CV (curriculum vitae) and portfolio provide a well thought-out presentation of your capabilities. From beginning to end, every section should show your skills in the best possible light.

As the CV is the written part of the presentation, all text must be clear and demonstrate your organizational and communicative skills. In this chapter you will learn the key elements behind building a professional CV that will appeal to employers.

WHY IS IT IMPORTANT TO HAVE A GOOD CV?

A good CV is a representational document of your personal achievements and career development. Each line should reveal your key skills and personality type. Through the achievements and patterns in your history, studios gain insights into your talents and decipher if you suit the position they want to fill.

Generally, you should document any events you have contributed to in your life besides your career history, education, and technical skills. These are especially important to include if you have no prior industry experience. Part-time and voluntary positions provide evidence of you actively making opportunities for yourself instead of waiting to be presented with them. Your participation will also often help to showcase your organizational skills and experience working in a team, commitment, and discipline.

THE CONTENT OF A CV

One to two pages of A4 is an ideal length and you should endeavor to make the CV presentation fluid and elegant. From the choice of font to the layout format, all items should be carefully crafted.

Starting with your name and title, pick a font that is legible and a bold font weight so that your name can be seen at a glance. List your contact information including your website, email, phone number, and address. You could put your contact information on one line with bullet separators, in order to keep your CV short.

The first paragraph should introduce you and what your area of expertise is. Follow this with your career highlights, listing companies you have been employed by in reverse chronological order, starting with your most recent employment. Provide a description of each job and your key responsibilities. If you have no prior industry experience, list your personal achievements and any experience that demonstrates your skills. Internships, freelance client work, and personal projects should all be included.

Next, you should demonstrate your education. If you are a recent graduate, list the degree you have obtained, including your grade and any honors obtained to support your credentials. Specialized classes, extracurricular activities, and relevant workshops you have attended are also extremely helpful to include as they show

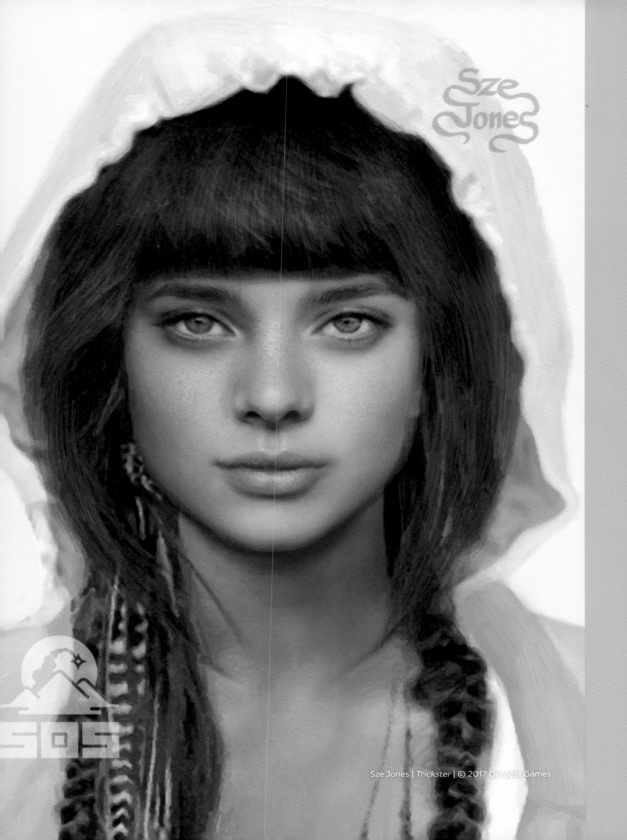

Sze Jones | Concept Portrait of Oracle | © 2017 Outpost Games

that you are eager to learn and self-motivated.

List in bullet points any significant awards or scholarships you have received, and any presentations, shows, or exhibitions you have given in order of importance. Provide a descriptive title for each, a date, and explain the significance of the achievement.

Finally, try to include between one and three positive referral quotes or recommendations. List the credential and title of the referrer, if applicable, and limit each referral to three sentences.

INCLUDING IMAGES ON A CV
Unless requested, save the first impression of your appearance for the face-to-face interview. The employer is interested in the written content of a CV so your profile picture is irrelevant when your application is reviewed. Including photos or artworks on the CV takes up space, and distracts from the written information. It is not an appropriate format in which to present your artwork, so save your images for presentation in your portfolio instead.

MAKING YOUR CV STAND OUT
If you already have professional experience, it is easier to create an outstanding CV. However, if you have no industry experience, you should focus on your academic achievements, training, software knowledge, and give a description of your skills. List any well-known industry mentor who you have studied under, and provide recommendation letters.

Be genuine and concise in your text and use your history to indicate that you are continuing to obtain new knowledge. When writing about yourself try to give an impression of your personality, work ethic, and ability to work under pressure.

When you format your CV, be selective in your choice of fonts. The font size should be easy to read and professional. You may find that sans-serif fonts appear friendlier to the reader. Keep section headings in bold font, and your paragraphs in regular font.

Overall, the design and layout of your CV should feel informative, but concise. Use margins to shorten paragraph widths, and keep a consistent structure. Well-designed white spaces will also give the reader a chance to pause, make the page easier to read, and show professionalism.

TAILORING YOUR CV TO EACH JOB APPLICATION
As with your portfolio, you should tailor your CV to each job and studio you apply to. Carefully read the job requirement and description so you understand it fully, read the studio's mission statement, and try to understand the company's culture. Then find areas of your expertise and personal strengths that correlate with the position you are applying for.

Design your CV to the job's requirements by highlighting events and keywords you know the employer is looking for. You should also research the products of the company and draw attention to areas of your CV that meet their needs.

You may also want to research software used in the studio's production pipeline, and search online for presentations and workflows from existing team members. Identify which of your strengths match the needs of the studio and focus on emphasizing those traits.

The precise layout and format of CVs varies from person to person, so it is worth researching existing CVs online to get an idea of what works for you and your skills. On the next four pages are two example CVs to give you an idea.

EXAMPLE CV:
CHARACTER CONCEPT ARTIST

Include a brief professional profile describing your unique attributes

List you career highlights with details of your roles and responsibilities

Make a list of your software proficiencies

SZE JONES
Character Concept Artist

PROFESSIONAL PROFILE
As a character concept artist specializing in costume design, hair design, realistic portraits, and personality and facial design for video games and cinematics, I integrate character modeling, rigging, posing, and rendering techniques with illustrative skills to create iconic promotional key art and posters.

CAREER HIGHLIGHTS
• **Lead Character Artist and Character Concept Artist at Outpost Games. 2015 – Present**
My responsibilities as a character concept designer for a 16-player PC survival game include costume design for the parts system, portrait paintings, hair design, and personality and facial design. I also create and oversee promotional character key art and provide artistic feedback on character-related assets.

• **Senior Character Artist at Crystal Dynamics, Square Enix. 2014 – 2015**
This role involved collaborating with lead concept artists to create a promotional poster for *Rise of the Tomb Raider* as well as rigging, posing, lighting, and rendering for promotional key art.

• **Lead Character Artist at Naughty Dog, Sony Computer Entertainment. 2011 – 2013**
I provided artistic feedback for the character modeling department on *Uncharted 3*, as well as character pre-production supervision for *The Last of Us,* and established a facial pipeline with the rigging and animation department on *Unchartered 4.*

• **Character Modeling Supervisor at Blur Studio. 2002 – 2010**
My artistic feedback and paint-overs for the character team helped establish a high-quality character pipeline and approval process. Working on the character facial expressions setup, I was also involved with rigging, modeling, facial animation, texture painting, and hair setups.

TECHNICAL EXPERTISE
• Maya
• 3ds Max
• Mudbox
• Marvelous Designer
• Photoshop
• Ornatrix
• Unreal Engine

TEACHING EXPERIENCE
• **CD Projekt RED – Promised Land**
Female Portrait & Hair Sculpting in ZBrush
Presenter, 2016

• **Los Angeles Academy of Figurative Art**
Female Portrait Study with ZBrush
Instructor, 2013 – 2014

- **CGSociety**
 Online Workshop: Iconic Heroine Design and Creation
 Instructor, 2011 – 2015

- **Gnomon Master Class**
 Digital Female Character Design and Creation
 Instructor, 2009

- **LA ACM SIGGRAPH Presentation**
 Digital Sculpture
 Artist/Presenter, 2010

- **Pixologic: Feature ZBrush Artist Presentation, SIGGRAPH**
 Artist/Presenter, 2010

- **Gnomon School of Visual Effects**
 The Making of *Warhammer Online: Age of Reckoning* Trailer
 Artist/Presenter, 2010

- **The Art Institute of Los Angeles**
 Brazil Toon Shader Presentation – A 2D Toon Takes a 3D Ride
 Artist/Presenter, 2003

Add your personal achievements

EDUCATION
- **Master of Arts**
 Majored in Computer Graphics, William Paterson University, 1999

- **Bachelor of Fine Arts**
 Majored in Computer Graphics, William Paterson University, 1997

- **Associate Degree in Applied Science**
 Majored in Graphic Design, County College of Morris, 1995

Include any exhibitions and publications you have appeared in

EXHIBITIONS
- **Comic-Con International**. Artists' Alley, San Diego, 2010 – 2016
- **Post It Show 9**. Giant Robot2 Gallery, Santa Monica, December 2014
- **RAW: Los Angeles Encompass**. Belasco Theater, Los Angeles, October 2013
- **Hive-Zilla!** Shinjuku Ganka Gallery, Tokyo, November 2012
- **Master Blasters of Sculpture 4**. The Hive Gallery & Studios, Los Angeles, November 2012
- **Tarot Card 3**. The Hive Gallery & Studios, Los Angeles, January 2012
- **Featured Artist: The Hive Gallery's 4th Annual Show**. The Hive Gallery & Studios, Los Angeles, August 2012
- **Cannibal Flower 10th Anniversary Group Show**. Los Angeles, September 2010
- **Red Geisha – Sherman Gallery**. Marina Del Rey, September 2009
- **Osmosis – Gnomon Gallery Group Show**. Hollywood, September 2008

PUBLICATIONS
- *3dcreative* **Magazine #102 – Crafting Iconic Characters**
 Artist Interview, February 2014

- ***The Art of Sketch Theatre: Volume 1***
 Featured Artist, October 2011

www.szejones.com art@szejones.com (555)555-5555

EXAMPLE CV:
SENIOR CHARACTER ARTIST

Include your area of expertise in the professional profile

SZE JONES
Senior Character Artist

PROFESSIONAL PROFILE
As a professional artist specializing in digital character creation for video games and cinematics, my production expertise is focused on character design, ZBrush portrait sculpting, facial expression setup, digital hair styling, costume design, artistic supervision, and workflow implementation.

CAREER HIGHLIGHTS
• **Lead Character Artist at Outpost Games. 2015 – Present**
My responsibilities in the production phase include character concept designs, facial expression setup, personality analysis, character pipeline establishment, and character asset authoring for Unreal Engine.

• **Senior Character Artist at Crystal Dynamics, Square Enix. 2014 – 2015**
I played a key role in the TressFX hair authoring pipeline and development for *Rise of the Tomb Raider*. My other contributions include the creation of cinematic character facial expressions, hair styling and shade texture authoring, high-resolution ZBrush sculpts, rigging, posing, and rendering for the promotional key art.

• **Lead Character Artist at Naughty Dog, Sony Computer Entertainment. 2011 – 2013**
I was tasked with creating cinematic-quality characters for Uncharted 3 and acting as the character pre-production supervisor for *The Last of Us*. I also established the facial pipeline with the rigging and animation department for *Uncharted 4*.

Describe your project contributions along with previous job titles

Contributions:
Uncharted 4: Next gen facial setup and character pipeline development
Uncharted 3: Katherine Marlowe, Chloe Frazer, and Elena Fisher
The Last of Us: Pre-production character supervisor
Facial expression pipeline development
High-resolution character creation for next-gen game
Key art creation for poster and magazine covers
Character art direction and team supervision
NPC head generations pipeline development
Hair styling and digital makeup design
In-game textures and shade authoring

• **Character Modeling Supervisor at Blur Studio. 2002 – 2010**
An award-winning visual effects production company where I implemented and managed the character modeling pipeline for eight years.

List your past clients and notable projects

CLIENTS & PROJECTS
• *SOS* – Character concepts, character pipeline establishment, persona analysis, facial expression setup, promotional key art
• *Hasbro* – ZBrush head sculpt for figurines, miniatures, and toys
• *Assassin's Creed Syndicate* – Cinematic character creation
• *Rise of Tomb Raider* – TressFX 3.0 hair authoring and pipeline development, character creations, facial expressions, key art for PR department
• *Uncharted 4* – Next gen facial setup and character pipeline development

- *Uncharted 3* – Katherine Marlowe, Chloe Frazer, and Elena Fisher
- *The Last of Us* – Pre-production character supervisor
- *Tomb Raider: Underworld* – Cinematic – Lara Croft
- *Star Wars: The Old Republic* – (Jedi vs Sith) Cinematic – Eleena Daru and Shae Vizla
- *Star Wars: The Old Republic* – (Hope) E3 Trailer – Satele Shan
- *Mass Effect 2* – Promo Interview Cinematic – Jack/Subject Zero, Miranda
- *Dante's Inferno* – Cinematic – Beatrice
- *Prototype* – Cinematic – Female Pedestrian
- *BioShock* – Cinematic – Little Sister
- *Empire Earth III* – Cinematic – Viral Carrie and Bowman
- *EverQuest II* – Cinematic – Antonia Bayle
- *BloodRayne II* – Cinematic – Rayne
- *Æon Flux* – Cinematic – Æon Flux
- *Warhammer Online: Age of Reckoning* – Dark Elf Sorceress
- *Fable II* – Cinematic – Theresa
- *The Simpsons Movie* – Trailer – Bunny
- *Disney* – Mickey's Twice Upon a Christmas

PRESENTATIONS & TEACHING

Passionate about teaching and merging the essence of digital techniques and traditional disciplines, my previous presentations and workshops include Los Angeles Academy of Figurative Arts, Otis College of Art and Design, Gnomon School of Visual Effects, The Art Institute of Los Angeles, Santa Monica College, CGWorkshops.com, SIGGRAPH, and Silvera Jewelry School.

- **Silvera Jewelry School**
 Jewelry Illustration1. Instructor, 2017

- **CD Projekt RED – Promised Land**
 Female Portrait & Hair Sculpting in ZBrush. Presenter, 2016

- **Los Angeles Academy of Figurative Art**
 Female Portrait Study with ZBrush. Instructor, 2013 – 2014

- **CGSociety**
 Online Workshop: Iconic Heroine Design and Creation. Instructor, 2011 – 2015

- **Gnomon Master Class**
 Digital Female Character Design and Creation. Instructor, 2009

- **LA ACM SIGGRAPH Presentation**
 Digital Sculpture. Artist/Presenter, 2010

- **Pixologic: Feature ZBrush Artist Presentation, SIGGRAPH**
 Artist/Presenter, 2010

- **Gnomon School of Visual Effects, Hollywood**
 The Making of *Warhammer Online: Age of Reckoning* Trailer. Artist Presenter, 2010

- **The Art Institute of Los Angeles**
 Brazil Toon Shader Presentation – A 2D Toon Takes a 3D Ride. Artist/Presenter, 2003

EDUCATION
- **Master of Arts**. Majored in Computer Graphics, Williams Paterson University, 1999

- **Bachelor of Fine Arts**. Majored in Computer Graphics, Williams Paterson University, 1997

- **Associate degree in Applied Science**
 Majored in Graphic Design, County College of Morris, 1995

www.szejones.com art@szejones.com (555) 555-5555

Include any presentations you have given and teaching experience

List your degrees and education history

DOS & DON'TS OF CVS

DOS:

DO STAY CALM
Stay calm when you compose and review the content of your CV, ensuring your text is factual.

DO WRITE IN YOUR OWN WORDS
Start with a thought, speak it out-loud, and write it down in your own words. Then polish and revise the text.

DO WRITE WITH PERSONALITY
State your goals, and how you would contribute to the team. Write in a positive mood to improve your word choice and help you express a good personality.

DO HAVE CONFIDENCE
Highlight your achievements and skills with confidence in your abilities. However, only give factual examples of your success and avoid extravagant words.

DO YOUR RESEARCH
Research the role, the company's products, and their promotional materials to see how you could contribute. Showcase any prior experience you have in those areas.

DO KEEP NOTES
As you compose your CV, note your thoughts for later reference. This will help you answer questions at an interview.

DON'TS:

DO NOT USE UNCOMMON WORDS
Keep word choices simple and relatable. The goal is to communicate clearly and with ease.

DO NOT REPEAT YOURSELF
Identify a new strength in each section of the CV. For example, promote your organizational skills in the career section and your leadership skills in the education section.

DO NOT WORRY ABOUT INEXPERIENCE
Focus your first CV on your educational achievements and life events. Employers want to see a good personality and clear growth.

DO NOT DWELL ON WEAKNESSES
Focus on your strengths, not your weaknesses. Highlight your good personal qualities and positive life experiences.

DO NOT WAIT TO BE GIVEN OPPORTUNITIES
Internships, volunteer work, and anything that shows you have proactively looked for opportunities to learn should be included.

DO NOT SUBMIT SILLY ERRORS
Get someone to proof-read your CV to spot spelling and grammar errors. Record and play back readings of the CV to expose areas that need clarification, and revise it until it is comfortable to read.

ARTIST PROFILE

SZE JONES
Lead Character Artist
szejones.com

Sze is a professional concept artist specializing in digital character creation for video games and cinematic projects. Her expertise is in ZBrush sculpts, facial expressions, hair, costume, artistic supervision, and workflow implementation.

Career highlights
· Lead Character Artist at Outpost Games
· Senior Character Artist at Crystal Dynamics
· Lead Character Artist at Naughty Dog
· Character Modeling Supervisor at Blur Studio

Have you achieved the career goals you had as a new artist?
My initial goal was to become a character artist, but I learned that most concepts are approved by the client before a character artist is involved. I would only interpret, translate, and build in 3D. After much thought, I put my dream into action. I trained in classical figurative painting where I learned to use light to depict form, and color to control value, hue, and saturation. After five years of training and perseverance, I achieved my goal and became Lead Character Artist at Outpost Games.

How has the industry changed during your career?
The video game industry used to be a niche market with very few prestigious production houses. It was extremely difficult to find information about production workflows and the only online communities were CGTalk and Polycount.

Now there are many online communities and industry events. Educational institutes are well equipped and their instructors have industry experience. The industry is developing quickly, with more talent and competition worldwide.

How have you developed your skills?
Working in production gives me opportunities to grow through collaboration and problem solving. I also invest time and personal funds in taking classes with artists I admire to acquire fresh insights. Away from my workstation I also enjoy participating in life drawing, oil painting, sculpting, and jewelry workshops.

What do you think has been most influential to your career success?
The most influential turning point was when I started to share my art. Initially, I was really nervous, but my colleagues encouraged me to share my art on CGSociety and, after a while, I realized it was important to do. I have grown as an artist because of the love, support, and encouragement I have received.

For several years I taught online workshops too, with participants from all over the world. It was a meaningful time where I met many amazing people with a passion to learn and tremendous self-discipline.

What are the common portfolio mistakes you see?
Common mistakes are including images that do not have a specific purpose other than showing technical ability, or copying a photograph without design or imagination. Including characters without context is also not ideal. It is difficult for the studio to gauge if the artist can deliver a specific vision as directed. Your portfolio should consist of images with context, design intent, and a strong technical foundation.

PREPARING A PORTFOLIO

BY SZE JONES

The portfolio is a visual representation of your artistic and storytelling skills, so you should choose your most expressive images to leave a vivid impression. In this chapter you will learn about the different elements you need to consider to best prepare and present your portfolio.

THE PURPOSE OF PORTFOLIOS

A portfolio is a tour around the artist's mind; each artwork is the product of the artist's ability to problem solve and their method of communicating ideas. Through the portfolio, employers can look in depth at the caliber of a candidate's artistic skill. It is vital that your portfolio has a clean, readable layout to convey your vision and personal style.

Technical and artistic balance can also be evaluated in a portfolio so make sure that you show how you use foundation art skills to perform a difficult task. A strong portfolio speaks louder than any words in crediting an artist and all the elements applied should showcase your ability to communicate ideas and tell stories visually.

Some elements that may be evaluated when you show your portfolio to a studio are: moods created by color palettes; the visual impact of compositions; emotions described in facial expressions; the believability of a rendered portrait; innovative design; and accuracy of anatomy, structure, and perspective. All these elements will be taken into account by art directors and compared against the portfolios of other candidates.

SELECTING WORK

For an entry-level position, five to ten artworks in your portfolio is acceptable, and for a junior position ten to twenty pieces is reasonable. For a senior-level concept artist position, twenty to forty artworks in a portfolio is appropriate. The best portfolio is exciting from beginning to end and will leave an unforgettable impression on the viewer.

The portfolio should focus on **how you convey ideas**, and show your **personal style** and **interpretation** of the subject matter. Your ability to create a convincing experience and inspire the imagination of the viewer will also be evaluated. It is important to show that you can not only render a technically realistic image but also that you can convey a style or personality type to suit a detailed backstory. Feature supportive elements to convey your ideas. It is a common mistake for portfolios to only focus on techniques and lack a purposeful storytelling aspect.

You should also provide concept art that shows a **wide range of possibilities**. For example a character concept artist should create diversity with various skin colors, facial structures, and body masses. They might also experiment with exaggerated limbs, or unique facial features, and create themed costumes. Presenting variations to communicate a story will show your imagination and understanding of what makes a concept work.

" Think of it as a **performance** that you need to orchestrate to create a **VISUALLY SENSATIONAL** presentation. "

Present the same subjects under different camera angles, lighting, and color settings to provoke distinctive moods and emotional responses. Also choose a couple of quick sketches that showcase your ability to quickly provide design options. You could even include some text to give context to the concepts.

Organize your portfolio by separating it into themed sections. For example, group your images by portraits and personality, mood and lighting, environments and compositions, and color palette and emotions.

It is important to maintain a consistent quality across your portfolio, and aim for quality over quantity. Only keep your best pieces in the portfolio so that each piece, from sketches to final render, represents the high standard of your work. Your portfolio should have a cohesive, unique style that clearly represents you as a trained and confident artist.

PORTFOLIO PRESENTATION

For presentation at interview, a case with a non-frosted clear sleeve which is 11 inches × 17 inches or larger in size is preferable. You could also attach your printed CV to the first page. Digital work can be printed on matte or semi-gloss paper in high resolution (300 dpi or more).

Arrange images in order of importance and quality, with your best work on the first page to represent you as an artist. Follow this with groups of concept work with similar themes and purpose. Then include a section with process images and sketches, and finally complete the portfolio with a polished artwork. Think of it as a performance that you need to orchestrate to create a visually sensational presentation.

An online portfolio is also essential for showing your work on the go. It must be well organized, cell phone friendly, and easy to navigate. The landing page should consist of a strong, representative image, your name, and title. The homepage should then showcase all the images in your portfolio at a glance.

Thumbnails or scrollable pages will help your potential employer to quickly get an overall impression of your style and artistic level. Simple layouts work best, and you should avoid animated items or auto-play music. The viewer should be able to browse through high-resolution images with ease and be able to quickly find the title and a brief description of each image.

Find out more about creating an online presence on pages 94–101

SZE JONES
CHARACTER CONCEPT ARTIST

EXAMPLE PORTFOLIO FOR A
CHARACTER CONCEPT ARTIST
FOCUSING ON COSTUME DESIGN

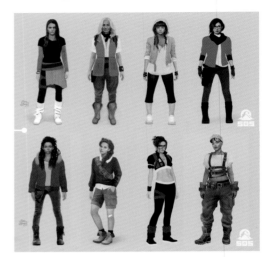

Include recognizably different
silhouettes

Show options for customization

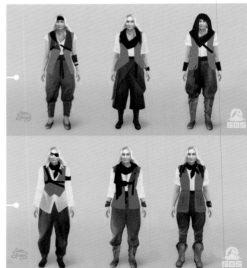

Swap costumes to show variety

Support the character's personality
with a themed wardrobe

Images © 2017 Outpost Games

EXAMPLE PORTFOLIO FOR A CHARACTER CONCEPT ARTIST FOCUSING ON PORTRAIT DESIGN

SZE JONES
CHARACTER PORTRAITS

Include subtle variations in facial expressions and head tilts

Explore hair designs that enhance different personalities

Show that you can design characters with diversity

Explore different body poses and facial expressions

PRESENTING STYLE IN YOUR PORTFOLIO

BY JUAN PABLO ROLDAN

It is important to consider the dynamics of your individual style when working in a studio. If you are looking for work, you should be aware of the style and level of your art in comparison with the style of the studio you want to work with. As you learned on page 63, targeting your portfolio work is a key skill for new artists who want to be part of the entertainment industry, but first you need to identify your objective as an artist. Do you intend to work in-house for a specific studio, or are you hoping to work more generally on different projects as a freelance artist?

If your goal is to work in-house, you should analyze the style of the studio before attempting it in your own work. Keep in mind that the majority of studios that create movies and video games have a standard level of quality and a specific art style. If you are looking to get a job in pre-production for a studio that produces very cinematic projects, your portfolio should demonstrate that you are adept at working in that style. The portfolio you present for applying to a job at Pixar must not be the same as a portfolio presented for a job at Industrial Light & Magic (ILM). Where Pixar looks for stylized and vivid images, ILM is keen on realism and desaturated pieces. If your portfolio matches their expectations you are more likely to be asked for an interview.

On the other hand, if you prefer to work as a freelance concept artist and have different projects with different styles, you could include a variety of pieces in your portfolio to show your versatility. It is important to have in your portfolio not only realistic images, but also stylized images with different types of lighting and camera angles, various genres, environments, characters, and prop designs.

Finally, it is a strong advantage to show in your portfolio that you are capable of working in 2D and 3D. This is true for both 2D and 3D career paths and a useful skill in many different industries.

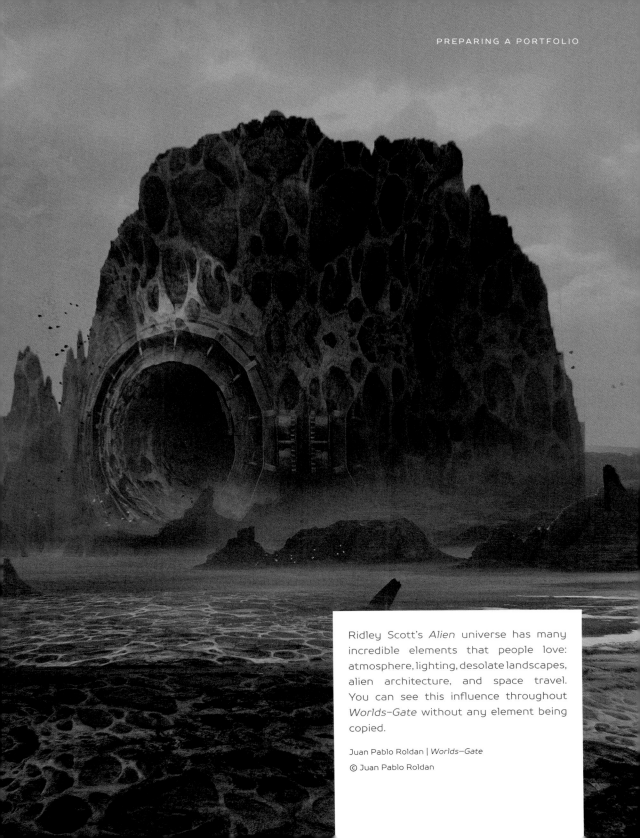

Ridley Scott's *Alien* universe has many incredible elements that people love: atmosphere, lighting, desolate landscapes, alien architecture, and space travel. You can see this influence throughout *Worlds–Gate* without any element being copied.

Juan Pablo Roldan | *Worlds–Gate*

© Juan Pablo Roldan

PROMOTING YOUR WORK AND YOURSELF

BY CRISTINA LAVINA FEREZ

In this chapter you will be given tips on how to build your professional contacts and showcase your work in person and on the internet. The way you choose to present your work when starting your concept art career is particularly important. Even if you are a great artist, if you do not show your work properly you will miss some excellent opportunities.

HOW TO BUILD A PROFESSIONAL WEBSITE

Your website may be the first impression people will have of you and what you are capable of creating, so it is important to build a website that fits your needs and shows your work well. There are a lot of support websites with great templates which you can use as a base for your own site. If you do not know how to program a website, this is the easiest way to construct a professional-looking online presence. Two recommended support sites are carbonmade.com, a monthly subscription site with imaginative themes, and cargocollective.com, where I have my website set up.

With ready-to-go themes, making your own website is not as hard as it might seem at first, and you can be very creative when building a good-looking website to show off your work to fans and potential employers. However, you should always remember to make your website easy to access and keep it organized. If you work on maintaining these two elements in your website design it will be a success.

It is also useful to make sure that the support site you choose has an ecommerce option built into it, so you can create your own online shop if you ever choose to sell your work (see more on pages 166–172).

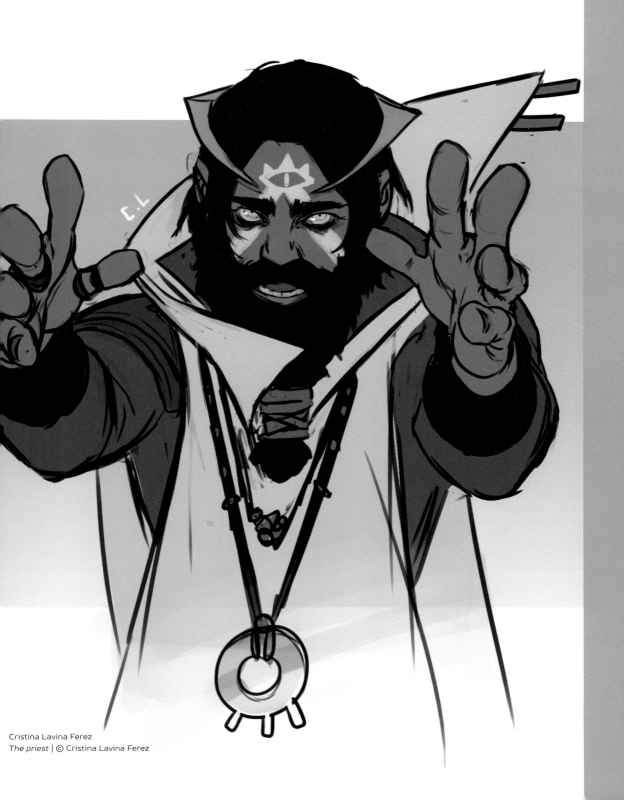

Cristina Lavina Ferez
The priest | © Cristina Lavina Ferez

TIPS FOR A GREAT WEBSITE

1. KEEP IT SIMPLE

Use a simple template for your website. Choose one with minimal colors and limited decoration. Think about what you want people to focus on when they look at your work, and make sure the design of your website does not distract from that.

2. MAKE IT ACCESSIBLE

This may seem obvious, but you need to make each section of your website easy to access with a single click of a button. You have probably come across websites which have links that you cannot click and this immediately makes it difficult for someone to navigate. Do not frustrate your audience and future employers with poor navigation.

3. BE EASY TO CONTACT

It is important to have a clear and simple route between your portfolio and your contact information. Whenever someone is looking at your portfolio, they should be able to easily find a way to contact you, either through a contact page or a prominently placed listing of your email address.

4. CREATE CATEGORIES

Organizing your portfolio work into separate categories on your website is useful to the viewer. For example you could group your work into environments, illustrations, mood pieces, and so on. It is important that your audience can find the work they are most interested in. Adding in forward and back buttons is also very helpful in enabling your viewer to move from image to image within each grouping.

5. INCLUDE CLIENT CREDITS AND LOGOS

If you intend to upload an artwork you have created for a company or client project, you may be required to add a text credit and the project or studio's official logo on your work. This will signal to your website visitors the professionalism of your portfolio and also ensure that you do not upset your clients. However, you should always check your contract, or with your company contact, that the image is not under a non-disclosure agreement and that you are entitled to share the work before you post the image online.

6. CONSIDER A HOMEPAGE IMAGE

An image on the home- or landing page is something you do not necessarily need to include, but it can be a good way to add personality to your website. Placing an illustration or artwork which you feel is a strong representation of your skills on your homepage can be an excellent introduction and also act as a statement for what visitors to your website are going to find there. However, this may not suit your chosen website theme so if you feel it compromises the aesthetics of your site, it is better to not use an illustration.

7. INTRODUCE YOURSELF

Adding an "About" page to your website to introduce yourself makes the website more personable. In this section you can put a portrait of yourself and give some background information about who you are, what you are interested in, and any training or career experience you have. Putting a face to your work will make you more approachable to fans and potential clients.

AN EASY-TO-NAVIGATE WEBSITE

Organize your work into categories

Add copyright information and logos to client work you have permission to show

Keep access to the main menu visible at all times

Ensure that your work has a clear layout that is easy to navigate

USING SOCIAL MEDIA AND NETWORKING WEBSITES

LinkedIn

These days most people have a social media account of some variety. There are even artists who use their social media to communicate more than they use emails. One of the best sites to use to build up a network of professional contacts in your industry is LinkedIn, an international networking site for professionals of all industries. On LinkedIn you can collect together your existing contacts, approach new contacts in a professional way, submit your CV, and start building a network of people who already work in the industry that you want to break into.

An important thing to remember with LinkedIn is that you should add people from your chosen industry. LinkedIn will suggest new contacts for you and from there it will create statistics about your contacts and the type of new contacts you would like to make. If you start adding contacts from within the film industry, it will start to suggest new contacts who are also working in film. Do not just accept every person who wants to add you, but instead be selective. Remember that LinkedIn is not for finding fans and followers, it is for professional contacts.

ArtStation and DeviantArt

There are other online communities that are dedicated to artists, and specifically concept artists, such as ArtStation or DeviantArt. Both sites allow you to post artwork to a portfolio-style account and interact with other users. ArtStation can also serve as a secondary website, which is useful if it is difficult to update your professional website regularly or if it is being redesigned.

The great thing about these two platforms is that they allow you to follow your favorite artists, upload work as you progress, and get feedback from your peers.

ArtStation also hosts contests and challenges that anyone can participate in, which are great exercises. These contests encourage you to work within a brief, so they provide brilliant opportunities for you to analyze and learn from the work of others.

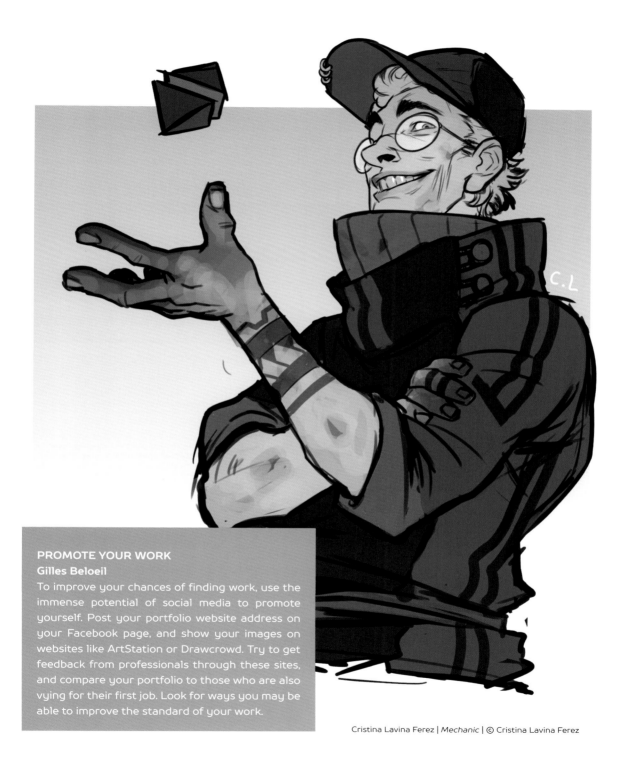

PROMOTE YOUR WORK
Gilles Beloeil

To improve your chances of finding work, use the immense potential of social media to promote yourself. Post your portfolio website address on your Facebook page, and show your images on websites like ArtStation or Drawcrowd. Try to get feedback from professionals through these sites, and compare your portfolio to those who are also vying for their first job. Look for ways you may be able to improve the standard of your work.

Cristina Lavina Ferez | *Mechanic* | © Cristina Lavina Ferez

99

Facebook and Instagram

Facebook and Instagram offer a way to keep up to date with industry events, new work by other artists, and news. There are other social media sites that artists use, such as Twitter, Tumblr, Vimeo, and YouTube, but Facebook and Instagram are particularly prominent in the art world. You can post rough work and quick sketches to these accounts as these platforms are intended to be a lot more casual. These accounts are closer in style to a blog than a professional online portfolio.

Being visible on these social media networks will bring you opportunities as your work becomes more visible to people online. However, you do not need to be famous on the internet to succeed professionally. It is a good idea to maintain some variety of online presence, but try not to obsess over the amount of likes and followers you have. Use your accounts as a means of learning to become a better artist day by day as well as promoting your work. One enjoyable thing you could do with your Facebook account is post weekly exercises. This will keep your account regularly updated with sketches and give form to those vague ideas you have in your head. You will also be able to look between your first post and the latest to see how you have improved with practice.

Keeping a large fan base takes a lot of work and effort. It is something that not everyone has time to maintain, so you have to find your own tempo. Some artists are not as active on social media as others, but that does not necessarily inhibit their career. Some artists prefer to work on a confidential tailored portfolio just for the company they are applying to and in their emails to the studio just add links to their other pages in case they want to see more.

Social media websites are good tools to get your work seen but use them to make your art better, not to become famous. If you are a good artist companies will be interested in you no matter how many followers you have. Instead, ask yourself what makes your work special. It may take you time, but part of your career journey is discovering who you are as an artist.

DEVELOPING AN AUDIENCE

There are a few things you can do to increase your online presence in order to be seen by more potential employers. When you update social media, make sure your posts are **eye-catching and engaging**. Different social media platforms have image-size guidelines that you can use to optimize your reach, but generally you will need to identify what it is that your audience want to see and comment on. You can do this through trial and error, by looking at what works well for other artists who have successful followings, and by using any **analytic**s offered by the platform you are using. There are plenty of resources online you can research, and the world of social media is one that is ever-changing, so it is best to try to keep up to date with any trends and new algorithms a platform might be using. **Being active** and commenting on other artists' social media platforms can be helpful (although avoid mindless comments or spamming). Joining in with online competitions and using appropriate **hashtags** to connect participating artists is another great way of building an audience.

GETTING WORK THROUGH ONLINE NETWORKING

Social media platforms are great to show your work to other artists, but what about when you want to apply for a position in a studio? Aside from applying through the website of the company, try to make relevant connections with the studio you want to work for through LinkedIn. This can prompt communication from the people you want to work with.

Whenever you see a position online you want to apply for, start looking for people who work for the same company – in HR or as producers, art directors, or artists – on LinkedIn. This strategy can help to get your work seen by the people you specifically want to see it.

However, do not be discouraged if you do not receive replies from these connections; it is normal in this process. Think about how many emails and messages these people might receive whenever there is a position open, and try not to take a lack of response as a personal rejection or failure. Remember too that if you do not have the experience the studio needs or fit the requirements of the role, it is highly likely you will not get a reply.

A useful thing about adding all these contacts is that you will be on their radar, and even if they do not reply to you now, they may do so in future when you have grown as a professional.

EVENTS AND GROUPS

Attending workshops is the most effective way to meet other people working in your industry. There are many workshops running throughout the year all over the world. A popular UK event is Industry Workshops in London. Industry Workshops is a three-day event where you learn and share your passion with many artists and other students. At a workshop event it is very easy to approach a professional and ask for advice or a portfolio review if they have time. Fortunately, in the concept art community most people are friendly and approachable.

The first time you attend an industry event can be overwhelming, especially with the amount of talented people per square meter. You end up with so much energy from meeting people who are interested in the same things, and with great feedback to keep you working harder and harder every day.

More so, you will come away with a collection of new friends and contacts for the future. If you have never been to an event before, start saving some money to pay for transport and a ticket so you can attend one. You will not regret it.

While you are saving for a ticket to a large event, look closer to where you live to find any art events that are happening in your city or local town. Search for Facebook pages and groups, and look at the accounts of any local concept artists that you know of. You may be able to find information on smaller events, and more general art-related events such as life drawing, or social events where you can meet, drink coffee, and chat with other artists.

There are international groups which run localized events and meetings, such as Drink and Draw events, where artists can just meet to drink beer and sketch together. In most cities it is possible to find some sort of art group, and if there is not currently one near to where you live, why not start one yourself? You could try to find local artists and create an event, or arrange a social gathering and spread the word.

BEING ACTIVE IN THE LOCAL CG COMMUNITY
Donglu Yu

Having connections in the CG community can give you lots of opportunities that you would never think of. With the exception of my first concept artist position, all my other jobs came about because of referrals from my connections.

To make contacts you can participate in life-drawing sessions, intensive seminars, studio open-house events, private concept art programs, or by taking up mentorships with industry professionals. In addition to practicing your skills at events, you can meet all kinds of people who may recognize your talent and refer you for a potential job opening.

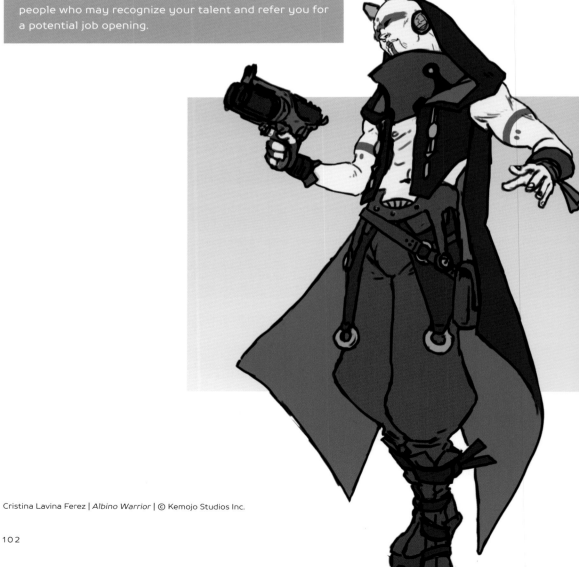

Cristina Lavina Ferez | *Albino Warrior* | © Kemojo Studios Inc.

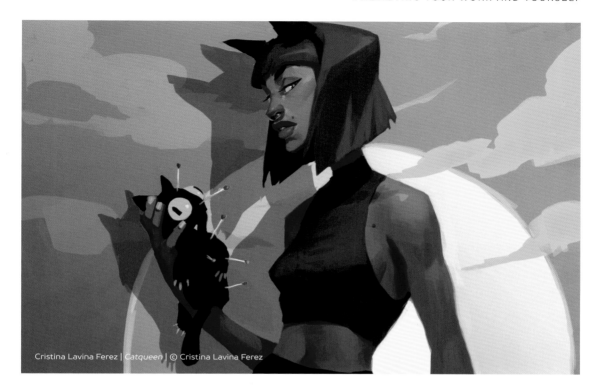

Cristina Lavina Ferez | *Catqueen* | © Cristina Lavina Ferez

HOW TO APPROACH EMPLOYERS AT EVENTS

At most events and workshops there will be representatives from companies who are looking to recruit new artists. A really positive thing you can do before an event is to research the people and companies who are going to be attending, as it will be a good indication of your dedication that you took the time to learn what they do.

Going to the booth of each company you are interested in is the easiest way to meet potential employers, but do not go and show your work immediately. The person there might not be the person you want to talk to.

Instead, ask them if you can have a meeting and they will probably be able to give you a suitable time slot for a meeting.

Not all of the potential employers at an event will have a booth, which is why it is important for you to research who will be there. You will need to be able to recognize the people you want to talk to and approach them whenever they are available. Do not be shy, but avoid being invasive. These people may be there to network, but everyone needs a break for a quiet coffee! When you spot someone you want to talk to, be observant and find an appropriate moment to approach them.

The two essentials you should have whenever you meet a recruiter are your portfolio and some business cards. Having a tablet can be very useful to show your work quickly in a way that is easily portable at events. Whenever you start a meeting, try to remain calm and just focus on having a pleasant conversation. When you are meeting with representatives from your dream studio it is hard to restrain your enthusiasm, but it is important that you show your professionalism while still conveying your passion. It is fine to tell them their work is something you have always admired, but try to avoid repeating it.

Cristina Lavina

Concept Art & Illustration

http://cargocollective.com/cristinalavina

cristinalavina@gmail.com

Font is hard to read

Image is too small

USING PROMOTIONAL MATERIALS

If you do not have one by now, get a tablet! Although it is not strictly necessary, a tablet can be really useful to have on-hand whenever you want to show your work quickly and with great quality. You can store a selection of your work on the tablet to show any new contacts you meet, as well as giving them a business card, so they will remember to visit your website later.

When making a business card, follow the same principles you use when making your website: keep it simple and easy to understand. Choose a font that will be easily intelligible so contacts can find your website quickly and contact you with ease.

To make your business card attractive, select an image that best represents your work (such as the image used on your website homepage) and dedicate one side of the card to it. The other side can be dedicated to your name and clearly presented contact information.

Cristina Lavina

Concept Art & Illustration

http://cargocollective.com/cristinalavina
cristinalavina@gmail.com

Keep the text simple and easy to read. Use an interesting crop of your image so your image is visible

ARTIST PROFILE

CRISTINA LAVINA FEREZ

Character Concept Artist
artstation.com/artist/lavinart

Cristina is a concept artist from Barcelona. She moved to London to work for Opus Artz before moving to Canada and working at Blackbird Interactive. Her concept artwork is focused on characters.

Career highlights
· Character Concept Artist at Blackbird Interactive
· Concept Artist at Kemojo Studios
· Concept Artist at Fathom Interactive
· Concept Artist at Opus Artz

Where do you look for inspiration?
I grew up admiring anime and manga artists, but then I started taking more interest in other styles, from Disney to Frank Frazetta. I try to extract the best elements of each form and learn why those styles are so successful.

I also find lots of inspiration on the streets. I have always paid special attention to how people move, talk, and dress. Sometimes observing the real world can be the best way to learn.

What is the most challenging area of your work?
Making something fresh for every new project is difficult. It is really hard to come up with new ideas as everything has been seen already. Another big challenge is creating characters that people will care about. Characters need to tell stories through their eyes or the clothes they are wearing.

What do you do when work gets tough?
There are many artists who finish work, then go home and work on their own project, but I have never been able to do that. I focus deeply on my characters so after eight or nine hours of work I need a mental break.

I find that doing activities aside from drawing is crucial to stay sane! Outdoor activities such as snowboarding are a welcome break.

How has your education affected your career?
I have always loved to draw and my mom encouraged me to do this. This was a brave attitude as art was not seen as a real job at the time. However, my mom did everything she could to give me opportunities and took me to a comic school in Barcelona. I spent every weekend drawing and meeting people who shared my passion. I am so thankful to my mom as I am a concept artist today because of her.

At eighteen I was recruited by a TV animation series to work as a character designer. It was not until I moved to London, however, that I discovered what working as a concept artist for video games was. I have to thank my mentor in that time, Björn Hurri, for teaching me so much and giving me opportunities to grow.

What do you hope to achieve in your career in the coming years?
My main goal has always been to do the thing I like most. That is easy to say but not so easy to accomplish because sometimes it is not entirely in your power. I want to make characters that are significant to someone else. Whether my work touches one person's soul or a hundred, I have always wanted my designs to be meaningful so I will always work to find that fulfillment in my work.

ADVICE FOR STUDIO INTERVIEWS

At some point in your career you will have a face-to-face meeting with a potential employer, whether it is at a formal studio interview, a review of your portfolio, or a convention. Although your ability to produce high-quality artwork will always be the most important factor in your employment success, you also need to be able to present yourself as an excellent candidate. This advice will help you prepare for the meeting and make a positive impression.

1. GO PREPARED

Once you have been invited to an interview, confirm with the studio the date, time, and location. Check that you will be able to attend the interview and that you have a suitable mode of transport on the day.

Research the company and their products online. Ensure that you are familiar with the company's values and working practices. Showing an awareness of how the company operates will signal to your interviewers your enthusiasm for the position on offer.

2. DECIDE WHAT YOU WANT

Think carefully about what you want to get out of the job. There is nothing wrong with wanting an income, but that is a very broad reason to want a specific job. What is it in particular you hope to achieve by working for this company? Do you want to develop a skill, or gain experience in a certain field? Having an insight into your own motives will help you talk passionately about your aspirations, and talk candidly about what your career expectations are.

3. DRESS APPROPRIATELY

Always aim to show yourself at your best. Although your interviewers will not be assessing your looks or fashion sense, you should be conscious of how you present yourself.

Treat the hiring process seriously and dress appropriately for the studio you are applying to. If the studio is quite formal in the way it presents itself publicly, try to match that with a suit or smart outfit. If the studio is more casual, you do not necessarily need to wear a suit, but you should still make an effort to be clean, neat, and presentable in your clothing and appearance.

4. PRE-PLAN YOUR ANSWERS

As you prepare for the interview, try to anticipate some of the questions you might be asked. What might someone want to know about your work or experience? Do you have an interesting personal project you could be asked about? Think ahead about how you might answer certain questions.

At an interview, if you are correct in your speculative questions, you will have pre-planned answers to help you respond in a clear and succinct manner. If you are not asked the same questions, your impromptu answers will still benefit from the time you spent organizing your thoughts.

5. PREPARE SOME QUESTIONS TOO

You will usually have an opportunity during the interview or meeting to ask questions, and

in the moment it can be hard to think of something relevant. Instead of asking no questions, (and being overwhelmed by thoughts and unanswered questions as soon as you leave the room), think ahead of your interview about one or two things you want to know.

Your questions can be about anything, from the specifics of the project you will be working on to questions about the team. If it is something that matters to you, and will help you decide whether to accept a job offer, then you should ask it.

6. BE HONEST, BUT POSITIVE

Never lie or exaggerate to your potential employers. It soon becomes clear if someone has been dishonest about their training and experience, and it could ruin your reputation in the industry. Interviews are not the place for false modesty or bragging either.

However, a confident and positive attitude is a very good trait at interviews. Even if you feel there are some areas of your CV or

portfolio that are lacking, you can still be positive and upbeat by showing an awareness of the areas you need to develop. Instead of pointing out your flaws, discuss how you are working to improve your skills. Employers want to see that you are interested in the process and willing to learn.

7. BE RESPECTFUL

Your interviewers may make comments about your work when they look through your portfolio. Even if these comments seem negative, or you do not quite agree with them, remember to be respectful. Your interviewers are giving their professional opinions and you should not take their critique as a personal

offense. Instead, thank them for their critique and ask if they can advise you on how to improve.

You can also show your potential employers respect by arriving on time for your meeting. If you are unexpectedly delayed or unable to attend your appointment, call the studio as soon as possible to let them know; they may be willing to rearrange the interview. During the meeting, avoid speaking when your interviewers are talking, and do not be dismissive of the studio's project. They are offering you an opportunity after all.

8. ASK FOR FEEDBACK

It is a privilege to have the time and attention of recruiters, art directors, and senior studio staff so make the most of it by asking for feedback on your portfolio. They will usually be able to point out one or two areas that you could improve on in your work and they may even be willing to share some tips on how you can do so. If they are unable to give feedback, then you have lost nothing, and at least you have shown them that you have a willingness to learn.

CAREER PROFILE: MAREK MADEJ

MAREK MADEJ
Senior Concept Artist
artofmarekmadej.com

Marek has worked in the industry since 2007 on projects including *The Witcher 3: Wild Hunt*, *GWENT: The Witcher Card Game*, *Melancholia* **by Lars Von Trier, and** *The Lost Town of Switez* **by Kamil Polak.**

CAREER HIGHLIGHTS

- Senior Concept Artist at CD Projekt RED
- Freelance Illustrator at Paizo Publishing
- Concept Artist and Matte Painter at Platige Image
- Concept Artist and Matte Painter at Human Ark
- Concept Artist at Metropolis Software

DISCOVERING CONCEPT ART

I was maybe fifteen when I discovered digital painting in general. Two years later I got my first graphics tablet and, although I didn't know what concept art was, I found conceptart.org, a forum dedicated to digital art, while I was searching for a place to share my work online. There I slowly learned what concept art really is. But back then the market for that kind of work was not as large as it is now.

Four years later concept art became a real career option and as soon as possible I tried to get some freelance work. At that point I was not necessarily looking to make money. Any kind of experience I could get was much more valuable to me.

EDUCATION

My education has not directly affected my career development. I went to Warsaw University of Technology and dropped out after a year. I had studied Production Engineering which is an interesting topic, but the amount of math and physics was just too overwhelming for me back then. I felt that I could spend my time more efficiently on something that I really wanted to do.

Most of the things I have learned about concept art have come from work, friends, and the internet. From the very beginning of my career I shared my works on sites like cgsociety.org and conceptart. org, where I received feedback. For me this was more important than just practicing. Feedback is extremely valuable as it gives you an idea of how you can improve your work.

This all took place before it was possible to learn through YouTube and Gumroad tutorials as you can do now. The only educational resources available specifically for concept art at the time were Gnomon DVDs; the schools that taught relevant courses were based in the USA, so they were out of my reach.

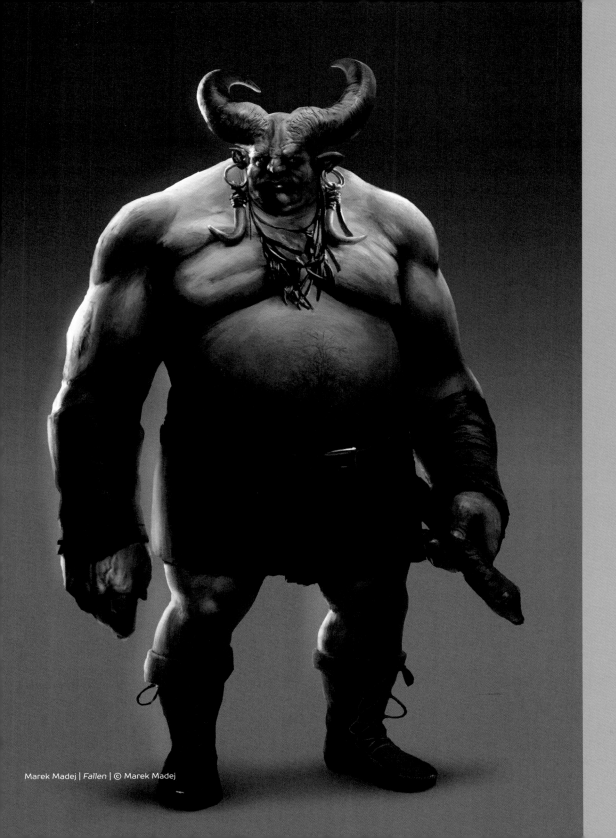

Marek Madej | *Fallen* | © Marek Madej

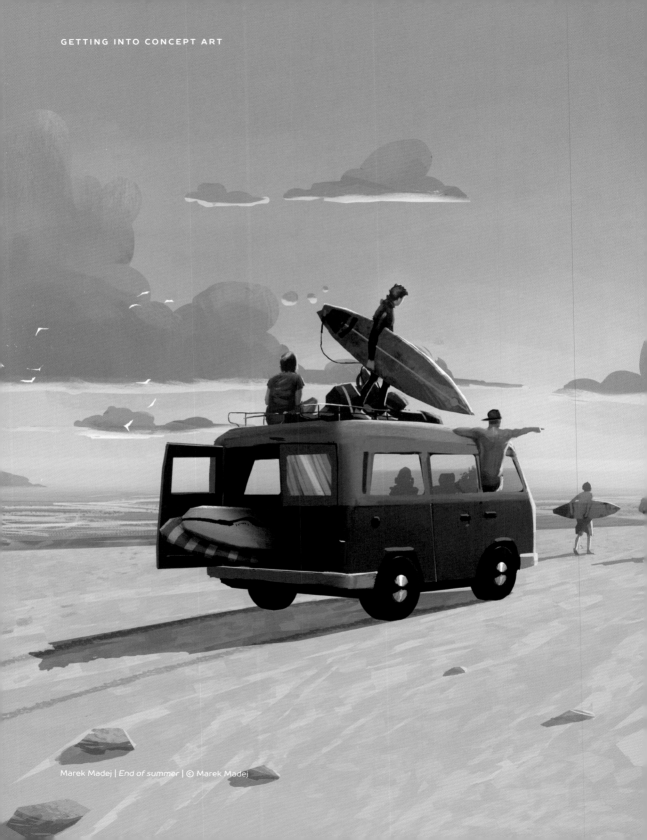

Marek Madej | *End of summer* | © Marek Madej

LAUNCHING YOUR CAREER

Gaining experience wherever you can is important, so when I was in high school I worked on projects with others who were also trying to learn about concept art. There were no indie games back then, but that is what those projects might be called now. Most of those people did not have any prior knowledge about how to make games – we were all learning together.

Through those projects I met and made contacts with a lot of people who are now working professionally. When looking for work, knowing somebody from the studio you are applying to is a huge advantage as they can confirm that you are great person to work with. Also, when it comes to companies searching for a new addition to the team, even for junior positions, they usually expect you to have some kind of experience. These projects are a way to get it.

GETTING A JOB

Most of the career opportunities I have had, especially at the beginning, I got mainly because I posted my art on the internet. My first full-time job was actually not related to games. I used Photoshop, but my job was making pack shots of children's clothes. While I did that I also searched for jobs where I could do something connected to games or digital painting. I had two offers, one in Kraków where I could work on small PC games for a company I had already done a couple of freelance jobs for, and one in Warsaw at a studio where I could work on cell phone games. As I did not want to move away from Warsaw I decided to go with the second option.

FREELANCING

When freelancing at the beginning of your career, it can be tricky getting paid and I was not knowledgable about this side of working. I did not know how an agreement should look, what to charge for my work, or how to send invoices. My art skills were also at a level that attracted small, start-up companies. I found that some of those companies depend on the inexperience of artists as they offer low rates or are hard to work with.

Fortunately I have not had many problems with being paid, but I know many artists who have. Very often you will need to wait up to three months to get paid for your work and sometimes you need to remind a company a couple of times that you are waiting for payment.

When it comes to work, and particularly freelance work, you should always have a signed agreement before you start working. You can also ask for part-payment upfront if you want more security in case something goes wrong with the project. Also check if the company works with artists regularly. Maybe someone you know has worked with the company before so you can ask them if they are a good employer.

" When working on **ambitious** games you can either **LEARN FROM OTHER ARTISTS**, or from the *challenge* of the work "

CAREER PROGRESSION

In the beginning I was excited, but eventually I wanted something more challenging. Back then cell phone games were very simple compared to games now, and pixel art and animation were not really my forte. I was given a hint from a friend that the studio he was working for wanted to hire additional concept artists, so I applied and was lucky enough to get a job.

Unfortunately the project was canceled after ten months, but I did not have to search too long for another job. The career decisions I made at that time pushed me further towards advertisement work where I was able to learn many new things. The knowledge and skills that I picked up then helped me to understand production processes and are still useful now. I had opportunities to learn compositing, matte painting, texturing, and a different approach which I now apply in my concept art work. I also learned the value of my work and how to work in a team. You should learn from all of your experiences to help you progress as a concept artist.

WORKING IN A BUSY STUDIO

Working at a large, busy studio can offer a lot of motivation through working with so many talented people, presenting huge opportunities to grow as an artist. When working on ambitious games you can either learn from other artists, or from the challenge of the work. As part of a big studio you also get to work on high profile-projects where the exposure on your work is much greater.

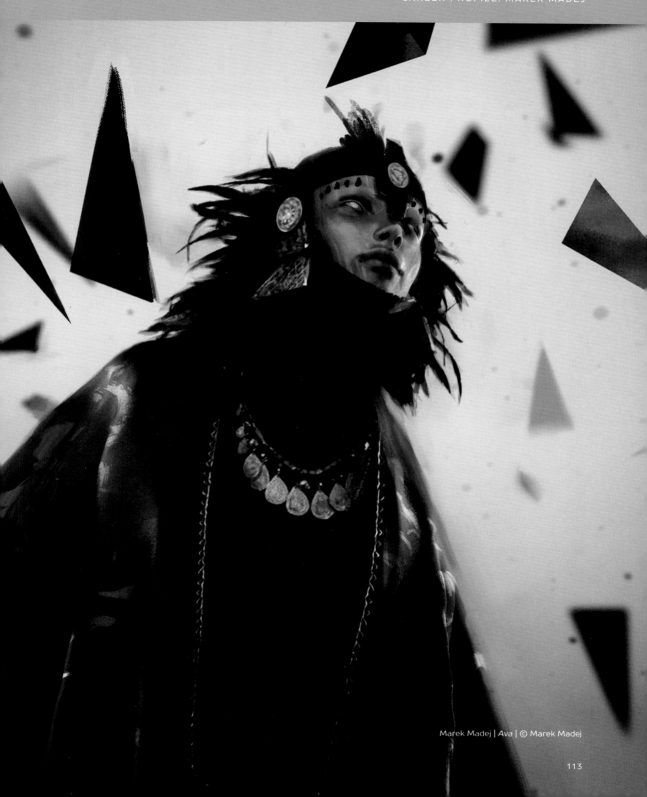

Marek Madej | *Ava* | © Marek Madej

CHALLENGES

Ideas and struggling with the lack of them is a challenge. I love the initial part of the process where the painting does not have to be perfect, but if I cannot get satisfying results it is extremely frustrating for me. Working on the same task for a long period can also be challenging. Fortunately in some jobs you can switch task if you feel that you are tired of a specific job.

SHARING YOUR WORK

Blogging used to be a big thing that worked as a sort of diary for artists. Now everyone has moved on to social media sites like Facebook and Instagram. Social media success will not automatically translate into a paid job, but those sites serve artists as a means of getting appreciation and exposure.

For example when we were searching for illustrators to work on *GWENT* at CD Projekt RED, we searched on ArtStation. So in that case the second most important factor for those artists, after being skilled at their work, was also being visible.

INDUSTRY EVENTS

At industry events people can learn who actually worked on the projects they love and put a face to the work. Attending events can help in terms of getting a job too. A couple of my friends from the studio were initially found at those kinds of events.

I attend events mainly because I love to meet new people. I also like to confront my fear of speaking in front of big groups. I feel that it helps me to grow as a person and build my artistic confidence.

THINGS TO CONSIDER WHEN APPLYING TO A STUDIO

You need to think about the kind of person you are and what sort of project you would like to work on. Being a fan of a certain project does not mean that you will like the work environment or fit the style of the project. Never focus on getting into only one specific studio. When you apply to work at a popular company you need to be aware that there are usually a lot of other people who want the same job. When it comes to internships there might even be hundreds of applications. So getting the work you want is not always only about your skills, but also about your personality and a lot of luck.

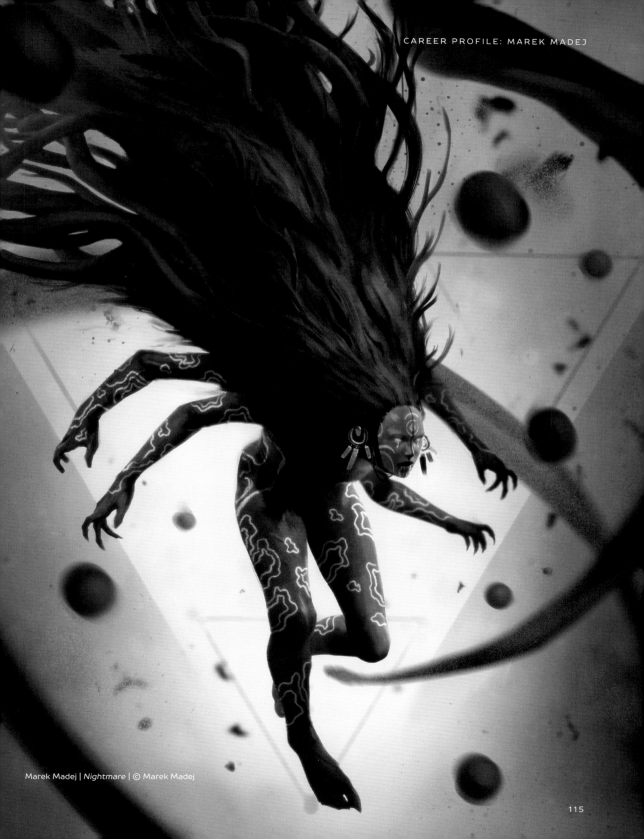

Marek Madej | *Nightmare* | © Marek Madej

A DAY IN THE LIFE...

8:30 AM

My working day usually starts around 8:30 am when my alarm wakes me up. I take a shower and then get dressed.

10:00 AM

I log on to my computer and say "hi" to everybody in the room. I check our internal software and share my work with the rest of the studio. Browsing through the work the rest of the team did the day before motivates me a lot to do my part. I look at my current project and try to analyze what I can improve or ask my art director for feedback if it is needed.

9:00 AM

I leave for work, and it takes me almost an hour to get to the studio. I travel by public transport so I use this time to read, reply to messages on Facebook, or answer emails. Sometimes I just play games on my cell phone.

1:00 PM

Lunch time. I almost always eat with the same group of people from my department. There is no specific time for lunch breaks at the studio, but 1:00 pm is the most common time for me.

11:00 AM

If it is Monday we have a weekly meeting to discuss the work we did over the previous week. It is the official time to share ideas and thoughts about our projects.

FIND YOUR PEERS

Try to surround yourself with people interested in a similar career path. If you live in a small town this might be hard, but you can still use the internet and social media. Reaching out to people in the concept art world is much easier now, and seeing other people's work is motivating. Healthy competition and sharing inspiration helped me to grow a lot as an artist.

1:45 PM

I go back to work. My working day does not have a regular pattern, but I usually find that I am most effective between 2:00 pm and 6:00 pm. I just sit and work, taking little breaks here and there for coffee or a short chat with my colleagues. I sometimes work for four hours without any real break. The afternoon is when I can usually see my art director to get some additional feedback.

6:00 PM

Around 6:00 pm I wrap up my work. I post screenshots of my work from throughout the day to the internal software so that my art director will be able to check it in the morning and give feedback. I note the amount of hours I have spent on certain tasks on our internal system to keep my producer informed too. I usually leave the studio after eight hours.

I might go straight from the studio to the gym as I try to keep fit. Bad eating habits and sitting for most of the day does not keep my body in shape!

8:00 PM
My workout is done and I head home. Once again I travel for around an hour on public transport so I do the same activities I do in the morning.

9:00 PM
Back home I eat dinner. This is my free time so I spend it with my girlfriend accompanied by our two cats. We play games or watch movies. Later on I might draw in my sketchbook or try to learn something useful.

KEEP EXPLORING
Be curious about life. You never know what kind of knowledge might help you in your next project. The better you know the subject you are working on the more believable the designs you make will be. If you have time during the project it is useful to do as much research as you can.

1:00 AM
If I feel tired I go to sleep. Sometimes I might continue to work on some personal artwork instead and go to sleep at around 2:00 am.

WORKING IN THE INDUSTRY

Finding work as a concept artist is just the start of your career journey. Exploring what working life as a concept artist is like, this section will guide you through the working habits it is useful to develop, how to manage your time, and how to adapt your art style for different projects. You will also find information on some of the ethical issues you may encounter as a professional concept artist.

GOOD WORKING HABITS

BY PAUL SCOTT CANAVAN

This chapter is about developing good habits that will help you throughout your career working as a concept artist. The following tips will save you time on your journey and help you avoid pitfalls as you take your first steps to working in the entertainment industry.

A PROFESSIONAL ONLINE PRESENCE

The internet is your primary means of showing work to employers and building a following that will help you promote your work. It is also increasingly the best way to meet and talk to like-minded people, and become friends with your future colleagues. So the way you present yourself online is actually extremely important for your career.

There are two schools of thought on the best way to use your online platforms professionally: the first is that you conduct yourself purely as a business; the second is to act as naturally as possible. The first approach allows you to focus on posting your work and maintains a professional distance from social situations, and thus you avoid controversy by operating more like a studio. The second approach shows your potential employers and followers more of your personality, but you will still need to keep in mind good professional practices.

Which approach you choose depends on how you want to brand yourself, and how much effort you are willing to put into social engagement. There are a few crucial things to maintain, whichever course you take:

· Be polite and friendly. This may seem obvious, but it is important to remember that everyone from friends to future employers can see your interactions online. A negative exchange online could cost you a job.

· If you ask an artist or art director to comment on your art and they fail to do so, do not pester them. Making friends online is no different to making them in person and it takes time. Focus on creating great work; in time these people will come to you.

· Be eager to learn and open to criticism. Concept art is an exciting career and there is always more to study. The best concept artists are those who actively seek out feedback from their peers and attempt to learn from their mistakes.

COPING WITH NEGATIVE FEEDBACK

Learning to take criticism takes practice, especially when it is unsolicited and catches you by surprise. But it is important to remember that all criticism is useful in some way if you break it down. A concept artist's job is to communicate ideas, so if someone is struggling to understand what they see in your art, or they simply do not like it, then that is something you can learn from.

Rather than becoming defensive over the negative comments,

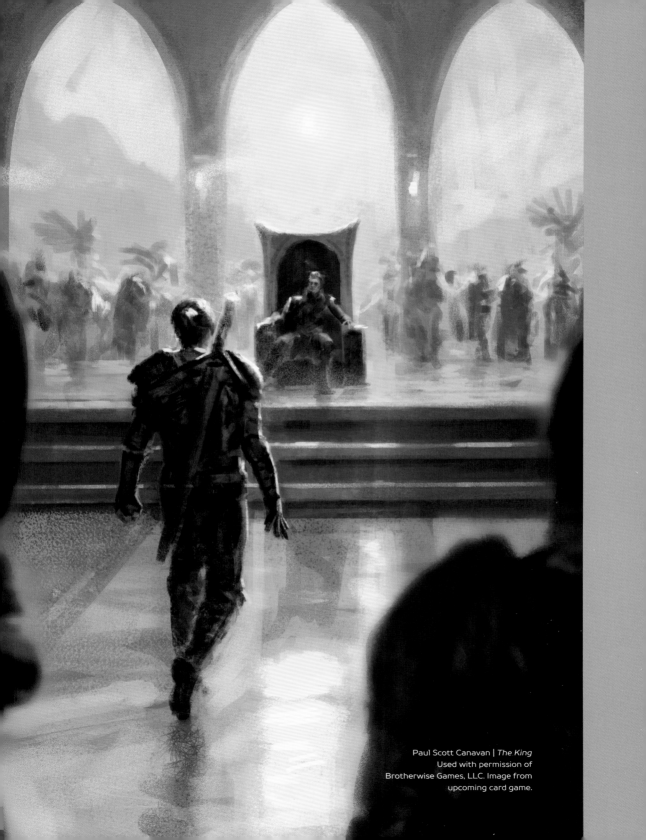

Paul Scott Canavan | *The King*
Used with permission of
Brotherwise Games, LLC. Image from
upcoming card game.

"The **general rule** when dealing with a work **CONFLICT** is to *act professionally* even if the person you are dealing with is *failing to do so*"

encourage the feedback-giver to elaborate. Ask them politely to tell you why they do not like the artwork or exactly what it is that they do not understand. Was it your presentation? Is the concept too detailed, or poorly rendered? Perhaps this person belongs to a specific demographic and you can research things that might appeal to them.

Over time you will become used to receiving criticism. To speed up this process, actively seek it out. Post your work in art forums and on social media platforms and look at the work of others with a mind to offering critique if they want it. See more on making the most out of critique on pages 140–145.

ACKNOWLEDGING SUCCESS

It can be difficult as an artist to acknowledge your own success or see that you have reached your potential. To the outside world you are on a road of constant improvement, but internally every artist struggles and has stressful times. Even if you are able to recognize your own achievements it is important to remain humble and treat your

fans with respect. Remember that you are all on the same continuous journey.

DEALING WITH CONFLICT

Conflict in the workplace can take many forms and will inevitably be experienced at some point in your career. The general rule when dealing with a work conflict is to act professionally even if the person you are dealing with is failing to do so. This can be difficult at times, particularly when you are in the right and the other party is in the wrong, but this rule should always apply.

When there is a conflict, instead of fueling it, attempt to bring the issue to an end quickly and amicably. There is nothing worse than becoming stressed out, distracted, and wasting studio time with something that can be quickly resolved. Do not be afraid to reach out to your lead artist, producer, or art director to help you sort out a disagreement with a colleague. There is nothing to be gained from dealing with a conflict in isolation and letting it escalate, so it is always worth asking other people to help you manage the situation.

Paul Scott Canavan | *Villain*
Used with permission of
Brotherwise Games, LLC. Image from
upcoming card game

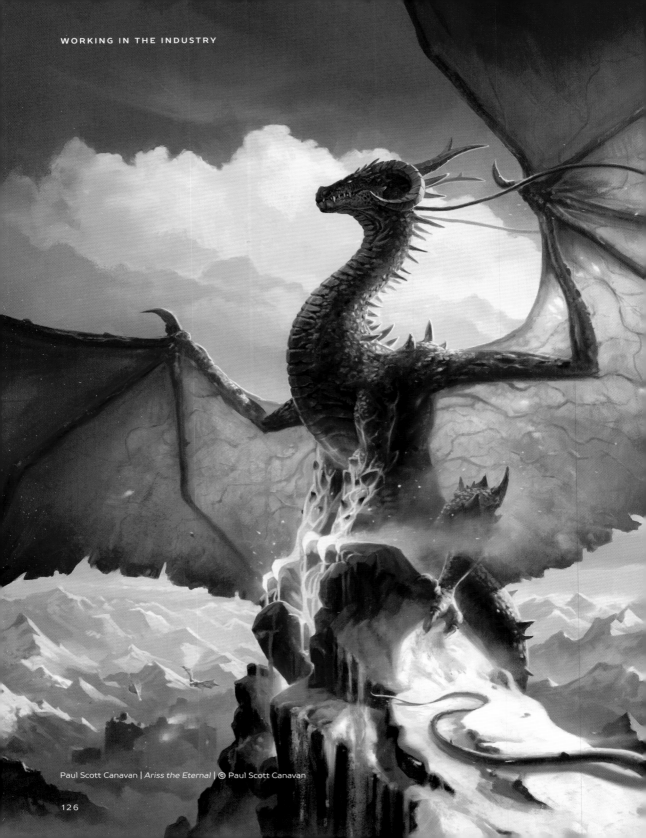

Paul Scott Canavan | *Ariss the Eternal* | © Paul Scott Canavan

TALKING TO EMPLOYERS ABOUT CONTRACT ISSUES, COPYRIGHTS, AND PAY

How to effectively communicate with your employer is one of the most important skills you will have to learn to have a successful concept art career.

Almost any issue that you might experience securing or working on a job can usually be resolved in early email or phone conversations. This is the perfect time to discuss exactly what work they expect you to produce for them and what their terms are. It can sometimes be difficult to negotiate the terms of employment as you will have your own set of requirements, but it is important to come to an agreement before you commit to working for someone.

SEVEN THINGS TO THINK ABOUT BEFORE SIGNING A CONTRACT

1. What is the deadline for the project?
2. What level of finish/ quality is expected?
3. What is the budget?
4. When will payment be transferred to you?
5. How will the employers offer feedback?
6. What rights do you have over the artwork you create?
7. When will the NDA end and when will you be able to show the work?

You should be able to cover most of the important points in the first email. List all of your requirements early so they can be discussed. A suitable contract should be created which both you and the client are required to sign before work begins. This ensures that the agreement is set in writing and thus if there are unagreed changes to the terms you have the option to take legal action, and vice versa. For freelance projects you can find sample contracts online.

If you are working in a studio environment you will usually have the benefit of an HR department. This makes life a lot easier as you can communicate with them about any employment issues. Depending on the studio, you may find that you can also talk to your superiors. For example you may be able to bring up issues of pay or working practices with your art director who is then able to take them further. This is another good reminder of why it is important to be a friendly, professional employee. These relationships can really help you when things get difficult.

Ultimately, no matter what your working environment is like, remember that you have rights and should be properly compensated for the work you do. No employer has the right to breach a contract, so ensure that you are covered from the beginning and that you speak out should something go awry.

HABITS OF A RELIABLE ARTIST

Being a reliable worker means a lot more than simply producing good artwork. Any artist, given time and practice, can create quality art but really great employees are the ones who truly understand the project and the needs of the studio. A good employee puts those needs in front of their desire to show off their technical abilities.

There are a few skills and personality traits which are particularly important to develop if you want to be seen as a reliable worker, and thus get more work. The first is to be a great communicator, which we touched upon on page 70. This could be considered the most important aspect of being a brilliant employee. If you produce excellent art but struggle to take criticism or engage with other members of the team then you are a liability for the company. You do not need to be an extrovert to succeed but being able to reach out for help, engage others when you need something, and offer your voice to conversations is very important.

The second key aspect is that a good employee will strive to meet deadlines. Deadlines and project milestones are there for a reason. If, for whatever reason, you find yourself slipping, make sure your client or superiors are aware immediately. This links back to communication as being open and honest about an issue as soon as you are aware of it can help the project recover quickly.

The third key skill you need to learn is how to manage your time and workload effectively. Spend time planning out how you will approach upcoming work, taking notes of things you might need, organize your references, and try to anticipate what issues might occur in the project. When you are working on multiple pieces, it is often best to bring them all to the same level before seeking feedback. You never know when a client might suddenly need to see all of your concepts, and you are better off giving them five half-finished images that at least contain information than giving them one finished concept.

The fourth trait a good employee has is that they are not afraid of doing some extra work if they have the time. I try to get as invested as possible in the projects I work on, sinking into the world and trying to ensure that I am excited about it. So when I am waiting for feedback or taking a break to sketch I will often draw things from the IP which could be expanded upon later. No employer or art director is ever going to complain about getting some extra work from an artist and it is the sort of gesture which makes you a highly valuable employee.

Paul Scott Canavan | *Triumphant Expanse* | © Paul Scott Canavan

FORMING GOOD HABITS

All creative people work a little differently so good working habits can vary, but if you want to work in a studio you will be required to be creative during specific hours. There are some habits which can help you do this and the most important of these is to get plenty of rest and take care of yourself.

Working as a full-time concept artist can be exhausting. A typical working day could involve multiple meetings to discuss the project, reviews with the lead artist or art director, and producing multiple concepts to varying degrees of quality depending on what is required. That is a lot to process in a day, and it requires a lot of energy. Make sure you take time to exercise, eat well, and get a good night's sleep. The difference this can make to your overall energy levels is amazing.

Another good habit to form is working in stages. Learn to work in batches, and bring each of your concepts to the same level before presenting them for feedback. Do not be precious about your work either: concept artists are not used to create masterpieces. Your job is to produce designs to pass on to the next person in the production pipeline, so

take feedback on board and make adjustments to the work accordingly.

Remember to take breaks when you need to. This applies to working both in-house and remotely. Sometimes you just need to stretch or take a walk. Naturally, some employers will have rules about the quantity and length of breaks you can take, and you certainly should not exploit breaks to avoid doing work, but pay attention to what your body needs.

Again, if you are struggling it is important that you communicate this to your employer. Nobody expects an artist to be constantly switched on and engaged, so find a way to rest efficiently in order to work at full capacity.

If you work remotely, it is a good idea to start your working day early. Pay attention to when you are at your most productive. Some artists work best late at night which is perfectly acceptable for remote work but not particularly useful if you want to work in-house. You may need to find a way to adjust your natural working pattern to suit your career choices. You can learn some more tips on managing your workload with Zac Retz in the next chapter.

ARTIST PROFILE

PAUL SCOTT CANAVAN

Freelance Senior Concept Artist and Illustrator

paulscottcanavan.com

Paul is a BAFTA award-winning concept artist, art director, and illustrator. He has worked in the games industry for over a decade across multiple game titles, films, and books.

Career highlights
- Art Director and Lead Concept Artist at Blazing Griffin
- Illustrator at Brotherwise Games LLC.

How did your career as a concept artist begin?
Since childhood I have been obsessed with video games. I spent hours gazing at artwork, pored over creature designs and environments, and copied them in my sketchbook. My school focused on the arts so I grew up drawing, painting, sculpting, and making music: all influenced by the games I played. I then studied animation at university and there I learned about concept art for the first time. Until then I had not truly realized that it was a career choice, but I was hooked on the idea. I began learning to paint digitally, posted work on websites, watched tutorials, and took workshops whenever I could. After graduating I was contacted by a studio that had seen my work online, and my concept art career began!

Were there aspects of the job that surprised you?
I was surprised by the variety of work concept artists do. I worked freelance for several companies at once on a range of genres and found myself working on a horror film pitch, concepts for children's video games, and screenshot paint-overs for a popular MMO). I realized quickly that a good concept artist has to learn fast and be adaptable. Although it was sometimes a struggle it was a valuable experience.

How do you approach a new work brief?
I am a compulsive researcher and note-taker. When I get a new brief I will usually spend a day going over it, making lists of themes and things to research. I study the source material so that I really understand the world I am working on. I think about how the designs can be grounded in reality, how I can portray this information through compositions or poses, and look at popular culture references to discover what people enjoy about the genre. Thus I learn what I should try to achieve and tropes to avoid. That is a lot to go through, hence all the note-taking!

What is the most challenging area of your work?
Working across multiple projects at once in a lead role is the most challenging aspect of my work. I am a very hands-on director so I like to paint concepts myself as well as oversee the output of the department. This is fine on a single project, but in the past I have juggled three titles at once, managing my own work and that of others. Luckily it is a highly rewarding task and I get a lot out of helping other artists grow. I inevitably learn from them in return.

How have you developed your skills?
I see art as a way to express an idea and I really like to experiment with that. This leads to a lot of skill development as I sample 3D programs, experiment with photobashing, and try out game engines. The more software I learn the more I find new ways to combine them, and that keeps me excited. For one pitch I might paint scenes fairly traditionally, but for another I might block it in using 3D then use Unity or Unreal Engine to show it in motion, and overlay music and sound effects.

MANAGING YOUR WORKLOAD

BY ZAC RETZ

Managing a large workload can be a daunting task and a source of a lot of pressure, especially when you are in your first job. In this chapter you will pick up tips on how to organize your time, tackle stress, and maintain your passion for art outside work.

MANAGE YOUR TIME EFFECTIVELY

There are many ways to ensure you manage your time effectively as a concept artist, and you will need to find the ones that work for you. You may find it useful to set a timer as you work to help you keep track of your time. If you search "timer" online you will find a simple tool to use in your browser. This is very helpful when painting color keys or doing environment concepts. You could try setting the timer for thirty minutes and do one quick sketch painting in that time.

This method is particularly helpful when you are given a new assignment and have to deliver sketches in two days for example. Spend a few hours gathering references and put them on a second monitor. Then, set the timer and do a new color concept painting every thirty minutes. You can then go into the meeting and show multiple paintings with lots of different ideas that the directors can choose from.

It is also important to take breaks throughout the working day to refresh yourself. Some artists will take an hour-long break for lunch at a set time each day whereas others will eat lunch while continuing to work, and then take a break later in the afternoon to go outside and sketch. How you choose to take breaks may depend on the policies of the studio you are working in, but ensuring you do take breaks that work for you will help you to have a productive day and work when you are most focused.

IMPROVE YOUR EFFICIENCY

There are also a number of ways you can develop your efficiency, which will allow you to maximize what you achieve in the time available. As an example, to become efficient at painting, it can be useful regularly make studies from film screenshots or paintings by the art masters. Keep these studies thumbnail-sized and do them in a short period, such as fifteen or thirty minutes. Set a timer and just focus on capturing the shapes, value structure, color, and lighting. Studies like this are great to do in the morning to warm up, during your lunch break, or at the end of the day. They expand your visual library and the more of them you do, the faster you will be able to create compelling concepts. There are some examples of warm-up studies on the right here that you can try.

Another way to be efficient while working is to gather all of your reference images together before you start working. Put all the references you will need on a single canvas in image-editing software and then save it as a JPEG file. You can then keep this single image open as you work and consult it without breaking

WARM-UP ACTIVITIES

GRAYSCALE STUDIES

Painting in grayscale is a great way to practice compositions. Limit yourself to two or three values and only use a hard brush with full opacity. You will be forced to group the value masses and simplify the lighting as a result.

Make studies of the values from paintings or films, by picking a couple of images and giving yourself ten minutes for each. This forces you to observe the general shapes and simplify the lighting. You can also do this outside with pen and ink. It is more challenging but a good exercise in grouping real-world values.

PLEIN AIR PAINTING

Plein air painting is very challenging but also very rewarding. You can choose any medium you want to work in, but I personally like to use acrylic. The important thing is to keep your studies small. I paint at around 3.5 inches × 4 inches.

Go outside and find something you want to make a color sketch of, and spend thirty to sixty minutes working on it. Your goal here is to do a quick painting that captures the lighting of the scene in front of you. Simplify and group the values in your composition, painting only the necessary details to make the lighting believable.

All images © Zac Retz

your concentration by searching for the correct reference.

You could also try keeping your tools to a minimum. By only using a few brushes when painting you will not have to waste time searching for a specific brush. You may find that using too many tools can break your artistic flow.

Keep your digital file layers organized and to a minimum too.

Try to use only a few layers at one time to allow you to paint almost the whole artwork on one layer. Just keep the characters or details separate. This practice means you do not need to repeatedly stop painting to search though your layers.

ORGANIZING YOUR WORK
When deadlines are tight and you are working on multiple things, making sure you organize your work is essential. You may

find it useful to keep a list of the tasks you need to complete next to you on a piece of paper as you work. It is a simple method that allows you to cross tasks off as you progress, which can feel very rewarding! You could try structuring your work by making two lists: one long list for the week which has big goals on it, and a shorter list of individual tasks for the day. Try to write the daily list the night before so that you wake up knowing what you

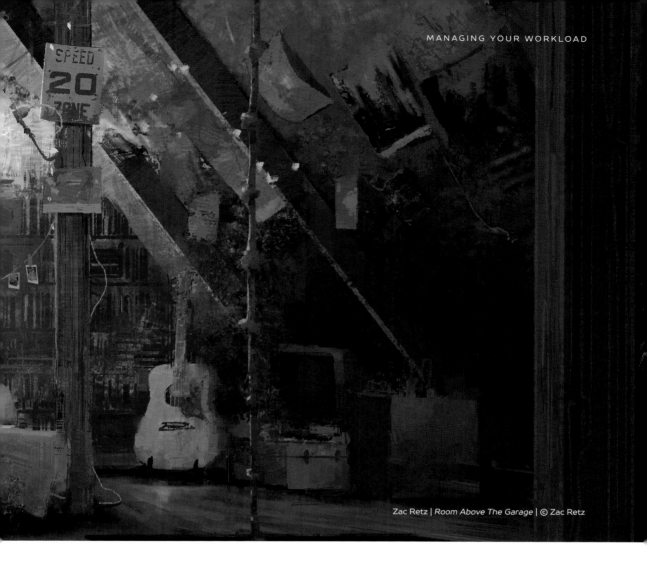

Zac Retz | *Room Above The Garage* | © Zac Retz

will be doing that day. Sometimes a daily list will only be roughly written, but it is an important reminder to keep you focused.

Make sure you keep your workspace clean and tidy. This helps to keep your mind focused on your work and not the mess around you. Try to clear your space and head before you settle down to work. Finish any paperwork you need to, or go through your mail. This will keep you focused on your work and not on the other things you need to do. You will do your best work when all your energy can go entirely towards the artwork you are creating.

COPING WITH STRESSFUL OR PRESSURED PROJECTS

Dealing with stress is hard. It is something that many artists struggle with, especially when just starting out, but there are many ways to deal with it. Again, what works will differ from person to person. Some artists find it useful to get up earlier to spend a few hours working, doing chores and other tasks before going to work in the studio. This means you can come home after work and just relax, make dinner, watch a cartoon, and go to bed. Other artists find it more beneficial to head to the studio earlier and finish earlier in the day. It is important to find a routine that works for you.

It is important to have a **designated time** when you do no work at all so you have time to relax and unwind. Not only is this better for your well-being, it will mean you are more refreshed and productive when you are working.

Quick deadlines on projects can be tough to manage, so one thing to remember when you are feeling stressed is that it is ultimately just a painting. You should, of course, try your hardest to complete the work on time and to a high standard, but there is no need to get too worked-up over painting some cartoons or games!

If you are struggling, remember that your client, in most cases, needs you and your work. Do not let yourself be pressured into impossible deadlines for freelance work. In a studio, your colleagues will always be very understanding of a project's workload so talk to someone about the issue. The important thing is **communication** and keeping everyone necessary up to date.

HOW TO MAINTAIN ENTHUSIASM FOR A PROJECT

Maintaining your initial enthusiasm for a project can be really hard, especially when the project is your full-time job. The best way to deal with this is to make sure your job is not the only art project you are working on. Have another project on the

side where you are in complete creative control.

Most artists have a creative itch that needs to be scratched, but while working on a film or game you are creating the vision of someone else. When you **work on your own project**, however, you get to create your vision which is very satisfying. If you have artistic friends who are also working on their own projects, arrange weekly meetings to help you all stay motivated. This does not have to be limited to artists and physically meeting up; you could do this as weekly video calls with a few other artists and writers to give each other support with your personal projects. You can do whatever you want with your project and the variety will keep you excited about your work project.

THE WORK-LIFE BALANCE

If you are a workaholic, you may find that maintaining a balanced lifestyle is very hard at times. Managing your work and the rest of your life could be something that you need to work on over time. You may find you are working all day, every day, only taking breaks for food and sleep, and spending little time with friends.

Almost every artist will have experienced this kind of lifestyle, for a while at least, until their work is at a high enough level to get a job. It takes a lot of dedication and sacrifice to succeed. The reality

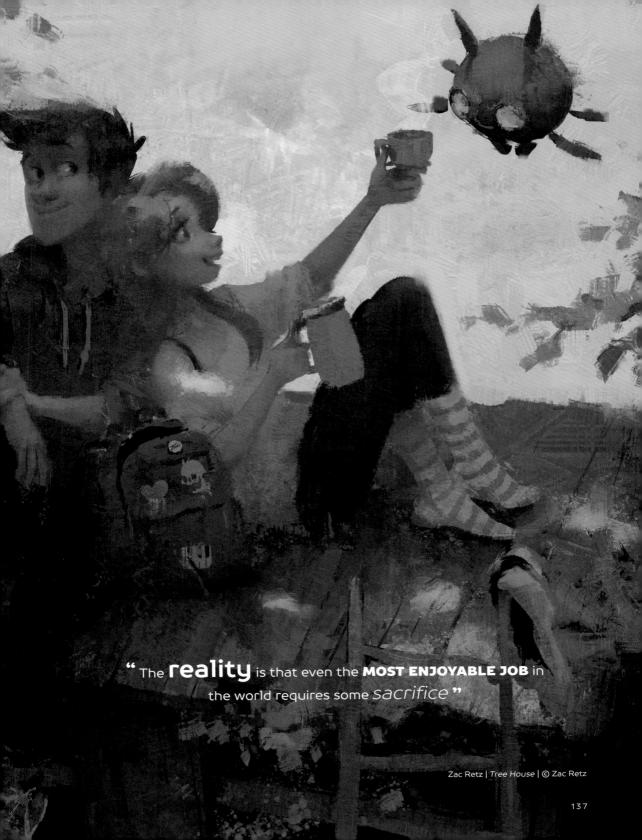

" The **reality** is that even the **MOST ENJOYABLE JOB** in the world requires some *sacrifice* "

Zac Retz | *Tree House* | © Zac Retz

is that even the most enjoyable job in the world requires some sacrifice. Many artists find that once they gain more experience and are in the field they love, they have a more balanced life.

At the same time, taking some time off from your art is an important thing to do to refresh yourself and your work. Try to dedicate at least a couple of hours a day to doing something else you enjoy. Whatever it is you like to do aside from art, try to make some time for it at the end of every day.

ART OUTSIDE WORK

Having a personal project and getting some friends involved can be a great way to enjoy art outside work. However, some people have trouble inventing a project to work on. We all have creative short–comings as artists so if there is something that you are struggling with, you could practice this in your free time instead. This practice may inadvertently turn into a project that you can develop for months or years. Maybe you will eventually be able to turn it into a graphic novel, short film, or picture book.

Many artists who work on personal projects outside work are even better at doing their day job. This is because they are creatively fulfilled and constantly pushing themselves to develop new skills.

Find some artist friends who you can go painting with on the weekends. Getting together with other artists is another good way you can enjoy art, build strong friendships, and maintain a balanced life.

PERSONAL PROJECTS

I started my personal project *Seek* as a way to get into the animation industry and to improve on something I was not very good at. *Seek* became a way for me to practice my visual storytelling as I wanted to get better at painting story moments and color keys, and designing props and characters. Because I was painting things that were of interest to me the story began to develop, and after almost two years of work on it my friends and I are creating an animated CG trailer for the project.

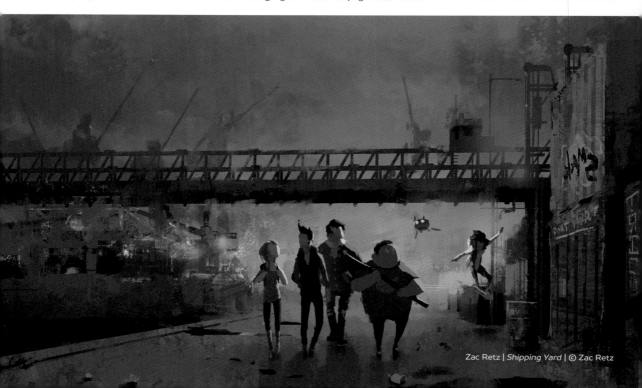

Zac Retz | *Shipping Yard* | © Zac Retz

ARTIST PROFILE

ZAC RETZ
Visual Development Artist
zacretz.com

Zac is originally from upstate New York where he studied illustration at the Rochester Institute of Technology. He works in animation and creates concepts for animated feature films.

Career highlights
- Artist for Workinman Interactive
- Artist for Reel FX
- Visual Development Artist at Sony Pictures Animation
- Artist for DreamWorks TV

What makes a project fun for you?
I really enjoy projects that give me time to research a topic. I have a lot of fun when I can spend a couple of weeks designing a set for a film, exploring the world, and creating art with clear storytelling elements.

What is the most challenging area of your work?
Pre-production is the most challenging part of the process. This is when you produce a lot of quick paintings to explore different options. The look of the film is not decided, so it is up to you to do so. It is a very collaborative process between the artists, production designer, and directors. Your job is to capture the director's vision and sometimes they do not fully know what they want. This can be frustrating but it is also a lot of fun because you are given freedom and time to experiment.

How has your education affected your career?
Post-college, while working at a games studio, I took extra online courses and really developed my skills for the animation industry. I learned from some of the best artists in the industry, and with a lot of hard work I was able to change industry. I continue to take Schoolism (schoolism.com) classes to improve.

How important is networking to finding work?
Networking is very important for a few reasons. There may only be fifteen artists needed for a film but a hundred applying for a job. If you know someone at the studio who can recommend you, it will help you get noticed. It is also very hard to get work without an online presence. Studio artists, over time, will become familiar with your artwork and recommend you when there is an opening at their studio.

Forming good relationships with other artists proves you are friendly and can work in a team too. One abrasive person in the studio can create an unpleasant environment.

What advice would you give about making big career decisions?
Making big choices can be hard. When I realized working in games was not for me, I had to quit my job and sacrificed a steady income to focus on redirecting my portfolio. Fortunately it worked out for me and I enjoy it more than I ever dreamed I would.

If you are unclear on your future: close your eyes and picture yourself ten years from now. What kind of job do you see yourself in? What kind of art do you make? Form an image in your head of what you want then direct your learning and experience towards that goal. If you do not have a clear image in mind then just allow your career to form organically. You can learn a lot from any experience, so make sure you make the most out of anything you do.

CRITIQUING AND IMPROVING YOUR WORK

BY GLENN PORTER

Giving critiques and accepting constructive criticism are skills that must be practiced just like any other aspect of your craft. They are vital to your growth as an artist and as a professional. In a work setting where you might be taking direction from an art director or creative director, being responsive to criticism is imperative to you succeeding at your job.

THE IMPORTANCE OF CRITIQUING YOUR OWN WORK

You may find that you experience about twenty minutes of euphoria when you complete a new piece. Initially, it will seem like the best artwork you have done to date and you may feel proud of the improvement in your skills. All the hard work is starting to pay off.

Then, however, the shine wears off and you start to notice the flaws in your piece. Suddenly you are looking at your beautiful new work and it is full of problems that you did not see before.

This moment is an opportunity for you to grow as an artist. You could allow your own critique to defeat you by going into a negative slump and telling yourself you will never improve; or you can take comfort in the fact that you will never be perfect, and see your mistakes as a challenge.

The problems that you notice in your own art are precious gifts. They are obvious signs to help you direct your practice. You are your own best critic because you already know where you have struggled or cut corners when you were working on it. If you show your work to others they will also point out things that you may not have noticed, which offers another great opportunity to grow.

HOW TO EVALUATE YOUR OWN WORK

In the process of creating your work, you will gain immediate insights into what you find most challenging. Whether this occurs as you are trying to fix a pose

that is just not working, trying to draw accurate perspective on a cityscape, or getting light to fall as you wish on a portrait subject; you will know where you generally run into difficulty.

This difficulty is your starting point. Listen to that internal voice saying "this is not correct" and take a hard look at what is wrong with those areas. From that point you will usually find other problem areas. The trick is to look critically at your work without unraveling and scrapping the piece entirely.

Once you have an idea of where your problem areas are, take a look at what is working in your piece. There are always plenty of elements that are good. What did you do well? What decisions did you make that worked out surprisingly well and what made you excited along the way?

Once you have a clear understanding of what is successful about your piece and what is not, pick one aspect from each area to

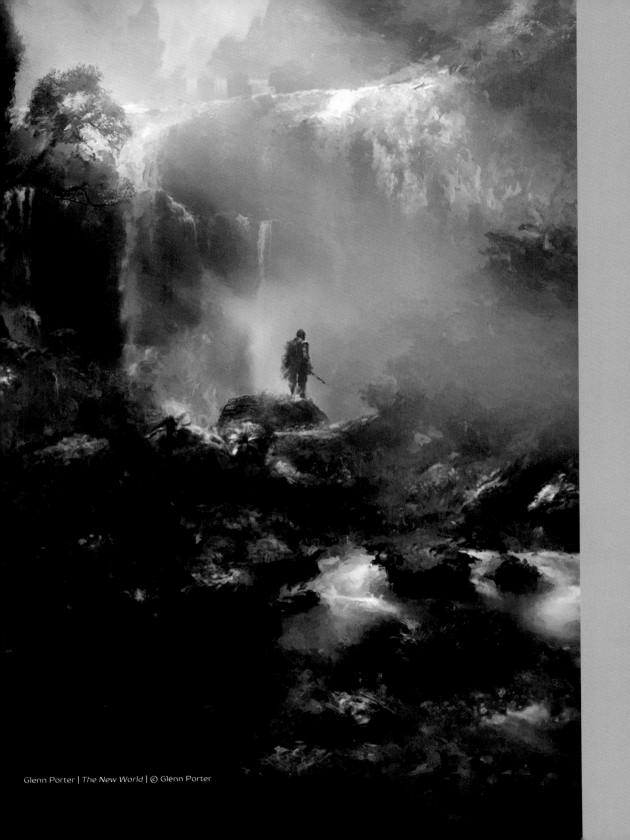

Glenn Porter | *The New World* | © Glenn Porter

focus on. Look for ways you can improve at something you are already good at, and practice determinedly something that you know needs more work.

For example if you have trouble drawing noses, spend an hour drawing hundreds of noses so that you are more familiar with the shapes. Then compare the final nose you drew to the first nose and see how much better it is. Once you have worked diligently on each aspect that needs improvement, pick another, and then another.

ASKING FOR, AND RECEIVING, CRITICISM FROM OTHERS

For the most part, artists tend to be more than happy to provide critiques of other artists' work. Giving feedback on someone else's work is a useful way of seeing where their own problem areas are, plus you get an uplifting feeling when supporting the art community by providing others with a constructive point of view. To encourage some feedback, put your work online on art portfolio sites or social media and ask for a critique. If you do not pointedly ask for a critique on your work then people will often be afraid to speak their mind for fear of offending you.

Another great way to get thoughtful, professional critiques is to seek out artists you admire and politely ask them if they would mind giving you a few pointers. The worst you will get in response is "no."

Alternatively, you may get some valuable, personalized advice that will stay with you for the rest of your career.

Art and animation conventions are excellent places to approach other artists for critiques. Professional concept artists come to these events often for the express purpose of teaching and fostering new talent. They want to see what you have to offer, so show them!

However, it is useful to remember that not all critiques are valuable. Ask yourself honestly if the criticism resonates with you. It can be fairly obvious when someone's criticism is not fair or well reasoned. If a critique falls into either category or it just does not have any real basis in your work, thank the critic for their opinion and move on.

FINDING WAYS TO IMPROVE

Aside from the tried and tested method of repeated practice, working outside your comfort zone is a great way to improve your work. If you are having trouble with drawing anatomy, take a few sculpting lessons instead. Getting a tactile feel for the proportions and structure of the human form brings tremendous insight which you can apply to your drawing. Having trouble with rendering lighting? Experiment with a 3D lighting program. How does your understanding of lighting change when you have control over every aspect of it in software?

Above all, do not look at these learning experiences as work. This is a chance for you to play and it should be fun. Even if you are being paid by a client, you can still think of this process in a positive way as a chance to grow. Improvements in your art will not come by being hard on yourself or adding unnecessary pressure. Improvement comes while you are engaged in what you are doing and exploring new things.

If you turn overleaf you will see some examples of critiquing being used to develop artwork.

CONCENTRATE ON INTERESTING IDEAS
by Cristina Lavina Ferez
The most important advice you can get is to work hard. Try to create variety in your work, challenge yourself to do new things, and push yourself out of your comfort zone to cultivate your ideas.

As a character concept artist, the idea behind a design is much more significant to me than the render. Seeing a beautiful render is great, but if the idea behind it is bland and unoriginal it will be easy to forget. Technique is a vehicle to express your ideas better, but it is never the final goal.

ARTIST PROFILE

GLENN PORTER

Art Director

gporterdesign.com

Glenn began his career as a rotoscoping artist before moving into concept art, matte painting, visual development, and art direction.

Career highlights
• Art Director at Glenn Porter Design
• VFX Artist at I. E. Effects
• Graphic Designer at Artmachine
• Animator and Concept Artist at Mousetrappe
• Freelance Artist for The Walt Disney Company
• Motion Graphic Artist at PETROL Advertising
• Art Director at Lindeman & Associates

What aspects of your job do you love?
Storytelling is really at the heart of everything I do. Being in a profession where my role is to tell the most compelling story possible is such a wonderful opportunity. I cannot think of another job where you can share an emotional response with such a wide audience through your work.

How has your education affected your career development so far?
My formal college education is a tiny fraction of my ongoing education in art. I think of education as a lifelong quest. As an art director I learn every day from the artists I work with. I hope to teach them a few things too but I feel that I learn more from them by far. I believe that being open to criticism and thoughtful comments on your work is a defining factor in how your career develops.

How do you promote your artworks?
I mainly promote my work through social media. I feel that if you are doing work that you find interesting and engaging, there will be an audience for it. Just put your work out there and you will find people who share your enthusiasm. I have yet to take up a booth at a convention although I hope to start selling my work and promoting my art across California in the coming years.

Where do you look for support when work gets tough?
I very much look to my family to provide some much-needed perspective. Being in tough spots at work is always an opportunity to grow but it is never a life-or-death matter. My family is the most important thing to me and work is always secondary to them. When work gets tough, or I get too weighed-down by the minutiae of a job, my family always show me what is most important.

What advice would you give to someone who is struggling to launch their career as an artist?
Your individual voice is a foundation to build your skills upon, and the unique way you tell stories cannot be faked. I would suggest that in the early days of your development you focus on portraying that originality.

By fostering your own creative voice and diligently promoting yourself, you will find a launching point for a career. It takes patience and a lot of practice to do this, and it also takes a lot of thoughtful acceptance of critique. Use critiques as a way to make your skills better but do not sacrifice what makes your work uniquely you.

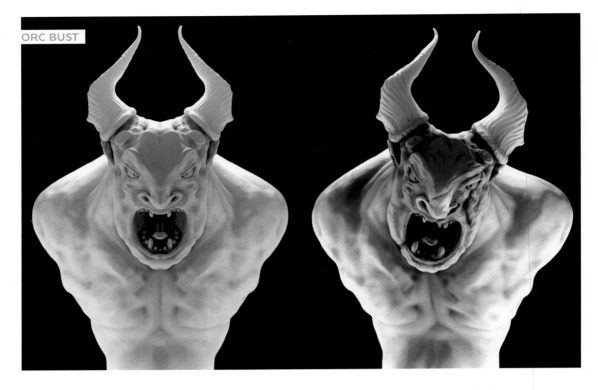

ORC BUST

ORC BUST

I experiment with digital sculpting on personal projects. For the orc bust above I begin by blocking rough shapes in ZBrush with Symmetry switched on. I am not a ZBrush expert by any means but I am comfortable using it. As I review the sculpt I realize some of the muscle structure looks odd. It is also too symmetrical, which is a problem because it can make a concept appear boring; asymmetry makes a character interesting.

I therefore attempt to make the sculpture more interesting by breaking the existing symmetry. I also check the sculpt conveys a backstory in order to add interest. What has the character been

through before this? I imagine he has seen quite a few battles, so I add scars and wear and tear to the skins surface. Stepping back, I also change the posture to make the character appear more threatening.

CERNUNNOS

Cernunnos is a Celtic god, known as "the horned god," who takes the shape of a deer-like creature. My goal in the image at the top of the next page is to capture an epic forest scene featuring a large deer with appropriately impressive antlers. I complete a rough value sketch which is the end result of fifteen or so even rougher thumbnails. Reviewing the image I feel I need to

clarify the feeling of mystery and emphasize the motion of the waterfalls.

I therefore begin working with bright greens and warm sunny tones to capture a mystical forest on a hazy day. I want everything to appear atmospheric and golden. Light should bloom and glow off certain surfaces. I also give the impression of time-lapse photography in the waterfalls by giving them a soft and velvety texture.

THE FIRST CORONATION

The image on the right is a large-scale coronation scene from the perspective of someone in the crowd. I focus on the light and dark value blocking of major

CERNUNNOS

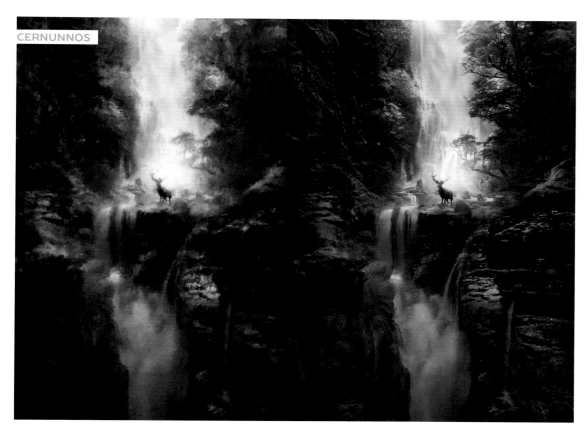

shapes. I decide to add to the story element by making the focus of the piece the excitement of the small child on a parent's shoulders. I also decide this excitement should be reflected across the scene.

To emphasize the feeling of excitement I add bright colors and the dramatic lighting of a beautiful sunny day. I keep the contrast between the light and dark values and also in the color tones so that the viewer's eye will keep moving around the image.

All images © Glenn Porter

THE FIRST CORONATION

ETHICS AND COPYRIGHTS

When producing work for yourself or an employer there are important legal and ethical considerations to keep in mind. Laws vary internationally, so you should research how your country's laws may affect your career. Here you will find a brief introduction to the most common issues a concept artist may encounter.

WHAT IS A COPYRIGHT?

A copyright is the legal recognition of the creator of a piece of work. The copyright holder controls how a work can be used. Copyright laws vary from country to country, but in general, if you create an artwork using your own ideas, you automatically obtain the copyright. In most cases copyrights are subject to the laws of the country the work was created in, or the governing law noted in a commercial contract.

COPYRIGHTS ON ARTWORKS PRODUCED FOR STUDIOS

When you produce work for an employer you usually work to a brief and art style provided by your employer, and therefore the work you create is frequently the copyright of your employer. This will often be outlined in your contract and is normal in creative industries. You cannot use or share work you have created for the studio without their permission.

COPYRIGHTS ON FREELANCE ARTWORK

As with studio work, the work you produce for a client as a freelance artist is often the copyright of the client. However, it may be possible to negotiate this with the client before you start work. If a client holds the full rights to your work they control how the artwork is used, and when and where it can be shown. You cannot re-sell or reuse work you do not hold the copyright for, and you may be restricted from including it in your portfolio. Therefore it is very important to establish in a freelance contract who holds the copyrights to any freelance work and rules about sharing that art in the future.

REFERENCES AND TEXTURES

If you use photographs and textures in your work you should be conscious of where they are from and who they belong to. Never assume that you can use an image just because it can be found online. Even on dedicated reference sites there may be restrictions on how resources can be used or altered, so you should always read the terms and conditions before using a resource. As a general guide, if an image or texture is verified by a reliable source such as textures.com, Adobe Stock, or shutterstock.com and has a CCO (Creative Commons zero) license, the image has been released into the public domain and can be used for commercial projects. Licenses can vary across these sources however so make sure you check the licensing information before you use any image.

THE ETHICS OF FAN ART

Although it is enjoyable to recreate scenes and characters from your favorite games and films, it is important to

remember that when you create fan art these concepts are the intellectual property of someone else. You should not create fan art in a professional or commercial capacity as selling work based on someone else's concept without their consent is illegal.

ART THEFT

Art theft is when an image is copied, or closely replicated, and presented as the property of someone else. For example an image that is copied and posted online as the artwork of someone else, or a recreation of a character used commercially without the consent of the copyright holder. In some cases, the person who has stolen the work may be a fan, and unaware that they have done anything wrong. It is also worth noting that if an artist has a very similar style to another, that this is not art theft.

WHAT TO DO IF SOMEONE STEALS YOUR WORK

If your work is being used by someone else without your knowledge or consent, your first route of action should be to contact the person involved. Politely but firmly inform them that you are the copyright holder and request that they remove your work from their site or product. Regardless of how frustrating you find the experience, you should never use threatening language. Often the person involved will have been unfamiliar with copyright laws and simply acted in error, so the issue will be quickly resolved.

If a person refuses to remove it from a website or social media account you can often report them to the site's moderators. This will usually result in their account being disabled and your work being removed. Occasionally, a stolen artwork may be used on a commercial product and polite communication will not remedy the issue. In this case you may need to pursue legal action.

You should always endeavor to remain calm and professional while protecting your work. Although it may be tempting to express your anger directly at the culprit, this course of action can often damage your reputation too by making you appear aggressive or volatile to potential employers.

ABIDING BY NDAS

Studios commonly use non-disclosure agreements to stop project information or images being leaked before the official release date. NDAs are legally binding agreements and breaching the terms of an NDA could result in the studio taking legal action against you. Therefore, it is vitally important that you read and understand the terms of an NDA before you sign it. You should ask the studio to clarify anything you do not understand. Most NDAs will state a date or period when you will be allowed to show project images. Until this time, you should not include any imagery from the project in your portfolio, website, or on social media.

UPHOLDING YOUR CONTRACT

When you do any professional work you should expect to sign a contract. The agreement should be signed by both you and the employer and specify what the work is, the deadline, and how much you will be paid. You should read the contract carefully before you agree to it. If there is anything you do not understand or are not willing to do you should notify the employer.

Once a contract is signed, you and the employer are legally bound to its terms. If one side breaks the agreement, the other may choose to take legal action. In a studio, the HR department will be able to help you navigate contractual issues. If you are a freelance artist however, you may need to seek the advice of an independent advisor.

THE OBLIGATIONS OF FREELANCE ARTISTS

As freelance artists are self-employed workers they are responsible for tax contributions on their work. Taxes differ internationally so you should research what the implications are for self-employed workers in your country before you pursue a freelance career.

Think carefully about the methods clients will use to pay you. Many banks and payment processors such as PayPal charge a fee to process payments. Consider these charges before agreeing a fee for your work.

ADAPTING STYLE

BY JUAN PABLO ROLDAN

While discovering your own style is important, understanding the style of others will allow you to be versatile and adapt where required, which is essential if you want to work in the industry. For example if you are a freelance concept artist working on both realistic and cartoon animation projects at the same time, the style you need to achieve in your concepts will differ. Being able to work to other people's styles and art direction is therefore necessary.

ADAPTING YOUR STYLE FOR DIFFERENT PROJECTS

One of the things that can be incredibly enjoyable about working as a freelance artist is that you have the opportunity to work with different studios and thus get to experience different art direction, styles, and genres. Having the opportunity to do this is often a result of having a versatile portfolio. The most exciting part of working like this is that every time a studio hires you, it is a completely new challenge.

You will need to use all your existing skills and learn some new processes to solve design objectives and to achieve the successful result you have been hired for.

Learning to adapt style is similar to learning your own style. Research and produce studies of the types of work you are aiming towards. Break images down and analyze them to understand how to achieve a specific look. Never copy an image by another artist, but instead make something that is similar under your own direction. Your intention should be to understand how the studio's artists solve design problems.

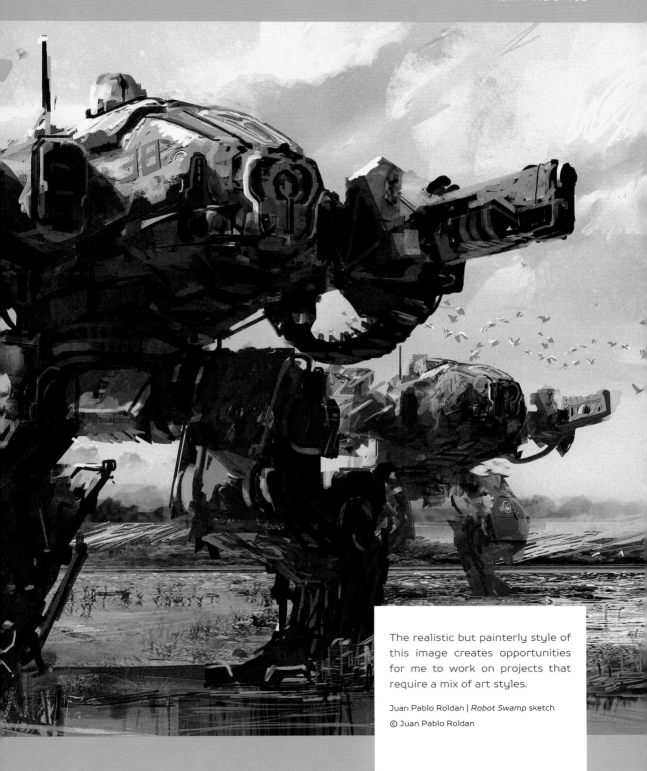

The realistic but painterly style of this image creates opportunities for me to work on projects that require a mix of art styles.

Juan Pablo Roldan | *Robot Swamp* sketch
© Juan Pablo Roldan

WORKING WITH OTHERS AND BLENDING YOUR STYLES

This issue applies mostly to people who work full-time in a studio. Sometimes the art director will start a new image, then delegate it to an artist to continue the process. Finally it comes back to the art director to be completed. This is due to the extreme amount of work involved and the tight project deadlines which are very common in the concept art industries.

At the beginning of a collaboration it can seem a little bit complicated and difficult to manage the collusion of personal styles. However, the good news is that when this occurs there is usually strong art direction, which means you will have more information to base your work around. You will also find that the skills of the different artists involved are often similar. The most important thing to keep in mind is to communicate with each other and maintain a strong sense of teamwork. You do not need to compete with anyone, and it is best to avoid giving unnecessarily destructive criticism to your fellow artists. Your working relationship will be affected as a result and it will reflect badly on you. You should analyze the brief deeply as a group to understand what the art director wants, and set clear tasks to achieve the best result together.

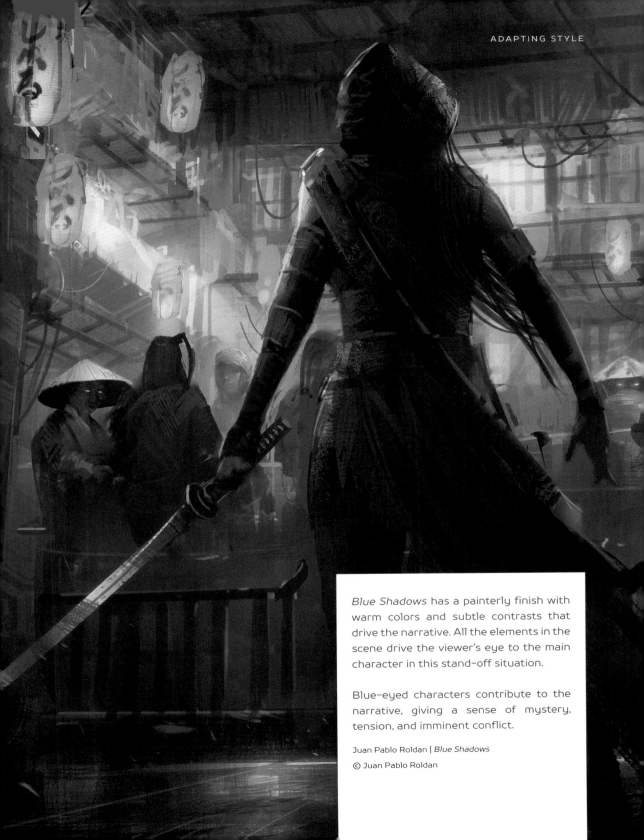

Blue Shadows has a painterly finish with warm colors and subtle contrasts that drive the narrative. All the elements in the scene drive the viewer's eye to the main character in this stand-off situation.

Blue-eyed characters contribute to the narrative, giving a sense of mystery, tension, and imminent conflict.

Juan Pablo Roldan | *Blue Shadows*

© Juan Pablo Roldan

CAREER PROFILE: KAMILA SZUTENBERG

KAMILA SZUTENBERG
Freelance Concept Artist
artstation.com/artist/karamissa

Kamila is a freelance concept artist and illustrator from Poland, living and working in Germany. She has worked on video games, trading card games, and films.

CAREER HIGHLIGHTS
- Freelance Illustrator at Slitherine Software UK Ltd.
- Freelance Senior Concept Artist at Fantastic, yes
- Freelance Concept Artist at Wonderment Games
- Freelance Illustrator at Fantasy Flight Games
- Freelance Illustrator at Cryptozoic Entertainment

BECOMING A CONCEPT ARTIST
The decision to become a concept artist matured in me for a very long time. I have always liked drawing, but a few years back I discovered Feng Zhu's training videos and with them, the magical world of concept art. The tutorials inspired me to paint digitally and post my work online. After some time interest in my work started to appear and I began to get commissions. Slowly my hobby became full-time work.

EDUCATION
As a child, I took private drawing lessons and I initially wanted to study computer graphics. For various reasons however this plan did not work out and I switched to information technology instead. As a result I do not have a traditional art education that is relevant to my work as a concept artist.

It is only recently that I have started to take different online courses and watch a lot of art video tutorials. This more informal type of education can have a significant impact on your work.

INITIAL EXPERIENCE
My first job was creating art for a board game called *Quodd Heroes*. My role involved designing many different props and characters, and I also had to paint large amounts of marketing illustrations to promote the board game.

ATTRACTING EMPLOYERS
When I first started I tried to get my work seen by posting a lot of my personal artworks online. Set yourself a target to find new contacts on LinkedIn and other social media sites. In addition to this, send emails to present your skills and services to potential employers.

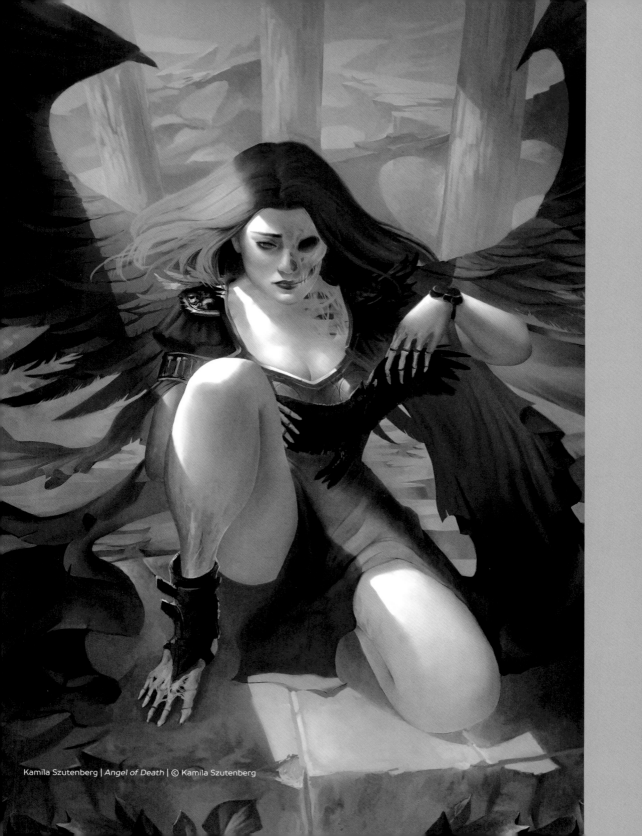

Kamila Szutenberg | *Angel of Death* | © Kamila Szutenberg

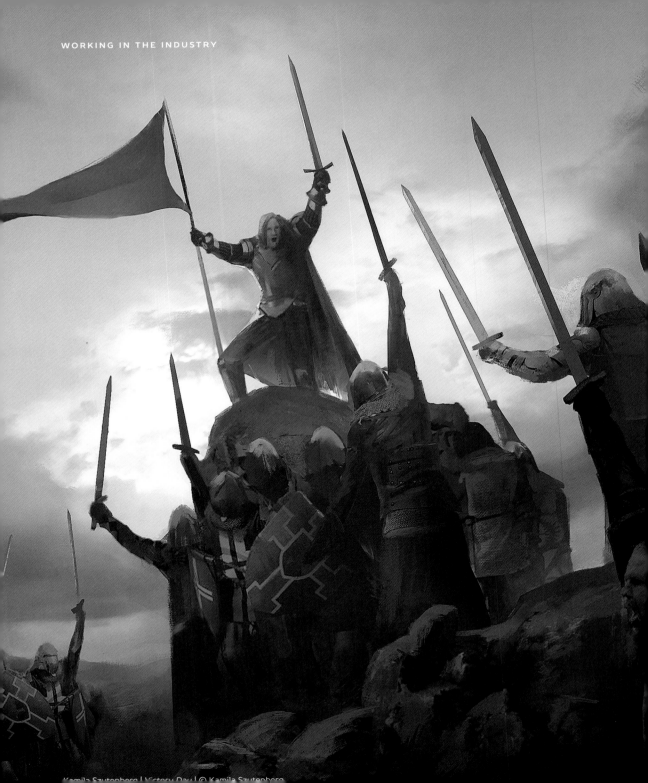

Kamila Szutenberg | Victory Day | © Kamila Szutenberg

INDUSTRY EVENTS

I go to the Promised Land art festival in Poland, because it helps me to get to know a lot of new people and also find jobs. Events like gamescom in Cologne are also good to attend. Aside from the exciting entertainment you can see at these events, you also get to know the industry trends. Always take a printed portfolio and business cards with you to show people.

FAN SUPPORT

I find that fans are a great motivation for me to work on additional personal projects and try different challenges. Having online support encourages you to persevere with your art, as there is a pressure to not disappoint people.

PERSONAL PROJECTS

I like to work on my personal artworks over the weekends so I try to do all my commercial work, and other commitments like shopping or paying bills, during the week. This gives me at least one quiet day a week for my personal projects.

PREPARATION

I recommend that you familiarize yourself with the production process of a concept artist, as the many polished final artworks that you see on the internet do not give a clear representation of the work involved. There are many iterations and quick sketches needed in a professional working environment, so you should try to get used to doing multiple versions of one concept.

Additionally, I encourage you to consistently try to get as many portfolio reviews as possible from people working in the industry. Find a common thread in their feedback and follow their advice in order to improve.

CRITICISM

Avoid taking criticism of your work as a direct or personal attack. Instead, you should try to build an emotional distance from your work. It is okay to be proud of the work you do, but over time each of us learns new things, and when you look back you will be able to see clearly where you made mistakes.

A DAY IN THE LIFE...

SNOOZE!!

SNOOZE!!

9:00 AM

I log onto Skype and discuss the day's work plan with an art director, usually getting my brief for the whole day. Depending on the complexity of the project, I plan ahead the amount of time I need to spend looking up references, sketching, and the final rendering.

6:00 AM

The alarm clock rings. I look at my emails, and if there is nothing important, I press snooze. If there are important messages I get up, drink coffee, and eat breakfast while answering them. Many of my clients are in a different time zone to me so there is a chance I may be able to reach them.

10:30 AM

This is a good time for a second breakfast and coffee! At this point, I have found all the references I need and I have a general idea of what direction my designs will go in. While I eat, I wonder if I can improve or speed up my workflow, by creating a quick 3D model for example, before I start to draw.

10:45 AM

This is my most creative time, when I must not be disturbed. I sketch, design, and cut myself off from the world. I do not even pick up the phone, so that I am not interrupted from the creative flow.

1:00 PM

I take a step back from my work and reset my mind. I have a lunch break and spend time with my family; I make plans for the day, or just watch an episode of a TV show.

DO NOT BE AFRAID

Treat your commissions responsibly, but remember that in the end this is a great job. You draw imaginative things for which people pay you money. Although you should always aim to do your best work, the world is not going to end if you fail. So do not be afraid of failure, and do not allow yourself to be distracted.

5:30 PM

My third coffee of the day. I finish work and hit the gym. I love physical activity at this hour; it is a good break for the eyes and hands, which are already a little tired. It also allows me to relax and calm my mind. After one and a half hours I return home, and shower, and this is the end of my day.

2:00 PM

Totally refreshed I go back to work. I look at my designs again, choose the best options, and continue to develop them. I try to finish everything by about 5:30 pm and send the concepts to the client so they have a chance to look at it before the end of the day and give me feedback for tomorrow.

7:00 PM

Just kidding! Often I still have some other commissions, usually illustrations, which I can work on over a longer period of time so evenings are a good time to get those done. If I have no further work at this time I spend the evening with my family, learn about new software, or watch some tutorials.

NEVER STOP LEARNING

You should never stop trying to learn new things as it is easy to get left behind. Watch and try to understand the world around you, think about how things function, and why they look the way they do. Go outside and observe your surroundings through the eyes of an artist and work on building your visual library.

8:00 PM

While working, I talk online with friends or on the phone with family. For this late hour I usually leave myself work that does not require deep concentration.

9:30 PM

Finally I finish my work for the day, log out of Skype, and close my laptop. I prepare things for the next day, relax, and watch something before going to sleep at around 11:00 pm.

FUTURE OPTIONS

Throughout this book you will have found personal accounts from professional concept artists, and therefore you will be aware that becoming a professional concept artist is not the end of the career path. Many artists choose to take on freelance work in addition to their studio work, and some even freelance full-time when they have enough experience. In this section you will learn about what is involved in freelancing as an artist, as well as some of the popular ways concept artists supplement their income, and create commercial products.

FREELANCING

BY BOBBY REBHOLZ

Once you have settled into your new career as a professional concept artist you may want to find other ways to supplement your income and gain more experience. Taking on freelance commissions is a great way to achieve that. In this chapter you will learn how to get freelance work and the important things you should consider before choosing this path.

FINDING FREELANCE WORK

As with getting your work noticed by studios, there is one major element to winning freelance work: put your artwork where potential clients can see it. Posting your work on the internet is the easiest way to do this but it can be terrifying to invite criticism. That fear is something that you will have to put aside and become accustomed to over time.

How to market yourself to your clients is unfortunately not widely taught, but it is important to understand that you have to make opportunities for yourself.

If you want to attract freelance work it is essential that you have an online presence such as a portfolio website (refer back to pages 94–105), and be an active member in art forums. Keep your online platforms regularly updated to grab the attention of potential clients.

However, getting your work seen does not have to take place exclusively online. You can also take your portfolio to conventions and gain new clients through face-to-face meetings. Additionally, it is useful to think about the little things such as having professional-looking business cards to hand out at events.

To gain new clients, you must be willing to be proactive about publicizing yourself and your work. Finding freelance work can sometimes be as simple as contacting a company and politely asking if they need help with any art they need producing as their deadline approaches.

MANAGING YOUR TIME

One of the many wonderful things about being a freelance artist is that you can come and go as you please. This means that if you need to just stop drawing and go outside, you can do that. You also have control over which days you work and can take days off when you want, as long as you are confident you will get your work completed by the project deadline.

Deadlines are extremely important in the freelance world because submitting a project late may mean your

TAX RESPONSIBILITIES

Be aware that when you are freelance, self-employed, or bringing in revenue yourself, you are subject to certain tax responsibilities. Make sure you are familiar with and follow the laws of your country when taking income.

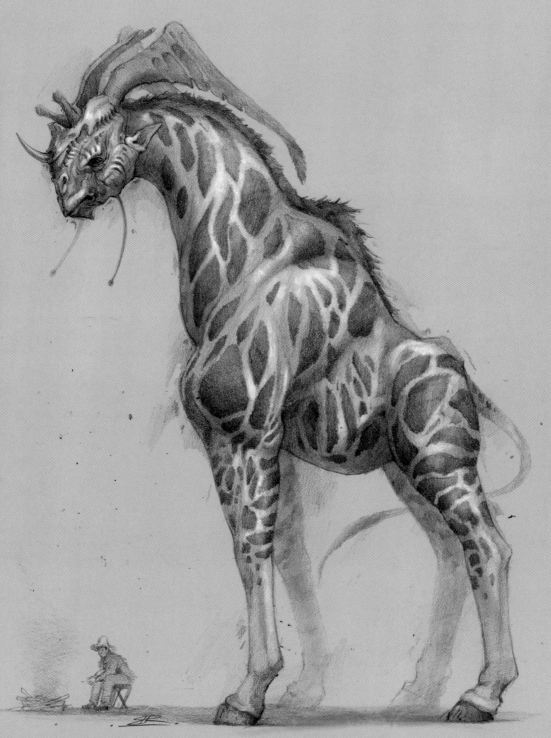

Bobby Rebholz | *The Bahmbar* | © Bobby Rebholz

work cannot be used for the purpose it was commissioned (in which case you may not be paid). A missed deadline can damage your relationship with the client, which in turn will limit the possibility of repeat commissions. Time management is therefore paramount.

You have to treat freelancing as you would a permanent studio job. Even though your office is at home and you dictate the working hours, you should still treat your freelance working time as seriously as you would if you were working in a studio.

You need to act in a professional manner towards your clients and remember that you are working for a paying studio or customer. This is especially true when your client list grows and you have several deadlines looming. By structuring your day in a similar way as you would working in a studio, you can enjoy spending time with your family, going to the gym and having a nice dinner at the end of the day.

OPTIMIZING YOUR APPEAL

Developing your own personal project is an excellent way to build-up your portfolio, learn new skills, and demonstrate to potential clients what you can offer them. If you are looking for work, you have to be able to prove that you can handle different projects. If you can also show that you can competently use multiple disciplines within a project, your chances of being hired will be even greater.

For instance, if you can skillfully paint vehicles but also sketch props and environments, you should include all of these in your personal project to show your versatility. Try to think of projects that will enhance your portfolio. These projects do not have to be complex; you could develop a simple project and add some narrative to link the different artworks. Many artists then also use these personal projects for additional income through crowd-funding, which we will talk about in the next chapter.

DRAWBACKS OF FREELANCING

While freelancing does offer you more flexibility in terms of holiday and the freedom to develop your own client list, there are a few negative points you need to think about. First, when you are self-employed you do not receive sick or vacation pay as you would if you were an employee of a studio. Second, while you may build up your reputation as a reliable concept artist that studios wish to work with, there can be periods without work and regular income is not guaranteed.

Finally, working on your own all day can be difficult at times. While you may have contact over emails and the phone, your face-to-face interaction with people can often be minimal. If you are someone who enjoys the buzz of working in a busy environment in a team of people, freelancing may not be the best option for you. You must give serious consideration to each of these factors and ensure that you have a contingency plan should freelancing not work out for you.

ARTIST PROFILE

BOBBY REBHOLZ
Instructor and Concept Artist
bobbyrebholz.artstation.com

Bobby Rebholz is an instructor and concept artist for the entertainment industry. He specializes in creature design and teaches master classes at CG Master Academy.

Career highlights
• Master Class Instructor at CG Master Academy
• Concept Artist at Mission Control Media Inc.
• Drawing Instructor at the University of Cincinnati
• Concept Artist at Subterranean Games

How do you stay focused when you are very busy?
I like to jump around from project to project which is how I have always kept my focus. A lot of people cannot do that but if I just turn on some house music and draw, I am in heaven.

What have you found to be the most effective means of promoting your work?
Posting on social media is definitely the most effective way to show your work. Places like ArtStation are also great because of the big industry professionals that frequent the site.

What advice can you give prospective students when selecting a school or training institution?
It is best to figure out the exact area you want to be trained in. For instance, students might choose FZD School of Design for broad training in the full spectrum of the entertainment design process. Or, they might pick online schools such as The Oatley Academy, CG Master Academy, or Schoolism for training in specific areas such as animation, figure drawing, and digital painting techniques.

What has been the "big break" of your career?
For me, the "big break" is not one single event that has happened but a combination of things. Being a part of *War for the Overworld* was huge because that was the first real game I got to make concepts for. Sketching for *Face Off* was fun because my work was on television, but I think teaching for CG Master Academy has solidified me as a creature designer. Once I started seeing people spending their hard-earned money on my class at a reputable place like CG Master Academy, it was both humbling and exciting.

What do you hope to achieve in your career in the coming years?
My current goal is to work in-house as a Senior Concept Artist. I have taken a bit of a backward approach because most designers start in-house and then later move to freelance. Instead I have taken the opposite approach.

CROWD-FUNDING AND SELLING PRODUCTS

BY BOBBY REBHOLZ

Creating your own products to sell is another way you can supplement your income. In this chapter you will learn how to crowd-fund your own projects and sell digital and physical products based on your artwork.

CROWD-FUNDING PROJECTS

You may eventually want to turn your personal project into a physical, saleable product and to do this many artists consider crowd-funding. Kickstarter and Indiegogo are two of the most popular crowd-funding platforms for artists. Both platforms allow you to propose a project through a video and campaign page to an audience willing to invest in it. In return you offer investors, known as "backers," special rewards as thanks for their support.

Running a crowd-funding project is a huge task that teaches you a great deal about marketing, social media, and project planning. The first thing you need is a definitive plan of action. Take your time to make sure your campaign is carefully thought out. You should especially consider the title of the project, the amount of money you need to raise to fund its production, and the options backers can choose as rewards. Put effort into making sure each reward offers the backers something different and research other successful campaigns so you can see how they have produced similar products and at what price.

Once you have a plan, inform your friends, family, and followers on social media about the project months ahead of the campaign launch. This step is frequently ignored and without it campaigns often fail. You must let people know about your campaign in advance so that they can prepare to help you with funding when the time comes.

Unfortunately, people new to crowd-funding sometimes view it as a means of making a lot of money without committing to making a product. This is a very bad way of going about a crowd-funding campaign. Nothing will hurt your reputation more than successfully funding a campaign but then failing to deliver the product. Make sure you come up with a financial goal that makes sense for the production costs of the project and takes into consideration things like overseas shipping, the materials needed to make your product, and offers you some flexibility for any unforeseen costs.

It is also very important that you create an attractive and professional-looking campaign page, which will reassure backers that you have the ability to produce a quality product. Why should backers pledge their hard-earned money to a campaign that looks half finished? Think carefully about how you present your product and yourself through the campaign page, video, and images. If you put time and effort into the look of your page, this will show backers your passion for the project. When backers see that you are serious about your project, the chances of it funding are increased

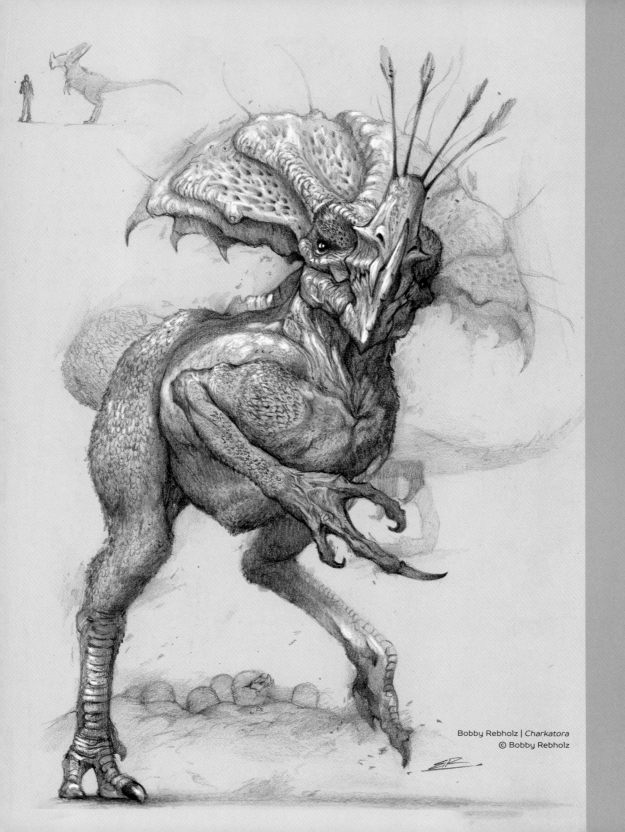

Bobby Rebholz | *Charkatora*
© Bobby Rebholz

exponentially. You want to excite them, entice them, and convince them that you will deliver a quality product.

When you have everything in place you can finally hit the launch button. Running a crowd-funding campaign is both nerve wrecking and fun. You will become obsessed with the project and its progress for the duration of the live campaign. Make sure you keep in contact with the backers, updating them as the project advances so they are reassured of your ability to produce their backer rewards.

Almost all Kickstarter campaigns experience some delay in delivering their products. It is an almost inevitable part of creating a commercial product that there are unexpected disruptions, and backers generally understand this as long as you keep them informed.

This care towards your backers will go a long way to helping you succeed, and if you decide to run another campaign in the future, you will have a group of backers who already trust your commitment.

CREATING AN ONLINE SHOP
As mentioned on page 94, when it comes to creating your own website, there are support sites you can use that offer an ecommerce option that can be added to your site. If you have the potential to set this up, it can offer an additional stream

of revenue as well as please any fans you have who might want to buy some of your work. Many professional artists like to create an extra source of income by selling products featuring their work, such as prints, art books, sketches, and even original artworks. One of the most effective ways to sell these sorts of products is through your own online shop, where you have full control of the products on offer and how they are presented.

Running an online shop can be fun but it can also be difficult. You never quite know who is going to find your shop and potentially buy from you so you should put a lot of effort into making sure the products you are selling are professionally made and presented. Do not rush this process. Jot down ideas over time about what you want to build as an online entity before you start.

Make sure your shop **looks good, is simple to use, and easy to navigate**. Plenty of **preparation** will ensure you have an attractive shop for customers. If you are selling only drawings and paintings, create the layout to show all of your work at once, as it is better than separating them onto different pages. Customers do not like having to search through collections or doing a lot of clicking. Have all of your work visible immediately when a customer visits your page, so that their decision-making can be done in half the time

It is also very important that the pictures of your product, and especially the main image which customers will see first, look good. Mediocre images will suggest to customers that you have a mediocre product. Take pictures of your product that are well lit, clear of clutter, and provide customers with an accurate representation of what the product looks like. You should also give a short, clear description of the product and any technical details like size and weight.

Every time you make a sale in your shop, it can be a good idea to contact the buyer via email and ask if they could take a few minutes to give a **review of the product**. When new customers visit the shop, the star rating system will show how happy past customers have been with their purchase, which plays an important role in reassuring new customers. They can see that multiple people have given your product a high rating, so they will be more inclined to make a purchase. However, never try to force customers to give you a review, or annoy them with repeated requests. Politely ask for a review and you will find that people usually respond positively.

Pricing products appropriately is as important to getting sales as having a good-looking shop. You have to be realistic with the price you set. Research other artists who have made similar products such as their

own art books, and look at what they priced them at. You should consider how much time and effort you have poured into making your product but also how much the product is worth in comparison to other items on offer.

Make sure you link all of your social media sites to your online shop. A lot of your followers might not know you have a shop but would gladly like to own your product if they did. The more people that know you have items for sale the better.

You should also make sure you take the time to fill out an "About me" section of any shop you have. If you are making an online shop with its own domain, you should still include some information about yourself. Customers like to know a little about who you are and what your shop is for.

SELLING YOUR WORK THROUGH ONLINE RETAILERS

In addition to (or instead of) selling your work through an ecommerce platform on your own site, you can opt to sell on other online retailers such as Etsy. Etsy is an ecommerce website where artists and craftspeople can sell their work. The advantage of this is that you don't have to set up your own ecommerce section, so it can be a much quicker and simpler option to take. However, sites like this will take a fee for what you sell, so it may not be as profitable as selling on your own site. At the same time, you are

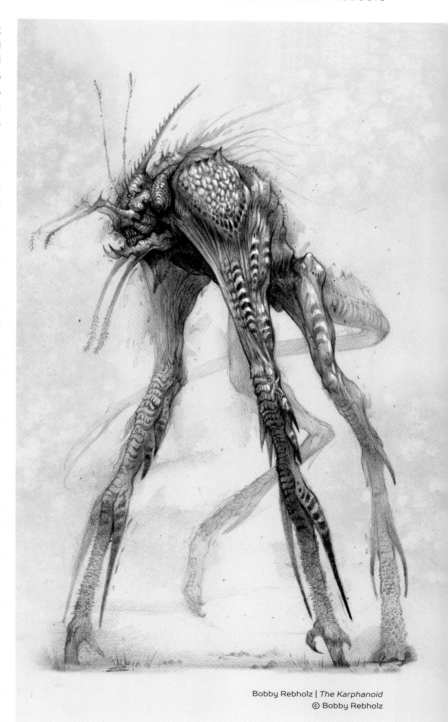

Bobby Rebholz | *The Karphanoid*
© Bobby Rebholz

"Titles will **help customers** develop an **EMOTIONAL CONNECTION** to your *gallery and products*"

Bobby Rebholz | *Trapped In a Web* | © Bobby Rebholz

likely to get more exposure on a site like Etsy which may mean you make more profit overall.

Online retailers such as Society6, Redbubble, and Inprnt are slightly different to Etsy and provide an opportunity for you to sell your artworks on products they produce for you such as prints, tote bags, cushions, and t-shirts. This has made selling your work much simpler than it used to be. Each company offers different royalties and fees on the products sold so look carefully at the different options before you decide where to sell you artwork.

The single most important factor in selling your artwork in this way is to **pick a good product**. Ask yourself if what you are selling is appealing. **Research your target market** and find out what it is that they like. It also helps to research what other artists are selling to a similar market. Every time you complete a new sketch, you could look at your Inprnt gallery to see if it will fit in with the other work. You could just put all of your sketches in the shop but it is better to focus on quality over quantity.

If you are going to use an online retailer, having a large amount of products is not always best. Instead, try to **categorize** your products to make it easier for customers to find the type of product they want. Make sure you title your product and give a short description of what it

is. You can easily just upload artwork and not bother with a title, but titles will help customers develop an emotional connection to your gallery and products.

Again, including links to your retail site on your social media accounts will help your target market find your products. Make all your sites are **easily accessible and inter-connected** to drive more traffic to your online shop. Do not be discouraged if the traffic to your shop is slow to start with. Patience is key to selling any kind of merchandise, and you should not expect customers to pour into your shop right away.

Do not be disheartened if your products are slow to sell at first. It is possible to have instant success if you spend several months posting on social media about your products before they are launched, but slow sales initially is normal. Just be patient and try to build-up public awareness of your work.

GUMROAD AND PATREON
Gumroad is a website where you can sell digital and physical products, such as brush packs, photo packs, and tutorial videos, to other artists for one-off payments or subscriptions. Alternatively, Patreon is designed to help you generate a regular supplement to your income by selling digital content and other rewards to your fans through monthly subscriptions or as and

OFFERING FREE CONTENT
A Gumroad or Patreon page can be very beneficial for a freelance artist. For instance, I run my own Gumroad account and will continue to add more content to it in the future. However, the majority of my content is free to download. This might seem surprising, especially for an artist who is trying to make a living without a salary. The reasoning behind this is that customers respect artists who give up their time to help others without charging for it. Therefore you should never treat Gumroad or Patreon as huge money-makers. Quite the opposite — you should think of them as a place where artists can support each other and learn new techniques.

when you create new content. You should treat your Patreon subscribers as members to your exclusive club and produce rewards that only they can access. On both platforms a seller or creator account is free to set up, with Gumroad and Patreon taking a small percentage fee of your earnings.

When setting up your accounts, try to upload files that you think will **benefit others**. Tutorials, reference photo packs, time-lapse process videos, and brush

packs can be valuable assets that other artists may want to use or purchase for a small fee. It is okay to charge for some of these things, if they are of a high quality, you spend a lot of time making them, and you know that they will help other artists.

SELLING PHOTO PACKS, TEXTURES, AND BRUSHES

As explained on the previous page, creating photo packs, textures, and brushes to sell online is a popular way to make extra money. Several artists take a lot of time out of their busy schedules to travel and take gorgeous photos to use as reference packs. These are wonderful tools for aspiring artists who do not have the means to travel. If you have a good-quality camera, you can take pictures of different environments, buildings, and objects which you can then package into bundles with brushes that could mimic the textures in the photos. The more work you put into these products, the more you will get out of them. Although your first goal should be to help other artists, being able to sell your work is an important part of sustaining a freelance career.

As far as the pricing of these digital products goes, try to be realistic about what they are worth. People typically will not spend a lot of money when they can spend time searching for high-resolution pictures elsewhere and get the same quality for free. Brushes are usually free to download too so if you do sell them, you need to ensure that you offer something unique to the customer.

Obviously it goes without saying that you should only sell work and resources that you own the copyright for.

Bobby Rebholz | *Brotherhood* | © Bobby Rebholz

CAREER PROFILE: RUDY SISWANTO

RUDY SISWANTO
Illustrator
artstation.com/artist/crutz

Rudy is an illustrator based in Indonesia who also works as a freelance artist in the games industry.

CAREER HIGHLIGHTS
- Illustrator at Caravan Studio
- Freelance Artist for Blizzard Entertainment
- Freelance Artist for Riot Games
- Freelance Artist for Wizards of the Coast

DISCOVERING CONCEPT ART
When I was little, I would often look at a book by an illustrator named Tony Wolf. In the book, he explores a world of gnomes, looking at how things function and work within their world. I consider this the first time I saw "concept art," although I am sure the term had not been coined at that point.

A few years later, when I was in elementary school, I played video games such as *Breath of Fire*, the *Final Fantasy* series, and *Diablo*. I realized that there were people who actually drew and designed all of those characters and environments, and I wanted to know how those designs were being implemented in the game. That was when I discovered that there are such jobs and they are, in my opinion, extremely fun! Because I like to play video games, love to draw, and I'm bad at subjects like math, I decided to pursue a career in art instead.

EDUCATION
I did not have a formal education specifically to be a concept artist since there was no concept art or entertainment design major at the colleges in my country. Instead I studied graphic design as my college major. So I am basically a self-taught artist, with the goal of creating professional standard concepts and illustrations. However, during my time in college, I did learn a lot about the different roles, jobs, and processes involved in a creative project. It is very important to take lessons from all your life and work experiences and employ them in your career.

INITIAL EXPERIENCE
My first concept art job was actually to design creatures for an indie movie, which unfortunately was never published. The project was a freelance job and although I did not gain any financial benefit from it, I learned a lot about the production pipeline, which has served me well ever since. The project made me more enthusiastic to work professionally in the entertainment industry and especially drew my interest to character design.

Rudy Siswanto | *Lizard folk Baby Beast* | © 2016 Metal Weave Games

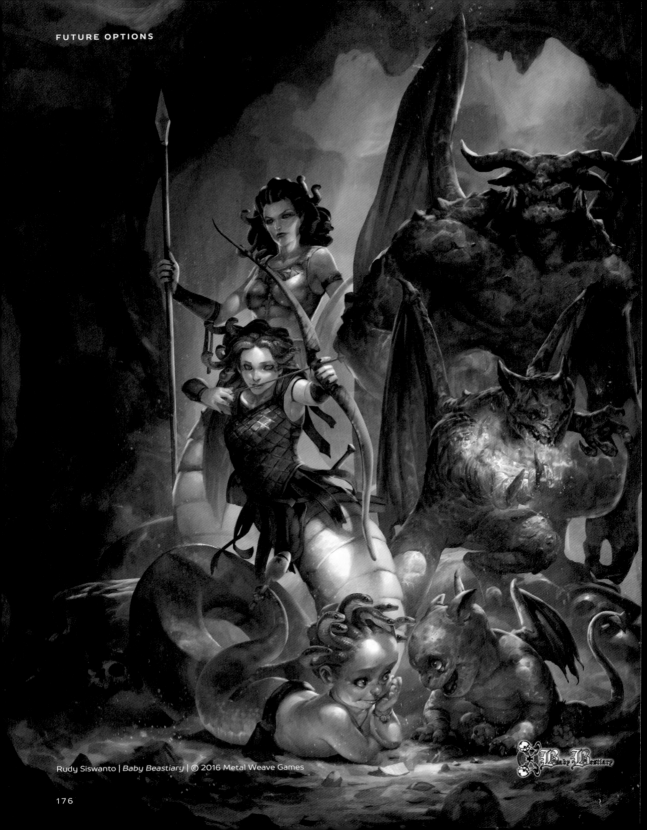

Rudy Siswanto | *Baby Beastiary* | © 2016 Metal Weave Games

THE ART OF BALANCING FREELANCE WORK

There was a time early in my career when I took on too many freelance projects at once. I thought that building a strong portfolio of professional work would help me to attract more clients, therefore I saw every commission I was contacted about as a great opportunity. I took every job offered, and as a result I was over-stretched and unable to deliver my best work. I disappointed my clients either through missed deadlines or by submitting inferior work. It was an unprofessional thing to do and something you should be careful to avoid.

You need to understand your own timeline and working process, so you can measure accurately how many projects you can take on in one month. Usually in that time, I will only work on one big freelance illustration, such as splash art or a cinematic illustration, and two or three smaller illustrations for card games for example. Additionally, I work twenty days a month full-time in a studio from 10:00 am to 6:00 pm. If there is an urgent deadline or project, I also work on weekends. If you do freelance work you need to establish your working hours and what you can achieve in that time frame.

TIME MANAGEMENT

One of the biggest challenges is taking charge of your time management and avoiding procrastination. It is easy to look at the deadline and think you have plenty of time before the due date, and that is when you will make the mistake of being distracted.

To tackle this make a plan for yourself, dividing the project into several smaller portions. For instance, on an illustration I will separate how much time I need to finish the main character, and how much time I need for the background, details, and so forth. Each day I will focus only on the portion of the work that I have already planned to do.

Rudy Siswanto
MIX Fortune teller
© Rudy Siswanto

" It is **better** to set one hour aside per day just to study **THAN IT IS TO DO EIGHT HOURS** of study on the weekend "

DEVELOPMENT

Development depends on your willingness to explore subject matter that you find interesting or useful. If you like a subject, you are less likely to become bored with it, so you will constantly be keen to research and learn new things.

For example I really like animals so I always enjoy observing them. By doing so, I find new references which I can use to design my next creature concept.

THE VALUE OF RESEARCH

My favorite part of the job is that I am continually exploring new things. This takes time, but it is very useful if you do it regularly. For example I was once asked to create a hyena warrior character. First I explored what makes a hyena interesting. I researched their attitude, behavior, habitat, how they eat, and so on as much as possible. This research was an important process, because it strengthened the character of the hyena warrior and made it believable to the audience. This level of research and observation is not only fun but will help you do your job effectively.

CONSISTENT LEARNING

Be consistent and persistent during the process of learning. It is better to set one hour aside per day just to study than it is to do eight hours of study on the weekend. I also strongly suggest that you have a very solid understanding of the fundamentals, which you can learn from books, and videos on the internet. When you have a solid understanding of the fundamentals, it will be easier for you to study from life.

AMBITIONS

So far I have worked on many interesting projects with a wide range of styles. In the future, I would love to focus more on my favorite type of project, which involves stylized animals. To achieve this, I plan to create more personal work that represents this and my personal style.

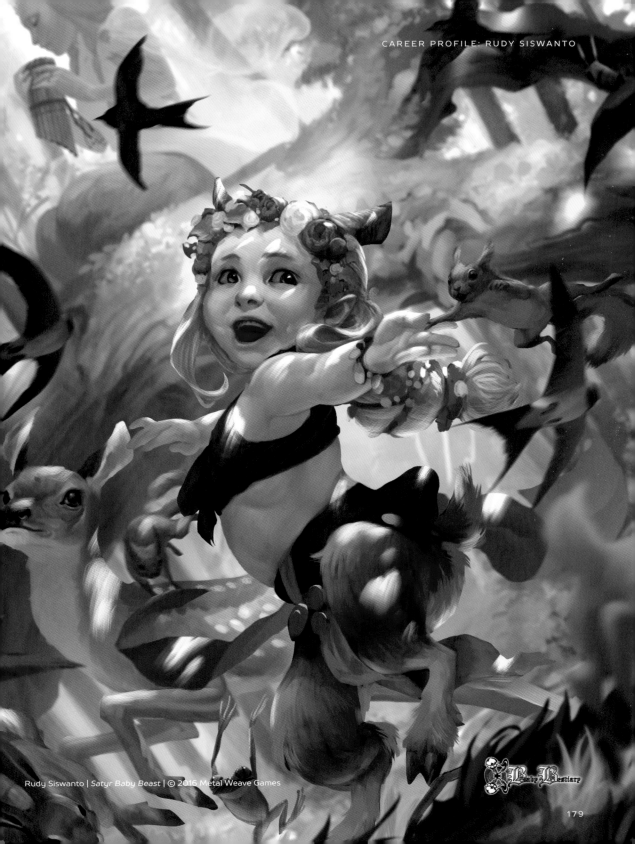

Rudy Siswanto | *Satyr Baby Beast* | © 2016 Metal Weave Games

A DAY IN THE LIFE...

9:00 AM

Before I start drawing, I usually check my emails to see if there is any feedback or updates from my clients. Since I live in a very different time zone to most of my clients, their emails usually arrive late at night.

8:00 AM

I start my day by taking a shower and getting some breakfast. I talk to my wife, who is also an artist, and we schedule our day ahead.

10:00 AM

I start to work on studio projects remotely from home. I work on a 27-inch iMac and a Wacom Intuos 3.

OBSERVATION

Google Images is more sophisticated now than ever before, but do not just look for images when looking for references. I suggest you research further and look for videos. For instance, when I am looking for a reference for a running horse, instead of looking at still images of a horse I open YouTube and watch a video of a running horse. I find that videos give a lot more insight than a still image.

2:00 PM

I continue my studio work. I work on card illustrations and concept designs, ranging from characters, to environments, to prop designs. Versatility is essential if you work within a studio pipeline.

1:00 PM

I take a break to get some lunch. I think taking frequent breaks is important, especially if you have long working hours. I also stretch a lot, and walk around my house in-between my work hours.

DO NOT BECOME TOO ATTACHED

Do not become too attached to your art. You might think it looks good in the moment, but remember that you are able to make your art much better, as long as you keep learning and exploring. As an artist, you need to be open to criticism and feedback. In order to receive constructive feedback, be confident and do not hesitate to post your work on art forums and social media sites.

7:30 PM

I start on my freelance work, which is usually concept art and illustrations for video games. I take freelance work that suits my portfolio and that means I will have fun while working.

6:00 PM

Once I finish my studio work, I have dinner with my wife and relax for a bit. I also do some chores around the house, before I start tackling my freelance work at night.

9:30 PM

I take a break to relax and play some video games, or watch a movie to entertain myself occasionally. I find that it is important to take breaks to stop me from burning out. I take notes whenever an idea strikes, even during my break time.

2:00 AM

Usually I wrap up my work and call it a day at around 2:00 am. It takes quite some time to get used to this kind of lifestyle, but so far, I am enjoying every minute of it.

11:00 PM

I continue working on my freelance work. As I reach the end of my working day, I check my emails again, or send some progress images or updates for my clients to see. It is important to keep in contact with your clients, especially when working freelance.

CAREER PROFILE: AHMED RAWI

AHMED RAWI
Freelance Concept Artist and Illustrator
rawi.artstation.com

Born in Baghdad, Ahmed Rawi is now based in San Francisco, California. With over a decade of experience as a professional concept artist and illustrator he creates art for games, films, and advertisements.

CAREER HIGHLIGHTS
- Concept Artist and Illustrator at Babil Games
- Freelance Concept Artist for Kirarito
- Freelance Matte Painter for Qabila Media Production
- Concept Artist at RGH Entertainment

INDUSTRY DIFFERENCES
The four different industries you learned about at the start of this book are very similar to each other, but as a concept artist who has experienced different environments, I can see clear variations in the production pipeline of each industry. There are small differences like the method you would use to search for references according to what type of project it is, however the main difference is the art direction and the way you are encouraged to tell a specific story depending on what type of audience the project is aimed at.

BE VERSATILE
I like to challenge myself, so I restructure my work strategies for different projects. This helps me to create new methods that push me to complete the whole task in a new, improved way. Not to mention, every project has its own direction and mood which creates challenges.

Switching between industries gives you the ability to mix styles and improve your project management skills. This in itself helps you to adapt and be versatile as well as keeps you open to change when working on tightly controlled projects in the future.

EDUCATION
When I think back to my college days, I remember three important things: the art fundamentals, visiting galleries, and the people who inspired me. That last of those three is the most important because if you do not surround yourself with people who will look at your work and give you their honest opinion, you will remain stuck in your own shell.

LEARNING CURVE
Learning to solve design problems has been my biggest learning curve. This skill keeps your pipeline stable because as a concept artist you have to deal with many different references and shapes, even in character details or an environment. Over time I have developed the ability to build my ideas with confidence and know exactly how much time a concept will take.

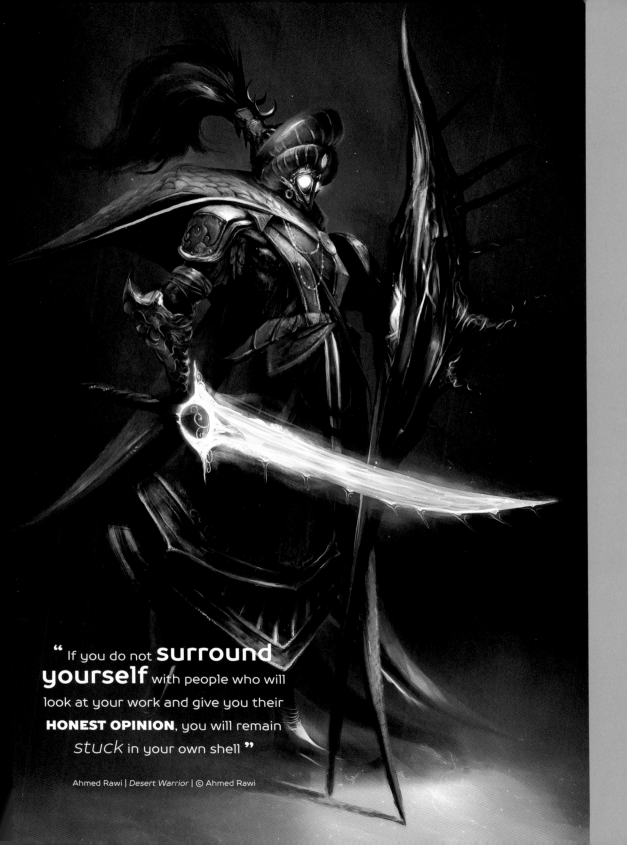

" If you do not **surround yourself** with people who will look at your work and give you their **HONEST OPINION**, you will remain *stuck* in your own shell "

Ahmed Rawi | *Desert Warrior* | © Ahmed Rawi

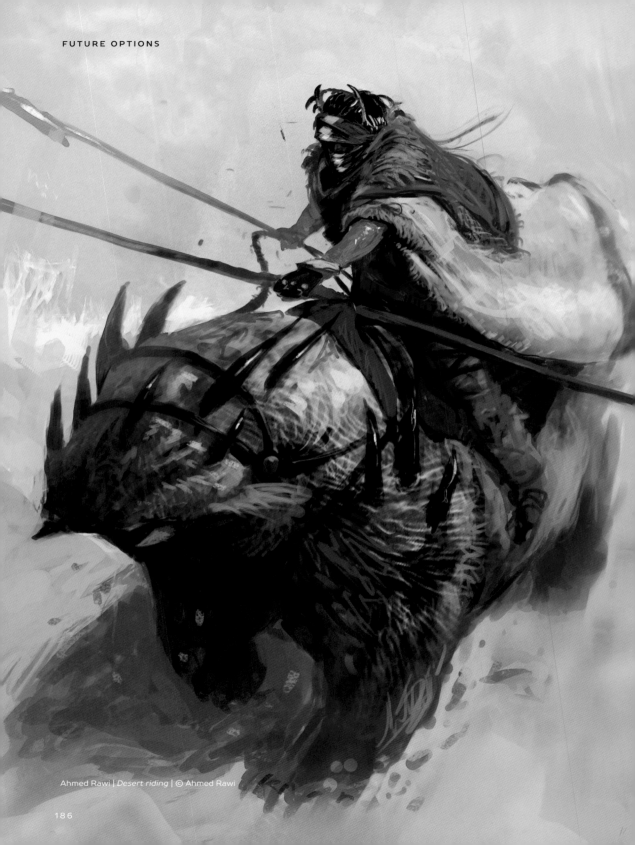

Ahmed Rawi | *Desert riding* | © Ahmed Rawi

FINDING INSPIRATION

I love classical music, which I find very inspirational, and I also enjoy video game music, especially on games like *The Elder Scrolls V: Skyrim*. I recommend reading art books, and doing plein air painting sessions as they help to keep your mind clear and encourage you to refresh your visual library. I find that perusing online art communities is also really inspirational too.

SELF-PROMOTION

I promote my work by using many social media websites like Facebook, Instagram, and LinkedIn. I share my sketches and new artworks almost three times a week. I like to link all my accounts together, especially when I upload a new project to one of my galleries which I find helps to spread my work online.

DEVELOPMENT

Practicing and studying every day is the key. I suggest that you should keep yourself mentally prepared for any new idea or imaginative moment and carry a sketchbook wherever you go. At the end of the week, look through the sketches, filter them, and try to develop them to a higher level.

CAREER GOALS

Feeling like I had achieved all of my goals would be a problem for me. Every goal I achieve creates a new vision for the future and sets a new goal. It is like a continuous chain of goals which never ends.

In the future I would like to be an art director and instructor, working with great artists to inspire, and be inspired by others. I love working in different styles and I am trying to improve the best of them to be more methodical in my approach.

ADVICE

Try not to waste time and pay more attention to practice. I would also advise you to create basic rules for your life as an artist, and not let anything discourage you. If I gave advice to my younger self it would be to play fewer computer games!

A DAY IN THE LIFE...

BEEP! BEEP! BEEP!

9:30 AM

One of the things I love to do in the morning is make breakfast. My wife Suzan loves my mushroom omelet, especially when it is done using Middle-Eastern spices.

9:05 AM

After waking up to my second alarm, coffee is my number one priority; I cannot really imagine my mornings without it. I turn my computer on while the water begins to boil.

11:00 AM

Biking time! I really enjoy cycling, especially when I travel through the forest near to my house. The fresh air and shining sun give me a huge feeling of energy which helps me to think and focus. I sometimes take my sketchbook with me just in case.

DRAW EVERY DAY
Daily study is the key to achieving a higher level of creativity, but try to analyze what it is you are looking at. Pick specific topics each week and study them, try to link what you have learned to the next week's topics. Then organize the collected references in a way that makes them easy to find in the future.

3:00 PM
Around this time I have a break. I usually make another cup of coffee and drink it on the balcony, chatting with friends and having a snack.

12:00 NOON
I return home and get into my studio. I usually check my emails first and re-check my schedule so I know what to do and what I need to finish. I collect the files and references, and start working with confidence.

6:00 PM

Dinner time! Suzan and I usually share this time making the lunch together; she does the main dish and I do the salad. The best part is a nice cup of tea after enjoying the meal.

3:30 PM

Back to work to get some stuff done! I use a Wacom Intuos Pro but also a sketchbook and a bunch of loose papers for very rough sketches. I prefer to work on A3-sized paper and I will keep some of those sketches for years.

7:30 PM

This is my hard-core gaming time! I take gaming seriously, so I spend an hour or more with my friends from around the world and have a great time.

11:30 PM

If I have had enough of drawing, I usually end the day by watching movies and documentaries to relax. I get the popcorn ready before we choose what to watch.

9:00 PM

It is time for some art study. I have a list of study objectives for each week; I will switch sometimes between character design and environmental shapes. I own a Wacom Cintiq Companion 2 too and use it particularly for studies and collecting references.

KEEP IN TOUCH

Social communities are within your reach online, so share your work and ask for opinions from fellow artists. Participate in art challenges and events, contact your favorite artists, and listen to or read interviews to be inspired by other artists' stories.

RESOURCES

EDUCATION AND TRAINING

Art Camp
artcamp.com

ArtCenter College of Design
California, USA
artcenter.edu

CG Master Academy
2d.cgmasteracademy.com

IDEA Academy
idea-academy.eu

New Masters Academy
newmastersacademy.org

Ringling College of Art + Design
Florida, USA
ringling.edu

Schoolism
schoolism.com

The Gnomon Workshop
thegnomonworkshop.com

Learn Squared
learnsquared.com

ANATOMICAL REFERENCE FIGURES

Male and female écorché, nude, planar, and half-and-half anatomy reference figures can be useful when developing your character skills. The ones below are available from shop.3dtotal.com

EVENTS AND CONFERENCES

CTN animation eXpo
California, USA
ctnanimationexpo.com

E3
California, USA
e3expo.com

Industry Workshops
London, UK
industryworkshops.co.uk

SIGGRAPH
North America and Asia
siggraph.org

Trojan Horse was a Unicorn
Portugal
trojan–unicorn.com

CHALLENGES AND COMPETITIONS

ArtStation Challenges
artstation.com/contests

Character Design Challenge
(CDChallenge)
characterdesignreferences.com/
themes

Inktober drawing challenge
mrjakeparker.com/inktober

Spectrum awards
spectrumfantasticart.com

BOOKS

Bridgman, George
Bridgman's Life Drawing
New edition. Mineola, NY: Dover
Publications, 2000

Hogarth, Burne
Drawing the Human Head
New York: Watson–Guptill, 1965

Hogarth, Burne
Dynamic Anatomy
New York: Watson–Guptill, 1958

Hogarth, Burne
Dynamic Figure Drawing
New York: Watson–Guptill, 1970

Whitlatch, Terryl
***Science of Creature Design:
Understanding Animal Anatomy***
Culver City, CA: Design Studio
Press, 2015

Williams, Richard
The Animator's Survival Kit
London: Faber and Faber, 2001

3dtotal Publishing
Art Fundamentals
Worcester, UK: 3dtotal
Publishing, 2013

Please visit 3dtotalpublishing.com/resources for links to further resources

GLOSSARY

AAA GAME
A big-budget video game. Studios that produce AAA games are highly regarded and competition for jobs can be high.

ART DIRECTOR/LEAD ARTIST
A senior member of an art team responsible for setting the art style and overseeing the visual development of a project. They are almost always involved in the hiring of concept artists.

BLOCKBUSTER
Films with a high budget. Working on a blockbuster film is considered a great achievement and competition for jobs on these projects can be high.

CG
Computer Graphics is the field in which concept artists work. Anyone wanting to work as a concept artist must be familiar with digital art and CG.

CINEMATICS
Film-like animated sequences in video games that provide context and are used for promotional purposes.

COMPOSITOR
Compositors compile image elements, created by the various art departments, in layers to create a finished artwork. Compositors work at the end of a production process of films, animations, and video games.

CONCEPT
A visual demonstration of an idea, usually developed to a brief and responding to research. Concepts are required before the production process can begin.

CONCEPT ARTIST
An artist working predominantly in a 2D digital medium to create design concepts.

CREATIVE DIRECTOR
A senior member of the production team, often working on games or films. They oversee the creative development of the project as a whole. For example the art, game play, narrative arc, sound effects, and music score.

FREELANCE ARTIST
A self-employed artist providing professional services on commission. Freelance artists control their work commitments, but do not have the security of permanent employment.

HR DEPARTMENT
The Human Resources department enables the hiring process and administration of a company. The HR department aids contract negotiations, visa applications, assists with professional conflicts, and changes to contracts.

IP
In the video game industry IP refers to Intellectual Property. The project concept of a studio or creator is their IP and they hold the copyright to it.

IN-HOUSE ARTIST
An in-house artist works at a studio with the rest of the team. Working in-house makes the review, feedback, and development process quick, and in-house artists can enjoy working closely with their team.

LEVEL ARTIST
Level artists are usually employed in the video game industry, as part of the development team. They design the content for one or more levels of game-play.

LIGHTER/LIGHTING TECHNICAL DIRECTOR
Lighters ensure that the light and color balance on a project is accurate, and that the lighting enhances the project's tone.

MATTE PAINTER

Matte painters create backgrounds and environments for the film and video game industry. Matte paintings are often photo-realistic and require a variety of photo-editing skills.

MMO GAME

Massively Multiplayer Online games enable large numbers of individuals to play simultaneously and interact in an expansive, multifaceted environment.

MODELER

Modelers create 3D models based on the designs of concept artists. These models are developed and used within video games or animations.

MODEL SHEETS

Model sheets show a character from multiple angles or in different scenarios. Concept artists may create model sheets to help the modeler render a character in 3D.

NDA

An NDA (non-disclosure agreement) is a contract between two parties, usually a studio and an artist, that ensures project information and images cannot be shared until the end of the agreement. It is normal to sign an NDA before working with a studio.

PHOTOBASHING

A technique of layering and manipulating photos and textures to quickly create an image.

PITCH

A presentation in which a project is proposed for production. If a pitch is successful the project moves into production, but if it fails, the project may be abandoned or revised.

PLEIN AIR PAINTING

A traditional art term for painting outside, and responding to the changing elements. Plein air painting is an excellent way to practice fundamental art skills.

PORTFOLIO

A digital or physical catalog of artwork. Candidates for concept art jobs are expected to show a professional portfolio at interview. Online portfolios are used to promote your work and encourage freelance clients.

PRODUCTION DIRECTOR

A production director, or producer, is a senior member of a studio who ensures that the project deadlines are met, that it stays within budget, and is completed to a high standard.

REMOTE ARTIST

An artist employed by a studio but working from home. This may refer to freelance artists.

SPLASH ART

An image used in video games to show the player's character selection. Splash art usually depicts a high-quality render of the character in action.

TECHNICAL ARTISTS

An artist in the video game industry who ensures that art can be properly incorporated into the game without losing quality. They often work in collaboration with the lead artist and the creative director.

VFX

Visual effects are digital images used in the film and television industries when something cannot be filmed in the real-world.

VR

Virtual Reality is a fast-growing area of CG which immerses the user in an artificial 3D world.

FEATURED ARTISTS

GILLES BELOEIL
**Senior Concept Artist at
Ubisoft Montreal**
gillesbeloeil.com

GLENN PORTER
**Creative Director at
Lindeman & Associates**
gporterdesign.com

PAUL SCOTT CANAVAN
**Freelance Senior Concept
Artist and Illustrator**
paulscottcanavan.com

AHMED RAWI
**Freelance Concept Artist
and Illustrator**
rawi.artstation.com

CRISTINA LAVINA FEREZ
**Senior Concept Artist at
Blackbird Interactive**
artstation.com/artist/lavinart

BOBBY REBHOLZ
**Master Class Instructor
and Concept Artist at CGMA**
bobbyrebholz.artstation.com

SZE JONES
**Lead Character Artist at
Outpost Games**
szejones.com

ZAC RETZ
**Visual Development Artist
at Sony Pictures Animation**
zacretz.com

MAREK MADEJ
**Senior Concept Artist at
CD Projekt RED**
artofmarekmadej.com

JUAN PABLO ROLDAN
Freelance Concept Artist
artstation.com/artist/roldan

SAM ROWAN
Concept Artist at
Framestore
samrowan.com

RUDY SISWANTO
Illustrator at Caravan Studio
artstation.com/artist/crutz

KAMILA SZUTENBERG
Freelance Concept Artist
artstation.com/artist/karamissa

JAN URSCHEL
Concept Designer at
Hendrix Design
hendrix–design.com

DONGLU YU
Lead Concept Artist at
WB Games Montreal
artofdonglu.wixsite.com/home

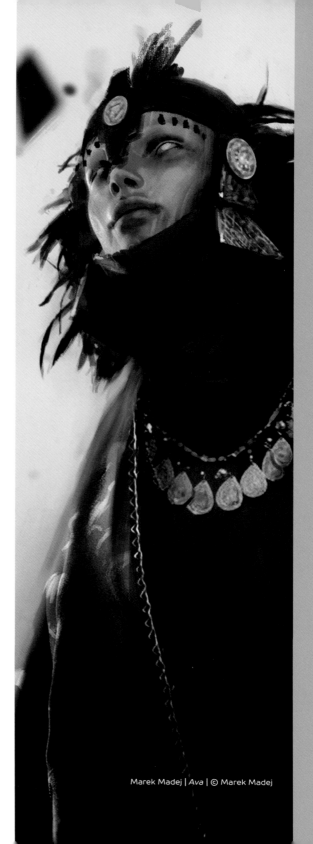

Marek Madej | *Ava* | © Marek Madej

INDEX

3dtotalPublishing

3dtotal Publishing is a small independent publisher specializing in inspirational and educational resources for artists. Our titles proudly feature top industry professionals who share their experience in step-by-step tutorials and quick tip guides placed alongside stunning artwork to offer you creative insight, expert advice, and all-essential motivation.

Initially focusing on the digital art world, with comprehensive volumes covering Adobe Photoshop, Pixologic's ZBrush, Autodesk Maya, and Autodesk 3ds Max, we have since expanded to offer the same level of quality training to traditional artists. Including the popular *Digital Painting Techniques*, *Beginner's Guide*, and *Sketching from the Imagination* series, our library is now comprised of over fifty titles, a number of which have been translated into different languages around the world.

3dtotal Publishing is an offspring of 3dtotal.com, a leading website for CG artists founded by Tom Greenway in 1999.